Close-up on
INSECTS

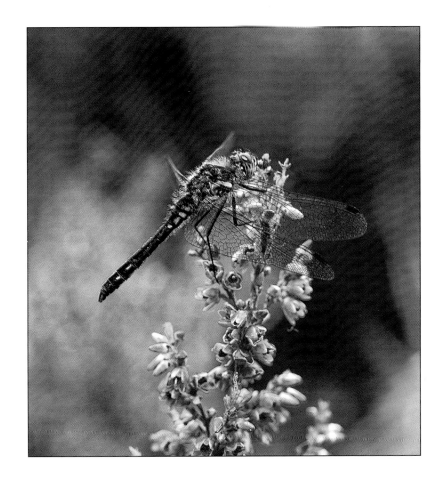

A PHOTOGRAPHERS' GUIDE

BLACK DARTER *Sympetrum danae*

Dedication

For my parents Jane & Samuel Thompson who were always supportive and took time to listen; my son Jonathan, who accompanies me on many of my field trips; and Catherine, who cheerfully puts up with my frequent absences and eccentricities.

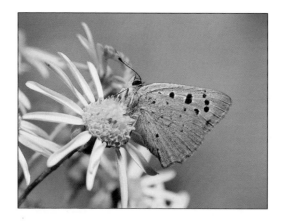

SMALL COPPER *Lycaena phlaeas*

Acknowledgements

I owe a debt of gratitude to many people who have helped me in various capacities throughout my photographic career; in particular Brian Nelson, Denis Brown, Roy Anderson and Kenny Murphy; and also Dave Allen and Frank Warren, with whom I have shared many enjoyable field trips.

I am particularly grateful to Stephen Dalton for his kind foreword, and to Tim Harris and the team at the Natural History Photographic Agency for their hard work on my behalf. I would like to thank April McCroskie, managing editor at GMC Publications Ltd, and David Arscott, my editor, for their commitment, guidance and invaluable contribution to the project; also Stephanie Horner for commissioning the book.

I would also like to acknowledge Banbridge Camera Club, where my photographic skills had their beginnings: I was fortunate to have the expertise of so many excellent photographers, both amateur and professional, especially Kieran Murray and Tom Fairley, who unselfishly give their time and provided answers to my many questions.

I owe a special thanks to Colorworld, especially Kerry White and her team who provide me with an exceptional service; also R. Calvert for all his help and expertise. Finally, I would like to thank Mamiya UK, particularly Mike Edwards, who on so many occasions were helpful regarding equipment and advice.

Close-up on INSECTS

A PHOTOGRAPHERS' GUIDE

Robert Thompson

First published 2002 by
Guild of Master Craftsman Publications Ltd
Castle Place, 166 High Street,
Lewes, East Sussex BN7 1XU

ISBN 1 86108 238 X

Editor: David Arscott

Book and cover design: Grant Bradford, Toby Haigh GMC Studio

Set in Veljovic Book

Colour origination by Viscan Graphics (Singapore)

Printed and bound in Singapore by Kyodo Printing Company.

Foreword

BY STEPHEN DALTON

This book is a remarkable achievement. Not only is it a treasure trove of superb, unpretentious pictures of insects – among the most intriguing creatures on earth – but it also has an accompanying text which is rich in practical guidance suitable for anybody remotely interested in the fascinating pastime of photographing insects.

I have always believed that good photography is more often the product of an interest in the subject rather than in the photography itself. It becomes clear from the start of Robert Thompson's introduction, that his success is largely the result of an abiding enthusiasm for insects dating back to childhood days spent searching for creepy-crawlies around the park setting where he grew up.

A casual glance through the pages of this book immediately reveals that the quality of photography is of a very high order. As well as being technically faultless, the pictures have been sympathetically lit and composed, and I suspect that many were well planned before the camera was taken out of its bag. There are no signs of over-lit out of focus foregrounds or that ghastly flat lighting so often seen these days caused by unimaginative flash technique; nor, on the other hand, has Robert been over-indulgent with his lighting or composition. Consequently the pictures not only appear natural but also seem to be the result of little effort – the hallmark of a true master.

Yet this is no coffee-table book: simply thumbing through the pages will not reveal the secrets of Robert's success. The text has to be read, and then you soon realise that he does not believe in compromises – small format, automation and digital image capture of course all go out of the window. Instead Robert chooses to move in the opposite direction, employing medium format and good old-fashioned film. Indeed, early in the first chapter the pros and cons of medium format versus 35mm are intelligently discussed.

I concur with his views about the difference in outlook that medium format photography often induces among its practitioners, engendering a more discerning and critical approach to one's work rather than the 'machine-gun style' of some 35mm users.

This comprehensive guide goes on to explore all other aspects of equipment and techniques that the newcomer or, indeed, the advanced worker needs to know before producing first class photographs of insects. It is packed with common sense advice and tips amassed through half a lifetime's experience of insect photography. Not a stone is left unturned – everything seems covered, from equipment and techniques to composition and field craft, finally concluding with a portfolio section of yet more engaging portraits of dragonflies and moths and other popular insects.

I cannot say more than that this book has rekindled my long lost enthusiasm for insect photography. I now yearn to go out into the field and take pictures of insects – something I have not done for many years!

Stephen Dalton

May 2002

Contents

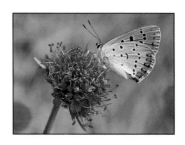
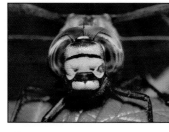
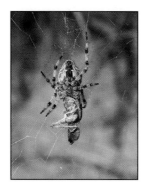
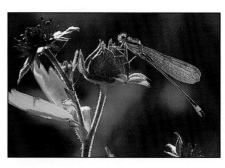

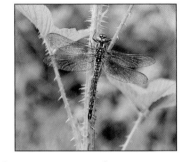

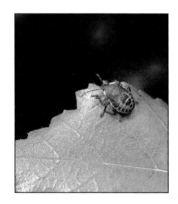

Introduction

INSECTS are without doubt the most successful creatures on earth. They occur in just about every part of the world and occupy virtually all types of habitats. They often arouse fear in people and are referred to by many as being unattractive or aggressive. While this may be true in some cases, many are creatures of great beauty and complexity, their presence in the countryside adding a welcome diversity to the landscape.

I was fortunate for most of my early life to have lived and grown up in a large park, where, as a child, I would often spend the summer months around the grounds looking for all manner of insects, especially butterflies. I was always intrigued by the bright blue damselflies that gathered in profusion on the bankside vegetation around the lake in early summer. My interest in the natural world and insects had its beginnings then, and while I have diversified into other fields of natural history and photography, I have always maintained that link and still remain fascinated with them more than any other group.

Like many other naturalists I spent the vast majority of my early years doing fieldwork on a few of the most popular insect groups, occasionally taking pictures in a casual way of subjects that I found. My interest in photography then was purely recreational and secondary to my fieldwork – until, in the early 1980s, I bought a book entitled *Borne on the Wind* by Stephen Dalton. I was fascinated by his stunning images of insects in flight, and the meticulous attention to detail so evident in his photographs. His book was in many ways responsible for my early photographic endeavours, which I began to tackle with a new-found enthusiasm once my student days were over and I was returning home.

John Shaw, in his first publication (*The Nature Photographer's Complete Guide to Professional Field Techniques*) said: 'To be a better nature photographer, be a better naturalist.' This statement sums it up simply, but effectively. The two go hand in hand, because you cannot hope to produce quality photographs of any subject if you have no concept of their life history and behaviour: your lack of understanding will inevitably show in what you do and what you produce.

The real secret of nature photography, no matter where your interest lies, is having a total commitment to what you do and a deep respect for your subjects. These factors are fundamental to achieving successful photographs in the field. There are no magic formulas or simple solutions that I know except dedication, perseverance and, above all else, a love of the subject. I have always been intrigued with nature and considered myself to be rather fortunate to have developed an interest in the natural world. The more you see, the more you realize how little you know. For those who pursue the interest, it is usually a lifelong commitment: you never tire of nature's beauty or diversity, as there is always something new to see and experience.

This book is written both for photographers who already have an understanding and working knowledge of photography, and for naturalists who wish to learn more about the equipment and methods used to photograph insects in the field. The vast majority of photographs in this book are of subjects that are commonly encountered. I have intentionally kept exotic material to a minimum. In Part One I examine the equipment hardware necessary to achieve professional standards and deal with exposure, film, composition and so on. In Part Two I have selected some of

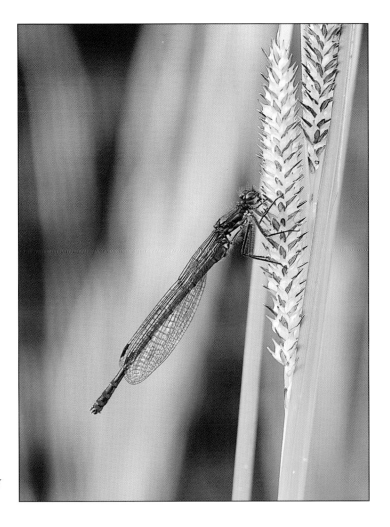

LARGE RED DAMSELFLY
Pyrrhosoma nymphula

the common insect groups, giving advice on ways to locate them, along with basic information on their habits and life cycles. Since this is essentially a photographic guide, I cannot describe in detail the life histories of each group, but I have given the names of recommended reference books at the end of each chapter, and these are, of course, more detailed. There are also names of societies that can hopefully provide further information on your own particular areas.

Many photographers, once they have reached a certain level in their photography, wish to find potential markets for their work. There is, indeed, a great feeling of accomplishment in having your work published in a book or a magazine, and in Part Three I have therefore included some tips about marketing images, whether through writing articles or working with an agency. There is also information about managing your expanding library, and some useful advice about working abroad.

I have purposely avoided filling pages with formulas and equations, as so many books do. While they may be of interest to some readers, I believe that the vast majority of situations require only your eye and experience to tell you what is right.

Finally I hope that, on reading this book, you will gain a greater understanding of the beauty and diversity of the subjects you photograph, and (since this should always take precedence over the camera) that you will have respect for their welfare and preservation at all times.

R. Thompson

Banbridge, Co. Down
May 2002

www.robertthompsonphotography.com

CHAPTER ONE

Camera Systems

IF I had written this book at the beginning of the 1990s this chapter would have been quite different. The advancement in camera design and technology over the last decade has been quite remarkable. For example, when I started to use a medium format camera back in the late 1980s, the choice of lenses for most systems was rather limited, the metering systems were basic and a couple of manufacturers had just introduced interchangeable backs into their 645 formats. Auto focus was still in its early stages of development, and so was TTL flash. Although some of the equipment I used then has changed or been superseded, however, the basic methods and techniques are still as valid today as they were then. You will constantly be reminded throughout this book about technique and the need to understand your subjects, because these, in my opinion, are the real secrets of success.

Since you probably already own a camera and are familiar with its capabilities and limitations, I do not propose to cover in any great detail the relative merits of leading brands: there are many other publications available that discuss camera selection in great depth. There are, however, certain points worth considering if you are coming fresh to close-up photography, or if you plan to upgrade your present system and are unsure of what features or requirements to look for when purchasing a new or second-hand camera.

Choosing a format

As you read through this book it will become quite apparent that the vast majority of its photographs are taken using medium format cameras. This does not mean that you gallop down to your nearest camera shop and exchange your 35mm equipment for a medium format system. The techniques and information apply equally to either format. I would however like to mention some of the advantages that medium format has to offer over 35mm. For photographing birds you will

need to run two systems, because medium format cannot match the versatility of 35mm when it comes to fast telephotos. I use mine selectively, but it has limitations – especially so when you need the use of long, fast lenses.

Medium format was, for years, generally associated with professionals mostly engaged in landscape and commercial photography. For a variety of reasons the vast majority of photographers never regarded this system as an ideal format for nature photography. The cameras, in comparison with today's modern designs, were generally heavy and sometimes slow to operate, and they lacked the large, fast lenses and some of the other accessories that were commonly available to 35mm users. The cost of roll film was more expensive, too, although in recent times it has become cheaper: the number of shots per roll is 15 for the smaller 645 format, 12 for 6x6 and ten for the 6x7.

There have always been countless discussions over the merits of 35mm and 120-roll film. If you want to publish your work, you will find that many companies will choose medium format slides over 35mm – especially calendar and commercial companies where quality is paramount. When I started to use this format back in the latter part of the 1980s, there were very few nature photographers using medium format exclusively, except for landscapes and occasionally static subjects such as plants and fungi. Since those early days I have continued to stick with it, and for the last ten years I have used it for virtually all of my work.

In recent years the trend has changed. More people are realising its potential, and manufacturers have responded by making their cameras lighter, and similar in design and function to 35mm. Mamiya has, in my opinion, gone further than any other medium format manufacturer by offering more streamline designs, with a greater range of accessories and lenses.

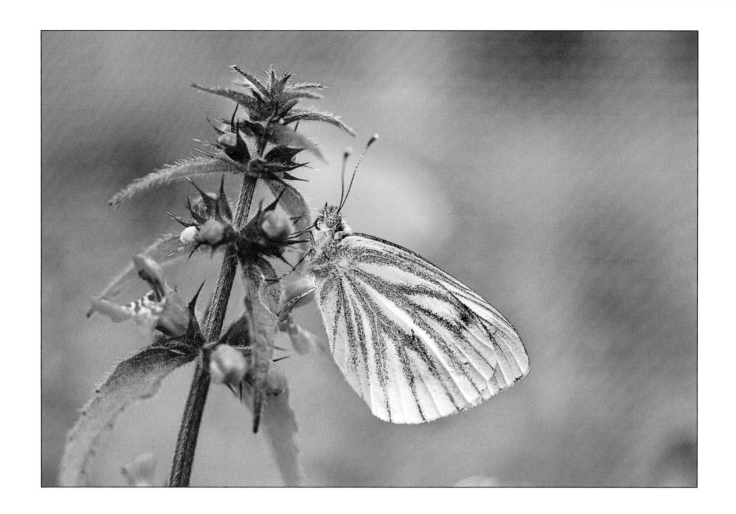

I have often heard it said that once you have used medium format you will never return to 35mm. In my case that is certainly true, for the vast majority of my photographs (including plants, fungi and, occasionally, birds) are taken on one of my medium format systems. I have always found the larger viewfinder more comfortable to look through, and it puts less of a strain on my eyes when working at higher magnifications. On the rare occasions when I have to use 35mm, I find it difficult to readjust to the smaller viewfinder, probably because I have become accustomed to the other for years.

GREEN-VEINED WHITE
Pieris napi

This is one of the first photographs I took using medium format back in the late 1980s. The 150mm lens together with extension tubes is one of my favourite combinations. It gave me the extra working distance I needed to photograph this resting adult.

Mamiya 645, 150mm lens plus extension tubes, Fujichrome 50D.

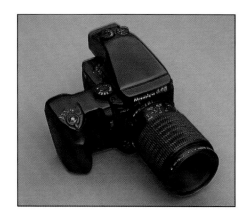

THE MAMIYA 645
One of the popular and versatile medium format cameras for close-up and general nature photography.

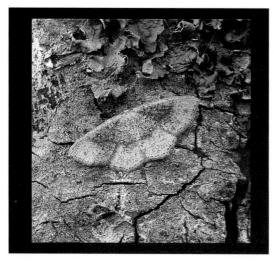

Bronica SQAi, 110mm macro lens, Fuji Velvia.

Pentax LX, 100mm macro lens, Fuji Velvia.

FALSE MOCHA
Cyclophora porata

Comparison showing the actual film size of 6x6 and 35mm. A subject taken on medium format can be photographed at a higher magnification if necessary, and will still show a reasonable amount of surrounding habitat. The format lends itself to cropping much better than the smaller 35mm format.

Advantages of medium format

So what has medium format got to offer over the vastly popular 35mm? The most obvious advantage is the greater film area. The quality of an image is largely dependent upon its original size and reproduction enlargement. The greater film area allows you to increase the size or magnification of the subject, and this has many advantages. First, the image will contain greater overall detail due to the increase in magnification. This is often useful with insects and other smaller subjects, as you can increase the magnification and still retain a reasonable amount of surrounding habitat. The dimensions of 35mm don't lend themselves easily to cropping compared with medium format. Reducing the size of a film format which is already quite small means that you have even less to play with when it comes to enlargement – an important consideration if you plan to sell your work. The larger format also requires less enlargement, either from printing or through projection, thus maintaining greater overall sharpness, colour saturation and tonality. Some photographers make the mistake of confusing enlargement with increasing magnification. You cannot obtain more detail from an image if it isn't there to begin with: increasing the size of the photograph merely enlarges the picture. Most 35mm images will enlarge up to a maximum of 20x16 inches if the image is extremely sharp and perfectly exposed. Medium format negatives and transparencies can take greater enlargements (up to 30/40 inches) without any significant loss of image quality.

Interchangeable film backs are one of the biggest advantages on many medium format cameras, allowing you to switch mid roll between different films and formats when conditions require it. This eliminates the need for additional camera bodies and saves valuable time in the field transferring lenses from one body to another – in addition to remounting the camera on the tripod and refocusing. Some of the smaller modern 645 formats weigh no more than the top-line motorized 35mm cameras. There is also greater versatility when using fill-in flash, as many of these formats use leaf-shutter lenses, allowing flash synchronization at all speeds – a limiting factor with 35mm systems.

The basic entry level into medium format is the 645. Its film area is 2.7 times larger than 35mm. This is probably the most popular format for most photographers with an interest in landscape and general nature photography. It is fairly small compared with other medium format cameras. The majority of manufacturers now produce a good range of lenses at the most popular focal lengths, along with other general accessories common to 35mm, such as macro lenses and extension tubes. The 6x6 is around 3.5 times larger, and is most frequently used by professionals, generally for commercial and portrait work. Most editors tend to crop the square format so that it usually ends up similar in size to the

RUDDY DARTER
Sympetrum sanguineum
(immature adult)

The square format is ideal for cropping in both horizontal and vertical formats. Editors often find this useful as it gives them a choice in either format.

Bronica SQAi, 110mm macro lens, plus 1.4x converter, Fuji Velvia.

LARGE COPPER
Lycaena dispar

I wanted to keep the background diffused as much as possible, since it was rather cluttered. I kept the camera back parallel to the wings of the insect, and chose an aperture which gave me just enough depth of field to keep the insect reasonably sharp.

Mamiya 645, 150mm lens plus extension tubes, Fuji Velvia.

645. I have switched in recent times to using the square format more often, because it allows cropping if required in both horizontal and vertical formats. This can be a useful feature, especially with editors looking for cover shots. Landscape and fashion photographers generally favour the larger 6x7 format, although I frequently use it for photographing plants and fungi.

The most suitable format for insects and general nature photography is the 645. It feels and handles like 35mm and is a good choice for the vast majority of photographers wanting to upgrade without sacrificing too many of the advantages they are accustomed to on the smaller 35mm format. There is no doubt that larger transparencies look more impressive on a light box, and can be viewed with relative ease by an editor. In the vast majority of cases, I feel, they do have a competitive edge over 35mm, especially when larger reproductions are required for cover shots and double-page spreads. The reduction in the number of shots per roll does increase the cost slightly, but this is not necessarily the case: the expense involved makes you think more carefully about each shot, which isn't a bad thing when you consider the film wastage often associated with 35mm. There is no doubt

that it teaches you to be a more discerning and critical photographer. It is often said that medium format users have a more methodical approach to their photography and look at composition more carefully before pushing the shutter – unlike the machine gun style of some 35mm users who rattle off frame after frame, hoping for a hit among the misses.

Things to consider before you buy a camera system

There are more cameras on the market today than ever, so making the right choice can be a daunting task. The most suitable camera for nature photography is without doubt the SLR (single lens reflex): what you see in the viewfinder is what you get. Whether you choose medium format or 35mm is for you to decide, but you should think carefully before you purchase. Don't fall into the trap of rushing out and buying the first system that catches your eye in the camera shop, without doing some research first. Try to obtain the manufacturer's brochure or even a copy of the camera manual. Most companies are happy to provide these. Read any literature you can find, including reviews, before making up your mind.

Investing in a good system should be a long-term commitment, so before you settle on a particular make you should look carefully at the accessories available for it. Your financial resources will play an important part in what you

SCORCHED CARPET
Ligdia adustata

I knew from experience that the light-coloured trunk of this birch tree would appear underexposed if I was to rely on my initial TTL reading. I opened up 1 stop from the meter's suggested reading to achieve the correct exposure.

Bronica SQAi, 110mm macro lens, Fuji Velvia.

can realistically afford to buy. The vast majority of modern cameras are fairly reliable, although a small number of the cheaper brands may have a limited number of lenses and accessories. Some photographers are of the opinion that in order to produce high quality images they need a Nikon or Canon swinging from their shoulder, but this is not the case: there are many other good cameras equally capable of producing excellent results. Your approach and technique are what decides the result on film, not the camera name, although having good reliable equipment does go a long way to help.

Although we are dealing with close-up photography in this book, it is important to point out the possibility that at some time in the future you may decide to expand your equipment to photograph other aspects of nature. Make sure that the system you intend to buy has a good selection of lenses at all focal lengths and has sufficient accessories to meet your needs in the future. Are they compatible with your camera body? There is no point in buying a system that offers a single macro lens with a focal length of 50mm if you intend to specialise in close-up photography of insects. There is nothing more disheartening, after investing your hard earned cash on a system, than to discover that it doesn't cater completely to your needs, or that the manufacturer doesn't make the item you require. Here are some of the features you need to consider before purchasing a camera that is suitable for close-up photography.

Shutter speeds and apertures

Make sure that the camera has a complete range of shutter speeds and apertures. Having a top speed greater that 1/000 sec is no advantage in close-up photography: I can't ever recall using speeds this high. Depth of field is paramount, which means that most of the time, if you are using natural light, you will be working with small apertures and slow shutter speeds. In terms of close-up photography it would be more important to have additional speeds at the lower end of the scale, such as four, eight and 16 seconds. These would prove more useful in the field, especially when photographing static subjects such as plants and fungi.

Exposure settings and compensations

Many cameras today have auto everything: these multiple program modes are largely there to make most, if not all, the decisions for you. This is fine for family prints and the run-of-the-mill holiday snaps, if you don't want to learn or develop your photographic skills and are happy to let a chip do your thinking for you. Most of these functions are not of any value in terms of serious close-up photography. Make sure that your camera has the capability to override the exposure system. The two most useful program modes are automatic, 'Aperture Priority' (you set the aperture it sets the shutter speed) and 'Manual' (you set both aperture and shutter speed). These are the only two modes that I use when photographing close-ups. I can, if needed, make

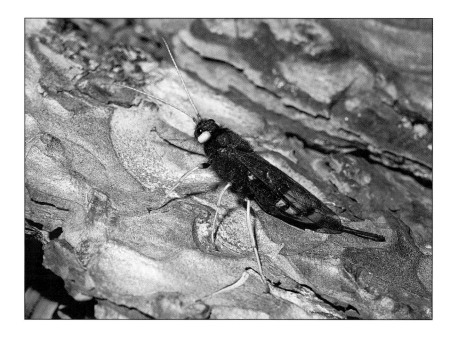

GREATER HORNTAIL
Urocerus gigas

Time is never on your side with active insects. I used the bracket and single flash set-up for this female resting on the trunk of a pine tree.

Mamiya 645, 80mm macro lens plus extension tubes, flash, Fuji Velvia.

decisions and changes regarding the final exposure. On automatic the camera should have some means to adjust the meter's exposure value in both directions (e.g. under- and over-exposure). This is usually known as exposure compensation. It should ideally allow a two-stop shift in exposure values in increments of one-third of a stop. In this way you will be able to make small changes in the exposure settings for subjects that are not mid-toned. Manual operation is my preferred mode for most of my close-up photography. This gives me total control over aperture and shutter speed.

TTL flash

Virtually all of the well-known brands of cameras today incorporate TTL flash in their cameras (see section TTL flash, p. 54). Ten years ago it was quite different, but I wouldn't now consider buying a camera that lacked this capability. Be aware, however, that it isn't fool-proof, and that it requires the same consideration regarding exposure of non-mid-toned subjects as your camera's TTL meter does. It is however reliable in the majority of situations, and it will save you valuable time in the field compared with manual flash, where all of the exposures have to be calculated. To take advantage of this feature you will, of course, need a dedicated flash unit that integrates with your camera.

Depth of field preview

This allows you to preview the image at the taking aperture you have chosen in order to check the depth of field. Remember that you are initially viewing the subject with the diaphragm wide open on the lens. What you see in the viewfinder at this setting is quite different from the final image on film. I consider this to be one of the most essential camera functions. I use it consistently to check the depth of field and the actual photograph prior to exposure. It also allows me to see the zone of sharpness of the subject, as well as the overall image as it will appear on the film. Many modern cameras no longer have this important feature. I wouldn't buy a camera that didn't have it.

Cable/electronic release socket

The majority of camera manufacturers have now removed the manual cable release sockets from their cameras, replacing them with an electronic equivalent. I have on several occasions got my electronic release wet, which meant the remainder of my photography for that day had to be undertaken without it – and I didn't have another. I now make sure that I also carry a cable release, which I can use if I'm stuck. Electronic units are not only generally small and easily lost, but unlike cable releases they are very expensive to replace. Fortunately most medium format cameras have

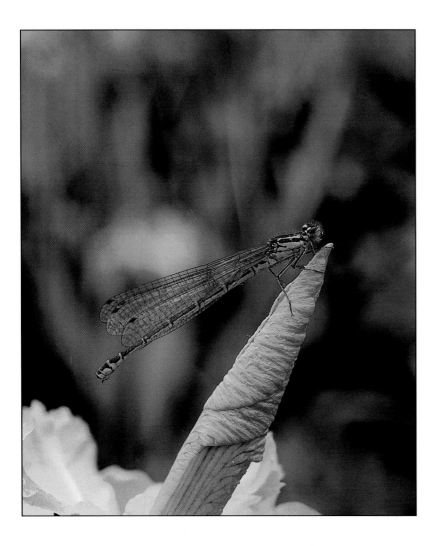

VARIABLE DAMSELFLY
Coenagrion pulchellum

In late May there is always a profusion of damselflies emerging at a local nature reserve near my home. I found this female at rest in a sheltered area off the main pools in early evening. The insect was too close to the vegetation for me to throw the background completely out of focus. I used the converter to help narrow the angle of view, and chose my aperture carefully to keep the insect sharp while at the same time keeping the background as diffused as possible.

Bronica SQAi, 110mm macro lens,
1.4x converter, Fuji Velvia.

both sockets. Make sure your choice of camera has provision for either. Working at slow speeds without the use of some type of release is inviting vibration.

Interchangeable focusing screens

The most critical part of close-up photography is precise focusing: there is no margin for error because the depth of field is so shallow. The standard screen normally supplied with your camera is usually a split image with a micro prism collar. This is useless for close-up photography, because the micro prism blacks out – making it very difficult to focus. Most people try to focus on the ground glass screen, but this is not really practical if you are going to do a lot of this type of photography. When choosing a system, make sure that it has this facility. Most of the well-known camera companies make a series of interchangeable screens for different applications in many of their higher spec camera bodies. The most commonly used screen for close-ups is a clear matt fresnel screen with a central circle or a grid overlay. This is what I have fitted in all of my camera bodies. It's a good choice for general photography, too.

Mirror lock-up

The single lens reflex camera allows you to view the image via a mirror and pentaprism. When you push the shutter button, the mirror swings up out of the way to allow the light through to expose the film. This rapid movement of the mirror as it hits the pentaprism can cause vibrations, making an image appear slightly blurred. The most vulnerable speeds seem to be from 1/15 sec to 1/2 sec. One way to avoid this is to lock up the mirror prior to tripping the shutter. When using full flash this problem is irrelevant, as you are using speeds from 1/60 sec upwards on your camera. Many of the older cameras had provision for locking up the mirror manually prior to exposing the film. Unfortunately most of the modern equivalents, with the exception of medium format and a small number of 35mm cameras, no longer incorporate this feature. I got into the habit of using mirror lock-up from my 35mm days, when I used a Pentax LX camera. If your camera has this feature it is good practice to do it whenever possible, especially when working in natural light and with medium format cameras that have focal plane shutters. I can in some situations see a slight difference in some of my photographs at the slower speeds which are taken this way. It's not always possible to use this approach when photographing insects, except when working off a

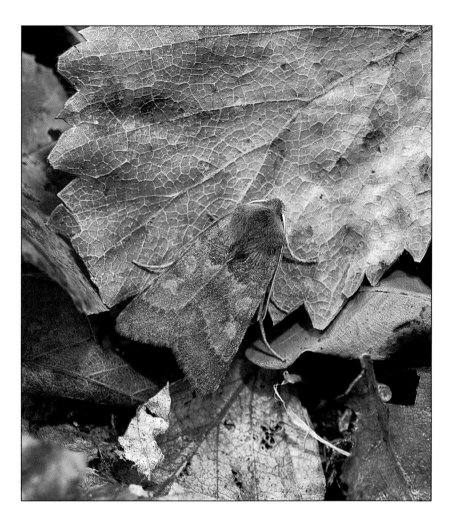

FLOUNCED CHESTNUT
Agrochola helvola

I always try to lock up the mirror, especially when using slow shutter speeds – which is usually the case when working in shady areas of woodland. If your camera has this option I would advise you to use it whenever possible, provided that your subject remains still.

Bronica SQAi, 110mm macro lens, Fuji Velvia.

tripod in natural light and where the subject is at rest. I do, however, use the mirror lock-up procedure for landscape and other types of photography. If your camera doesn't have this feature, don't worry. It's not essential, but you will need to exercise due care when using shutter speeds that are within the range susceptible to vibration.

Auto focus

There have been great advances in auto focus during the last several years, with virtually every currently manufactured camera having this capability. It has made a considerable impact on the way some pictures are taken, particularly in the field of action photography. The use of auto focus in nature photography has a much more limited use. It can be particularly beneficial in bird or mammal photography where action or shots are needed. In landscape and close-up photography it serves no purpose but to irritate you: as the

lens moves back and forth at every fraction of movement, either from the camera or the subject, this causes more problems that it solves. Manual control is still by far the best approach to dealing with subjects in close-up. It also allows you to decide the point of focus within the composition.

Motor drives

Most modern 35mm cameras have some type of motor drive incorporated as an integral unit. For close-up photography this is more than adequate. Having the capabilities of several frames a second is of no real advantage, whereas using a motorized drive can save you time and allow you to take several pictures in succession without having to cock the shutter manually between each exposure. It also obviates the need to touch the camera between shots – which, in turn, often demands a slight adjustment in focus each time the shutter is cocked, especially at higher magnifications.

CHAPTER TWO
Tripods and Accessories

A tripod is without doubt one of the most valuable accessories, and one that is greatly under-rated by many photographers. Learning to use one in all aspects of your work is essential in your development. It is an important tool in close-up photography, and absolutely necessary if you are serious about the photographs you take. I hope that by the end of this chapter you will appreciate the role it plays, and realize its importance with regard to obtaining consistency in your photographs. I can't think of any professional I know who works without one, but I have encountered many amateurs who greatly under-rate them or prefer not to use them at all. Photographers, often without too much hesitation, invest large sums of money on a lens which they imagine will deliver the ultimate in sharpness and colour reproduction – and they then proceed to mount the camera on a cheap flimsy tripod, expecting great things from it. Expensive lenses produce equally disappointing results through the application of poor technique or the lack of adequate tripod support.

Working with a tripod

Some photographers argue that carrying or using a tripod is a hindrance to them. Many think that they are more than capable of hand-holding a camera, even at slower speeds, and can deliver perfectly acceptable results. I have seen this time and again, often on field trips and in camera club outings. Their pictures may look sharp at their original size, but on close examination or through a loupe on a lightbox it will be quite apparent they are not.

Enlargement and printing will clearly demonstrate how false these claims are. The higher the magnification the more critical you have to be regarding your technique and, especially, how you exercise it. Close-up photography demands the highest standards as regards attention to detail,

with any failure clearly visible in your results. Remember that as you increase the magnification you magnify your errors – and this is especially true in close-up photography. I use a tripod in every situation possible and would never consider hand-holding a camera except when working with a monopod or small insects with flash.

One of the biggest advantages of using a tripod (apart from obtaining sharpness in your images) is its ability to hold the camera exactly where you want it. You lose this advantage when you hand-hold because you can't keep the camera still. This makes it difficult to compose and focus precisely, especially when your framing needs to be accurate, which is usually the case in close-up photography. Using a tripod means that you can look directly at the subject if you wish without having to keep your eye to the viewfinder when making the exposure. It also gives you the capability of choosing any combination of shutter speeds and apertures to suit your needs – an essential requirement, since most of the time you will be working well below the threshold for hand-holding. A tripod will allow you to produce consistency in your images in terms of sharpness and accuracy of composition. Failing to use one will severely restrict your capabilities and your development. For example, you will be confined either to taking pictures of insects at low magnifications on bright sunny days, or having to use fast

Benbo mark 1 tripod with the modified Manfrotto ball and socket head I use for all of my close-up work.

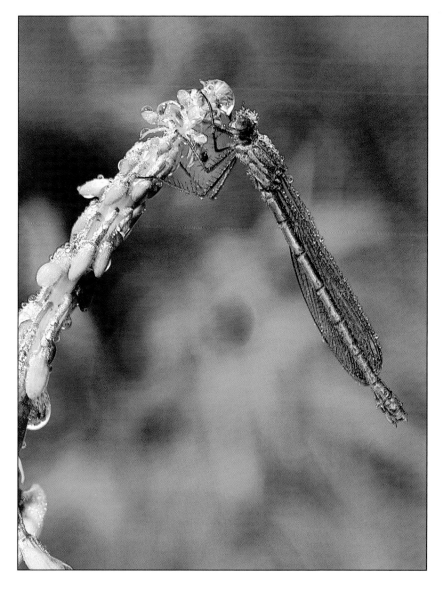

EMERALD DAMSELFLY
Lestes sponsa

I was out extremely early on a cool damp morning, at a local nature reserve when I came across this female damselfly covered in light dew. I was careful not to approach too closely in case the insect would attempt to fly, destroying the delicate water droplets on its wings. The tripod allowed me to frame the subject precisely, while using a longer lens gave me that little bit extra working distance – which meant that there was less chance of disturbing the vegetation close to the subject.

Mamiya 645, 150mm lens plus extension tubes, Fuji Velvia.

films, with a consequent reduction in sharpness and quality. You will be forced to use wider apertures with little or no depth of field, and you will be restricted to a limited range of shutter speeds. All these drawbacks are the result of not using a tripod. If you seriously want to produce good images and publish your work then carry one with you.

There is a wide variety of tripods to choose from. Many are not really suitable for serious close-up photography and should be avoided. There are certain features that I consider essential for achieving consistency in your results, such as sturdiness in all positions, having the capability to work at ground level and still remain firm without slipping under the weight of the camera: most of your photography relating to

insects will be carried out between chest height and ground level. No one tripod can cover all aspects of natural history photography, no matter what manufacturers claim. In fact, the designs of most are flimsy and in some cases totally inadequate for any serious photography. My personal preference is the Benbo mark 1, although Gitzo also produce high quality tripods. Neither make is cheap, but you get what you pay for. Don't cut financial corners regarding a tripod: consider the numbers of years' service it will give you. Avoid the thin, lightweight models offered by many companies. They are not sturdy enough and will undoubtedly increase the risk of vibration when a camera is mounted on them. Manufacturers love to advertise their tripods as being light and therefore easy to carry in the field: they are obviously

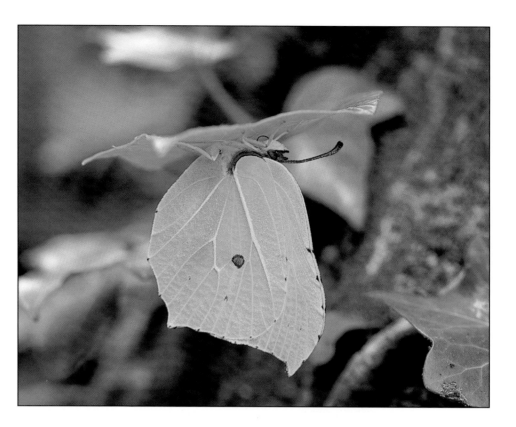

BRIMSTONE
Gonepteryx rhamni

This shot would be extremely difficult to take without the aid of a tripod. I found this insect in early evening in overcast light, resting on the underside of an ivy leaf. A slow shutter speed was needed to allow me to use a smaller aperture to gain sufficient depth of field.

Mamiya 645, 150mm lens plus extension tubes, Fuji Velvia.

targeting those photographers who moan at the burden of having to take one with them. I carry a heavy tripod, plus a large ball and socket head and a backpack full of medium format equipment – and yes, I do at times moan silently to myself about the weight. I feel, however, that it is essential for what I do, and for me there is no compromise.

I have three tripods of different sizes, two of them made by Benbo and the other a Uni-loc. They are all designed on the same principle of a central bolt that passes through all the legs and is locked in one action by a lever. I use the larger Benbo for landscape photography. Its additional height means that I don't have to raise the central column, a movement which can often affect stability and encourage vibration. The other two are slightly smaller and geared more for low-level work. I also use a large Manfrotto ball and socket head that I redesigned to incorporate an internal focusing rail (see section on tripod heads, facing page).

Before you consider buying a tripod I would advise you to take your camera with you and try it out in the shop, making sure that you are comfortable with it and that it is sturdy and solid when attached. Check that it is capable of going down to ground level and is stable and solid in all positions. Try to

purchase a model with as few leg extensions as possible: you don't want to spend half an hour extending it and the other half closing it. The Benbo has only two extensions: an outer and inner tube. Don't even consider buying a tripod that requires you to reverse the central column for close-up work. These are definitely not practical for insect photography, and they are far too awkward to use for any type of fieldwork.

You need a tripod that will function easily in all positions. Benbo and Gitzo are, in my opinion, among the best available. They are sturdy and well designed, and they should last for years. The Benbo is a little awkward for first-time users, so exercise due care when loosening the lever.

Whichever tripod you choose, make sure that it is capable of working at ground level.

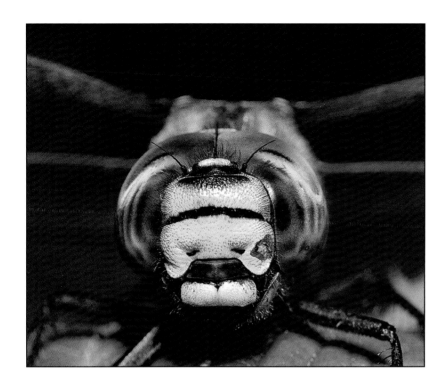

COMMON HAWKER
Aeshna juncea

The movable platform is indispensable for higher magnifications such as the large compound eyes of this male hawker. Shots like these are possible only when an the insect has settled for a period of time. I was able to make fine adjustments once I had positioned my tripod. Flash is essential in these situations in order to arrest any movement.

Mamiya 645, 80mm macro lens plus extension tubes, flash, Fuji Velvia.

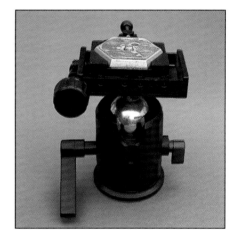

The modified Manfrotto ball and socket head with the re-designed movable platform. The black knob is used for making fine focus adjustments to the platform table in either direction.

You must always support the camera with one hand while opening the lever, or the camera and central column will hit the ground. The tripod is locked in one action by tightening the lever in whatever position you have the legs set: this makes it quick to position and use.

Tripod heads

Once you have made a decision about the tripod you need to consider a head. You basically have the choice of pan/tilt or ball and socket. This comes down to personal choice. I prefer to use a ball and socket, because I've always felt comfortable with it and find this type of head easier to use in close-up photography. True, you lack the ability to make fine adjustments in a particular plane as you would with a pan/tilt, but I have not found this to be a disadvantage. The only heads I would consider (especially when using medium format) are those with a large diameter of ball with an adjustment screw to alter the drag or tension on the ball, so that the head doesn't flop down when loosened. A good head

should have the ability to hold the camera set-up firmly in any position without slipping. Avoid small, lightweight heads, as these will impair the performance of your tripod. Good high-quality ball and sockets are not cheap: you will pay in the region of £250 ($350) upwards for the best. Arca Swiss have a good range to choose from. Kirk Enterprises (an American company) are also well worth considering.

I use a Manfrotto (or Bogen) which I find works well with my medium format systems. I chose this particular make for a reason, as I wanted to modify the platform to incorporate a built-in focusing rail. The engineering department at Queen's University, Belfast, were happy to oblige, producing a movable focusing platform that also incorporates my hexagonal base plate. This gives me the ability to make small adjustments at higher magnifications, without the need to add additional accessories such as a focusing rail. This cuts down on weight and additional height on the head. I find it indispensable, and use it most of the time when I need to make minor corrections regarding focus and camera position.

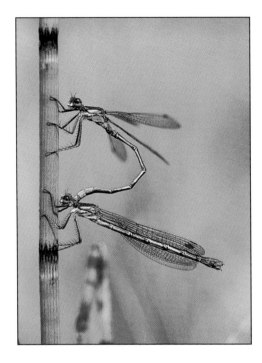

**EMERALD
DAMSELFLIES**
Lestes sponsa

*These paired
damselflies were at the
edge of a small pool.
The female was about
to descend into the
water. It would have
been impossible in this
situation to use a
tripod since the insects
were a couple of feet
out from the edge of
the ramp. I forced the
spike into the edge of
the peat; this gave me
additional support for
the camera.*

**Pentax LX, 100mm macro
lens, Kodachrome 64.**

*Monopods are useful in situations
where the terrain makes it difficult
to use a tripod. They also provide
some additional support when
stalking active insects.*

Monopod

A monopod has a limited use in photographing insects. It can
be helpful in situations where the terrain makes it difficult
for a tripod to be used without disturbing the surrounding
vegetation. I have found it helpful when stalking dragonflies,
which often perch on the top of bramble or bracken at the
edge of a stream or pool. It is really only practical for
working at lower magnifications or stalking larger active
insects. Even in good light, most of the time you will be
working with apertures around f/8 to f/11 and shutter speeds
around 1/15 sec. When I am forced into using it,
I often change to a slightly faster film such as Provia to give
me an extra stop, and this can be very useful. The
interchangeable backs of the Mamiya and Bronica make it
quite easy to switch, depending on the situation. Medium
format cameras can be a little more cumbersome when hand-
holding, so extra support from the monopod proves useful.
Remember that a monopod is not a substitute for a tripod,
and should be used only when, for hand-holding, additional
support would be beneficial.

Pan/tilt heads are much slower to use than ball and socket
heads, but they are more precise in their movements. Each
movement is governed by a separate control allowing you to
make changes in forward and backward positions, as well as
left and right. The biggest drawback with these heads is
speed of use, since you have to loosen and tighten each
control individually, slowing down the whole procedure.
While some photographers use them for close-up work, in my
opinion they are more of a hindrance for insect photography.
Manfrotto (Bogen) have some good models which are worth
considering if you prefer this type of unit. Before you decide
to purchase, however, I would suggest trying them out, as
they don't suit everyone's style of photography.

You will want the head to incorporate a quick-release plate.
The expensive heads come with their own design. This gives
you the facility of a quick change-over from one camera to
another. You will need to purchase additional plates if you
have more than one camera.

BEAUTIFUL DEMOISELLE
Calopteryx virgo

***This male was perched high on the bramble. Working a
tripod in such terrain was always going to be difficult,
and the monopod can be more useful in these situations.***

Pentax LX, 100mm macro lens, Kodachrome 64 Monopod.

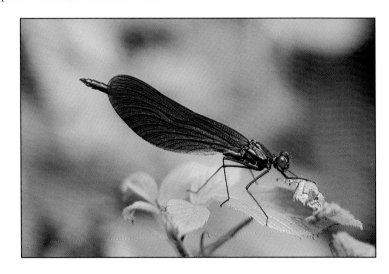

SMALL SPURWING
Centroptilum luteolum

Focusing needs to be absolutely precise when working at magnifications beyond life-size. My own built-in unit works extremely well in these situations.

Mamiya 645, 80mm macro lens plus extension tubes, flash, Fuji Velvia.

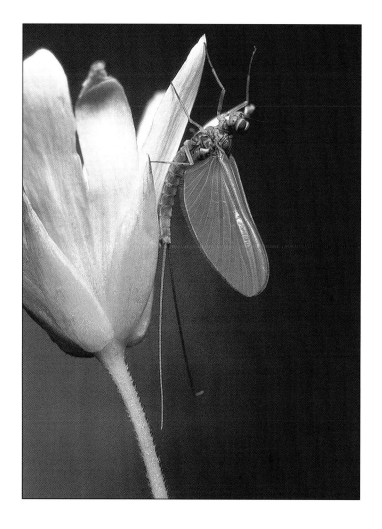

Most monopods are generally a little long for working close to the ground. I have reduced the length of my Benbo slightly and have made a spike for the bottom that I can force into the ground for extra stability when I am roughly the right distance from the subject. I can then make small adjustments to the focus by moving it forwards and backwards: my body gives additional support and helps to stabilize the camera as well.

You will also need a small ball and socket head for the monopod (these are usually sold separately) to allow you to make adjustments to the camera angle: you will otherwise be able to use it only when the monopod is at right angles to the ground. There is a good selection of monopods available from well-known tripod manufacturers, but they should be regarded as for occasional use only.

Focusing rail

When working at magnifications below life-size you normally focus by moving the tripod and camera assembly into position, and fine-tune by rotating the lens-focusing mount. This method does change the magnification slightly, but at low magnifications it's easier to make adjustments. When you want to photograph subjects at life-size or higher it becomes much more difficult to focus using the focusing mount in the lens. Rotating it at larger magnifications will alter the composition of the image quite dramatically, as well as changing the subject size. Making fine adjustments with a tripod is almost impossible at these magnifications, as the slightest movement in position or from the subject puts the entire picture out of focus. The only practical solution for working at higher magnifications is to use a focusing rail. This permits you to make fine adjustments by moving the whole camera assembly backwards and forwards without having to alter the tripod position. The rail is mounted on to the tripod head and the camera is then attached to it. You

can use any make of rail, but do select a good sturdy model. The only drawback with using a rail is that it adds additional height to the head, although this becomes a problem only with subjects that are very close to the ground. It can be difficult in these situations to keep the camera back totally parallel to the subject.

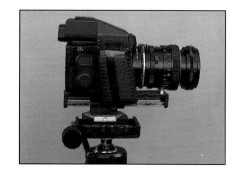

The Mamiya 645 on a typical focusing rail. Make sure the rail is sturdy and capable of holding the camera firmly.

CHAPTER THREE
Film

THERE are more brands of film available today than ever before. Your choice will largely depend upon your palate and your long-term aims regarding your photographs – something which it is useful to establish from the start. You may be taking photographs purely for pleasure; to accumulate subjects for use in lectures and other presentations; or to build a library with the intention of selling your work at a later date. The vast majority of professionals and advanced amateurs use transparency film for their work, and this is what I recommend you should do until you have mastered the basics of exposure and have perfected your techniques.

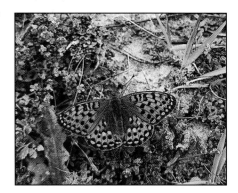

DARK GREEN FRITILLARY
Argynnis aglaja

Film choice is a matter of personal taste. While Kodachrome may be slightly more accurate in terms of its colour rendition, many photographers prefer the slightly warmer tones of Fuji Velvia.

Mamiya 645, 150mm lens plus extension tubes, Kodachrome 64.

Film choice

The two main manufacturers of film are Kodak and Fuji. They have the biggest percentage of sales in the market, and both manufacturers make professional and amateur versions of their most popular films. They are sometimes given different names, but basically they are the same emulsion and both will deliver excellent results. There are no real major differences in the two film types except that professional films justify the slightly increased price because they are governed by more stringent controls in terms of sensitivity and colour consistency. This is especially important in commercial and fashion photography where the colour reproduction has to be consistent. They also differ from amateur films in that they are released by the manufacturer only when they have reached maturity. To keep them in their optimum state they must be refrigerated before and after use and processed as soon as possible. I have on a few occasions, when I've been stuck, used professional film that has been a year and a half out of date, and I found no perceptible difference when it has been kept refrigerated. The majority of amateurs and professionals use a combination of Fuji and Kodak. All of these films deliver superb results when used properly. It's really a matter of

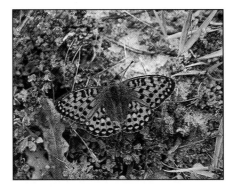

Mamiya 645, 150mm lens plus extension tubes, Fuji Velvia.

personal choice: some photographers prefer the slightly warmer, accentuated colours of Fujichrome, especially on overcast days, and others swear by Kodachrome. Most, if not all, roll film for medium format cameras is generally manufactured to professional standards.

Kodachrome (64 and 25) was for years the standard film used by both amateurs and professionals. Its reputation for sharpness and colour rendition was ahead of any of the E6 films during the peak of its popularity. In recent years it has lost considerable ground to the E6 market, largely due to the

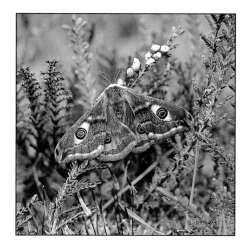 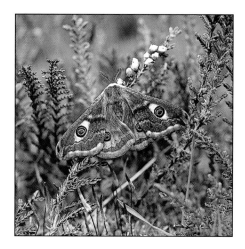 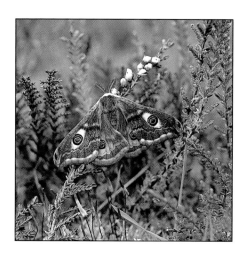

EMPEROR MOTH
Saturnia pavonia

Bronica SQAi, 110mm macro lens, Fuji Velvia.

Bronica SQAi, 110mm macro lens, Fuji Provia.

Bronica SQAi, 110mm macro lens, Kodak E100VS.

advances in film emulsion technology which has dominated the market for the last ten years. Kodachrome films require specialised processing because the colour dyes (unlike E6) are formed in the emulsion layers during processing. You cannot, therefore, use conventional photographic laboratories to process these films, except in the USA: the exposed films have to be returned to Kodak or an authorised laboratory in the mailer provided. This is the major drawback with Kodachrome, which now has to be sent from the UK to Switzerland for processing. With many professional photographers this can be a disadvantage, especially when you need to view your results quickly. E6 technology has progressed rapidly in the last several years, with Fuji and Kodak producing a wide range of high quality films that deliver extremely high levels of sharpness and colour saturation. The larger processing laboratories have also introduced quality control management systems into their processing service, and this has gone a long way to towards improving the standard of E6 processing. This surge in E6 technology has, without doubt, had an effect on Kodachrome sales in recent years, with many photographers both amateur and professional shooting the vast majority of their pictures now on E6 films.

It is worth experimenting with different brands of film, and comparing the results. My advice is to stick with a couple: get to know their characteristics and their limitations in the field. Run some test shots with different films side by side of

Here are three of the most commonly used films. Note the differences in colour saturation between Velvia and Provia. The colour in the E100VS is warmer than the other two. I leave you to make up your own mind as to your preference. There's no right or wrong film.

subjects in the same light, and see how they perform at slow speeds and in poor and contrasting light. Many of the major films available in 35mm are also available for medium format cameras in 120/220-roll versions, with the exception of the Kodachrome range of films. A 120-roll version of Kodachrome was introduced back in the mid-1980s and withdrawn in the early 1990s for a number of reasons, mostly associated with processing. The rapid development of E6 emulsions made it difficult for many photographers to justify the cost, and this was no doubt a contributing factor that helped seal its fate. This was unfortunate, because many medium format users had been pressing Kodak for years to develop a 120-roll version.

Another factor you should consider is the long-term value of your photographic material. Kodachrome is not suitable for constant projection and will fade much more quickly than E6 emulsions if exposed frequently to light. However, in the past it has always been stated that Kodachrome emulsions have the best longevity when it comes to archival storage, showing little change in the emulsion and colour if stored in the proper conditions of 40°F relative humidity. If you plan to use your slides a lot in terms of projection, I would

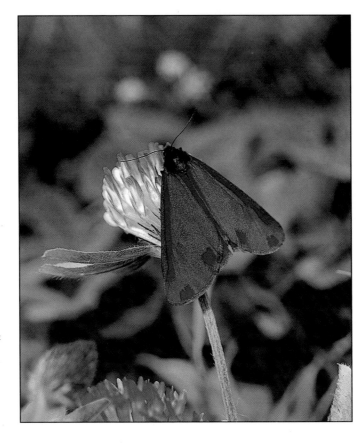

CINNABAR
Tyria jacobaeae

I prefer the colour and saturation of Velvia to any other film. I use it for all of my work, except when I'm forced into using faster film.
I like Provia as an alternative when I need extra speed.

Bronica SQAi, 110mm macro lens, fill-in flash, Fuji Velvia.

suggest using E6 emulsions, as they are much better at coping with frequent exposure to light. They may (depending on storing conditions) show a slight colour and chemical change over a period of time, but the modern E6 films are much more stable today, and they have archival parity to Kodachrome — or so the manufacturers claim.

My own preference

For insect photography you should use the slowest film that conditions will allow. There is no one film that can cope with every type of situation. For the majority of my insect photography, including pictures taken with flash, I use Fujichrome Velvia (professional 120-roll), which has an ISO of 50 and a diffuse RMS granularity value of nine. It performs well in the vast majority of situations, including low light. It is also extremely fine-grained and delivers deep saturated colours. This is one of the films most widely used by amateurs and professionals on both 35mm and medium format. I also use Fuji Provia, which has an ISO value of 100 (one stop faster) in situations where I'm working insects in very low light and the extra stop is useful. It has currently

been revamped, and the new Provia F in my opinion is truly an excellent film – almost as saturated as Velvia and a good compromise when conditions require it. Fuji are claiming a diffuse RMS granularity value of eight, which is lower than Velvia, although it still has a greater resolving power than Provia F. Kodak have also been promoting their new range of E6 films, incorporating the latest developments in T-Grain technology. Kodak E100VS (vivid saturation) is intended to compete with the Fuji duo, and is also a highly saturated film with a diffuse RMS granularity of eleven. Kodak claims it is suited for subjects that require brilliant dramatic colours. The film is a little rich in the palette for my taste, but is popular with nature photographers.

It's a good idea not to fluctuate from brand to brand, because it becomes difficult to remember the performances of different films when used in challenging conditions. I personally use only Velvia and Provia for virtually all of my close-up work, and I'm more than happy with their performance. I don't as a rule use fast films when photographing insects, mainly because of the reduced image quality.

Print film

I will dwell only briefly on this film because, for a number of reasons, I don't consider it to be a good choice when it comes to producing consistently high-quality photographs. The first and most important reason is its sharpness. Colour negative film cannot deliver detail and image sharpness in the way that transparency film can: the tonal contrast and colour range is much more limited. Prints that are produced from transparencies are usually much sharper, more vibrant and generally have more of the characteristics of the original slide. The results from colour prints in terms of colour accuracy, sharpness and exposure are extremely varied, and depend entirely on the processing machine and its operator. The other big disadvantage with taking prints is that you cannot easily evaluate exposure, sharpness and your mistakes by looking at a negative. Prints are usually more expensive per shot, and if you plan to sell your work through agencies, note that the vast majority of them will simply not consider prints.

For many years I carried a spare back loaded with print film and, where possible, I duplicated some of my work so that I could quickly show it to clients if required. This proved to be quite expensive over the years, especially when using a medium format camera and printing the film to 10x8. Cibachrome printing has always been a popular method of obtaining prints from transparencies: it does work well with slides that have a fairly even contrast. I have in recent times, with the help of a professional laboratory, been experimenting with high-resolution scans of my slides and digitally printing them on to photographic paper with truly excellent results. In fact, I have been so pleased with the outcome from these experiments that I no longer feel the need to carry a film back for prints.

Transparency film

This is by far the most preferred choice of advanced amateurs and professionals. If you are serious about your photography, this is the only choice. I'm not saying that prints have no place in nature photography: they do, but for different reasons. One of the most important advantages in using transparency film is that you can see the actual exposure on film and check the colour balance and sharpness on a light box. It is also possible to see the result of fine adjustments made to the exposure and its effect on the picture. Furthermore, it is easier to relate a transparency

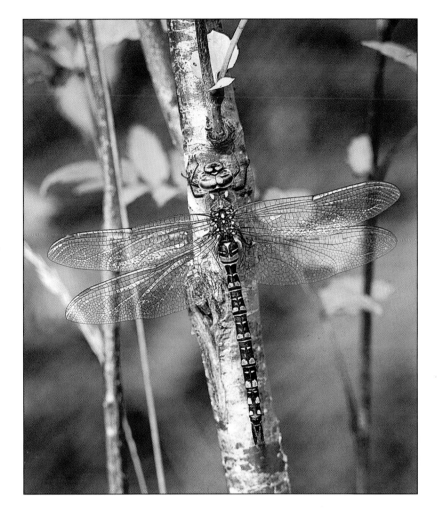

MIGRANT HAWKER
Aeshna mixta

Shots like this are always tricky. If you move too quickly you are likely to lose the subject. I often take an initial shot from slightly further back before I try to get closer. If the weather is slightly cool or overcast the chances are that it will stay put.

Mamiya 645, 150mm lens plus extension tubes, fill-in flash, Fuji Velvia.

to the original subject as you remember it: a negative is meaningless in terms of evaluation to all but an experienced printer. Viewing a slide will also allow you to analyse your technique and make any necessary adjustments. It is worth noting that transparencies are the preferred medium for agencies and book publishers, should you decide at a later date to market your work. Projecting transparencies is an exciting way of showing your work, and useful for lectures and talks where the results of your labour can be enjoyed by many.

Exposure

ONE of the most important parts of the photographic process is being able to record the subject correctly on film, and yet this part of the procedure is where many photographers experience the greatest difficulty in achieving consistency with their exposures. Getting close to insects under certain conditions can be a real challenge. Because so many factors play an important part in a successful picture, the last thing on your mind should be whether the image is exposed properly on film. Many photographers shooting landscapes or static subjects often bracket their exposures as a safeguard, but this approach can be rather hit-and-miss with insects. If you are serious about your photographs then it is vital that you understand exposure and how to apply it properly to a given situation. After all, you may only get one chance to get it right!

Calibrating your camera's meter

The majority of modern cameras have pretty advanced TTL metering systems – so why (I can hear you ask) do we need to bother about making decisions regarding exposure, when the camera should be capable of handling the vast majority of photographic situations? A camera's metering system gives a reflected reading: that means it measures the light reflected from a subject and then assigns a suggested value to it. When you purchase a camera, one of the first tasks you should carry out is an ISO calibration test to ascertain the accuracy of the meter and a baseline for your exposures. What you're really trying to achieve is an accurate reference position for rating what is often referred to as a mid-toned, or medium-toned, subject.

The easiest way to perform this test is to select a subject which has a mid-tone value, such as green grass or foliage of a similar shade. Mount your camera on a tripod and focus on the subject. It doesn't matter what lens you choose as long as you perform the test with the same equipment focused on the same subject. Choose an overcast day when the lighting conditions remain constant. Set the camera's ISO setting for your chosen film – let's say, for example, that we are using Fuji Velvia, whose ISO value is 50. Use the aperture priority mode on your camera for this test. Check to make sure that your compensation dial is set at zero. You will need to make a note of your adjustments to the ISO dial. You can either use a notebook, or incorporate something at the corner of each frame to remind you of the exposure details so that you can refer to these settings when your film is returned.

The first exposure should be taken at the recommended setting given by the film manufacturer. For the next exposure (moving up the scale) advance the ISO dial to the next position, which will be 64 (with some older cameras it may just be a dot between the most common ISO values) and 80. It's unlikely that any modern camera's metering system will be that far away from the appropriate ISO number on the dial. Repeat this procedure moving down the ISO scale, at 40 and 32. What you now have is a range of photographs with incremental changes of approximately one-third of a stop made to the exposure by adjusting the ISO dial on the camera. On return of your film, select the one which offers the best exposure: this will be your new ISO setting when using this camera and film. Once you have performed this test you can calibrate your other cameras to this value by adjusting their ISO settings. The ISO values will not necessarily be the same for each camera. For example, on my Bronica I expose Fuji Velvia at an ISO setting of 64, on the Mamiya 645 the dial is set at 80, while the Mamiya RZ67 is fine at 50. Adjusting ISO values does not have any effect on the processing of your film. I would suggest sending your test film to a good laboratory, and then evaluating their handling and processing of it. If they're careful, and your films are clean and devoid of finger marks, stick with them.

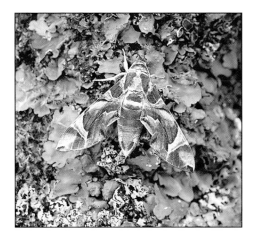

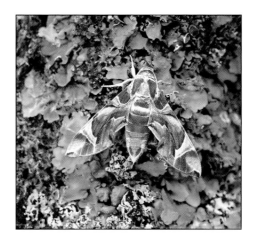

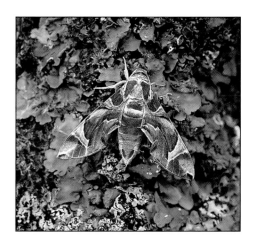

OLEANDER HAWK-MOTH
Daphnis nerii

Bronica SQAi, 110mm macro lens,
Fuji Velvia exposed at 32 ISO.

Bronica SQAi, 110mm macro lens, Fuji
Velvia exposed at 40 ISO.

Bronica SQAi, 110mm macro lens, Fuji
Velvia exposed at 50 ISO.

These five frames are taken from my test roll of film to ascertain the baseline exposure for a mid-toned subject. I adjusted the exposure value in increments of approx $^1/_3$ stop in both directions, and took shots at 32, 40, 64 and 80. On return of my film I could then choose the best image and check the ISO value for that particular shot: this would now be my new setting for this film using this camera body.

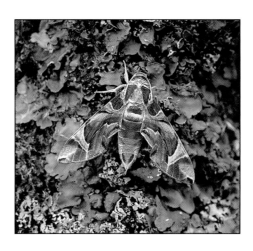

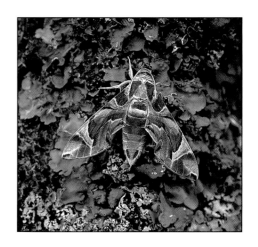

Bronica SQAi, 110mm macro lens, Fuji
Velvia exposed at 64 ISO.

Bronica SQAi, 110mm macro lens, Fuji
Velvia exposed at 80 ISO.

Metering modes

The majority of modern cameras come with an array of metering modes, which are designed to make virtually all the decisions for you. With regard to photographing insects you can ignore all of these program modes with the exception of aperture priority (you select the aperture: it controls the shutter speed) and manual metering (you control both aperture and shutter speed). These are the two most useful settings, giving you control over the exposure and the ability to make alterations to the final exposure value.

Aperture priority and manual metering

For speed and ease of use I find aperture priority the most useful of all the program modes, especially when I'm photographing larger insects such as butterflies and dragonflies in natural light. It's useful to be able to preset the aperture you want. This frees you to concentrate on the subject, especially in situations where the light is constantly changing. It can also be useful when you want to be selective in your depth of field in order to control background focus.

GLAUCOUS SHEARS
Papestra biren

In situations where you are photographing a non-mid-tone subject you will have to make corrections to the final exposure value. You could try metering on a mid-tone subject close to the image if possible: lock the exposure value, re-compose and shoot.
The camera's suggested reading for this first picture produced an under-exposed image. I used the exposure compensation dial and increased the exposure value by 1 stop to render the moth and rock in the second picture at the correct value.

Bronica SQAi, 110mm macro lens, Fuji Velvia.

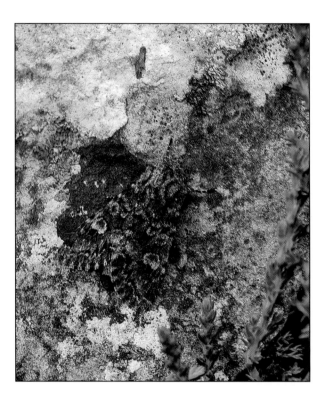 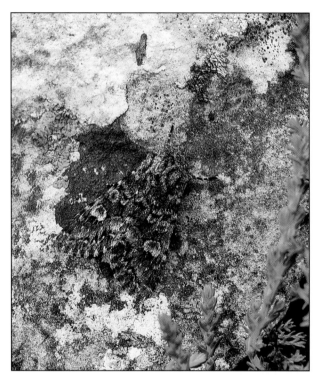

Auto exposure, like other program modes, will render your subjects as mid-toned: when you are photographing a subject that is lighter or darker than your mid-toned value you will therefore need to make an exposure adjustment. For example, photographing a white-coloured butterfly against dark background will produce a pale over-exposed insect. Any adjustment made to the aperture will not change the exposure on film, as the camera automatically counteracts your action by increasing or decreasing the shutter speed. In these situations you must have the facility to override the camera's metering system and expose for the true value. For this, you must use the automatic compensating dial located on the top of most cameras. The dial allows you to make incremental adjustments to change the exposure value in both directions. Remember, when finished, to return the dial to zero or you will be over- or under-exposing any additional subjects by the adjusted amount.

Many of the current cameras offer spot metering which can be extremely useful in situations were there is an extreme variation in exposure values. Faced with a situation where there are multiple tonal values in your picture, you can use this feature to your advantage by pointing the camera at a value which is mid-toned, locking the exposure and then recomposing and shooting. There is usually a facility on the camera to lock the exposure value. This is achieved either by depressing the shutter button slightly and holding it in that position while you recompose your shot, or by pressing an auto-exposure lock button which retains the exposure value for a short time.

Making adjustments manually to both the shutter speed and aperture is the most reliable method of all. You have total control of the whole exposure process. If you have to make adjustments for subjects which are not mid-toned, you simply alter the shutter speed or aperture to your requirements and this will retain its settings irrespective of the changing light. I prefer to use this method when lighting conditions are generally stable, especially when using fill-in flash and mirror lock-up photography.

Mirror lock-up photography
With the exception of some of the more expensive camera bodies, many modern 35mm cameras no longer have the facility to lock up the mirror prior to making an exposure. Manufacturers claim that this is largely due to improvements in design and in the mechanisms that help to reduce the effects of shutter bounce. Having the ability to lock up the mirror is not an essential requirement in 35mm, but it

ANGLE SHADES
Phlogophora meticulosa

The chances of getting vibration are greatly increased when you are forced into using slower speeds. If your camera has the facility, I would recommend that you lock up the mirror while photographing subjects that remain perfectly still when at rest.

Bronica SQAi, 110mm macro lens, Fuji Velvia.

becomes more of an issue when using medium format cameras in close-up – especially with focal plane shutters which at slower speeds can cause vibrations that result in unsharp images. Medium format cameras with shutters incorporated into the lenses produce virtually no vibrations at all when the mirror is locked up, due to the smooth action of the shutter. Shutter bounce can be one of the most irritating problems with medium format cameras, so great care must be exercised at all stages when using speeds in what I call the 'vibration zone', from 1/15 to 1/2 sec. All single lens reflex cameras prior to exposure of the image have to raise the mirror before the light can reach the film plane. This is a very rapid procedure, and the force of the mirror as it hits the base of the pentaprism can produce a vibration, especially if the camera is not securely attached to the tripod head or if the tripod is not solid or strong enough to support it. At high speeds the duration of the exposure is brief and above the speeds most associated with this problem. Mirror lock-up is feasible only when using a tripod: once it is raised you cannot usually view the image until exposure is made. Raising the mirror also eliminates the time delay between pressing the shutter and making the exposure. If you have this feature on your camera I would strongly recommend that you use it whenever possible. When

combining auto exposure with mirror lock-up, you will need to lock the exposure value prior to raising the mirror, or you will have an incorrect reading. I generally prefer to use mirror lock-up when in manual metering mode, because it is much less hassle. There are other ways that help to reduce the effects of vibration, such as avoiding the use of small lightweight tripods (especially when you are using medium format cameras), since this will perpetuate the problem. Using a good firm tripod with a solid head will go a long way to help, while positioning the tripod on a good solid foundation will be beneficial, too. Trying to avoid the offending shutter speeds by choosing a wider or smaller aperture will further reduce the risk.

Mirror lock-up photography has a limited use in photographing insects compared with other aspects of nature photography. I always try to employ it where possible, however, especially when I'm forced into using slower shutter speeds – which is often the case when photographing larger insects in the early morning or late evening. If there is a lot of movement, either from the insect or the wind, it is not practical to adopt this approach. I do however apply it religiously when I am photographing landscapes, plants and other static subjects.

Magnification and Depth of Field

IN general photography we are used to photographing subjects that are normally a reasonable distance from the camera. If we want to make that object appear larger in the frame we must either use a longer lens or physically move the camera closer, decreasing the distance between the two. In this way the subject or part of it occupies a larger portion of the frame. In close-up and macro photography, magnification rather than the distance from camera to subject is the factor which determines the final size an object will appear on film.

Understanding magnification

When we talk about magnification in close-up photography, we are really describing the relationship between the actual size of the subject you are photographing and its image size reproduced on film – not enlarged on a print. The magnification rate is the ratio between the two, usually expressed as $\frac{1}{4}$, $\frac{1}{2}$, $\frac{3}{4}$ and 1:1 (or life-size, as it is commonly known). These figures indicate the magnification rate on film compared with the subject's true size. Photographing any subject below 1:1 means that the image of the object produced on film is actually smaller than its real size. For example, photographing an insect at half life-size will result in the object appearing at half its true size on film.

When we talk about photographing a subject at 1:1, we mean that the size of the object on film is exactly the same size as it is in real life: an insect 2cm long will appear 2cm long on film. Subjects such as larger dragonflies and butterflies which are bigger than the dimensions of the 35mm format have to be photographed at a reduced magnification in order to get the whole object within the frame. Photographing at 1:1 means that any subject which is bigger than the dimensions of the film format being used cannot be reproduced in its entirety within the frame. Most of today's macro lenses focus

to life-size, which adequately covers the vast majority of subjects and situations commonly encountered in the field. Some of the earlier models required an additional extension tube to increase the magnification to 1:1.

If you want to photograph very small subjects it is often desirable to increase their size on film. Life-size or 1:1 is often referred to as the border between close-up and macro. Macro photography is a term often loosely applied to close-up photography, as well as being frequently misused by manufacturers to describe additional features on a lens, such as macro capability. The definition of macro photography in the true sense relates to photographs taken beyond life-size. Photographing at this level means that we are now magnifying the object or part of it on film. If we photograph a 1cm ($\frac{3}{8}$in)insect at a magnification of 2:1 (twice life-size) it will appear 2cm ($\frac{3}{4}$in) long on film, because we have doubled its actual size. Focusing at magnifications above 1:1 requires a greater degree of care, since the depth of field at these magnifications is very shallow. The execution of your technique has to be absolutely precise if you are to master the challenge of working at this level. The vast majority of popular insects commonly encountered in the field don't usually require magnifications in excess of 1:1 unless you want to isolate part of the subject on film.

Life-size is not constant, but varies according to the film format you use. For example, a 35mm transparency measures 24x36mm or approximately 1x1$\frac{1}{2}$ inches. At life-size you can photograph any subject that conforms to this measurement and all of it will appear within the frame of the 35mm mount. Anything larger than these dimensions, photographed at life-size, will not fit entirely within the format. If you wish to include the entire object you will have to reduce the magnification in order to accommodate the whole subject within the frame. If you photograph at 1:1 on a

YELLOW-TAIL
Euproctis similis

These two photographs are taken at different magnifications. The one on the left is taken at just over half life-size; the other is photographed at the insect's true size.

Bronica SQAi, 110mm macro lens, Fuji Velvia.

$2^{1}/_{4}$ inch square camera you have a greater film area, which allows you to shoot any subject at life-size up to a maximum of $2^{1}/_{4}$ inches square. However, an insect measuring 2cm ($^{3}/_{4}$in) and photographed at life-size with still appear on this format at its true size. There will be more surrounding habitat included in the picture because of the larger film area.

Depth of field

Depth of field is one of the most important factors in close-up photography. When taking pictures of normal subjects with a standard lens and camera, we are used to expressing depth of field in terms of feet and metres. In close-up and macro photography the situation is quite different, since we are working with smaller subjects and higher magnifications: depth of field in these situations is reduced to a matter of millimetres.

In normal photography, if we focus a lens on an object four feet from the camera the only part of the subject that is in true focus is that part which is exactly four feet away from the film plane. Everything in front and behind this point of focus is not as sharp. Since the fall-off in sharpness is a gradual one, the area in front and directly behind the point of focus still remains reasonably sharp. This range or zone is commonly referred to as the depth of field. If we apply this principle to close-up photography, however, the acceptable zone of sharpness is only a few millimetres. There is little scope for focusing errors when you're working to such fine tolerances. When using medium format, depth of field is usually less, since the magnification tends to be larger to take advantage of the greater film area. The only way you

can increase depth of field is to use smaller apertures or reduce the magnification of the subject.

One of the biggest problems facing any photographer working in close-up is getting enough depth of field to render a subject sharp from front to back. Magnification is very much the controlling factor and has a direct bearing on how much of a subject you can keep in acceptable focus. It also dictates, in many ways, how you compose a picture, since you are trying to keep as much of the insect sharp as possible. You will naturally opt in most cases for an angle or viewpoint that comes closest to achieving this. In some situations compromises have to be made because, for a variety of reasons, it is not always possible to achieve total sharpness. As magnification increases, depth of field decreases: at magnifications above 1:1 it becomes extremely difficult to maintain sharpness throughout the entire subject. We are often told to use the smallest apertures we can in order to extend the depth of field coverage. This may at first seem the best approach in terms of solving the problem but, as we are all too often aware in photography, there are other factors to consider before we adopt this regimented approach.

First, using smaller apertures in natural light means being forced to use slower shutter speeds. This increases the risk of movement either from the subject, or as a result of the elements. If we are using flash to freeze the movement of the subject, it will allow us to shoot at smaller apertures but we cannot easily control its effects on the background. We can also reduce the magnification, and this may help, but the subject will appear much smaller in the frame – and this will sometimes be unacceptable. Choosing your camera angle and

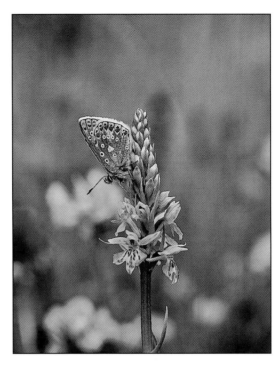

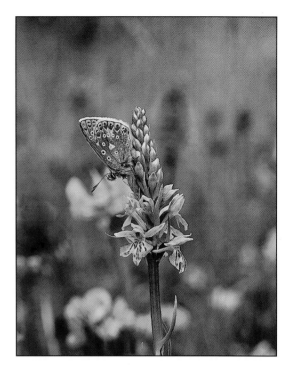

COMMON BLUE
Polyommatus icarus

These three photographs show how depth of field affects the overall sharpness and appearance of the image, and how the background looks behind the subject at different apertures. In this first shot the lens is set wide open at f/5.6: what you see in the viewfinder is what you get on film. The depth of field coverage at this aperture is not quite sufficient to keep the complete insect in total sharpness, but it is still acceptable.

While there is an increase in overall sharpness of the subject at this aperture (f/11), the background is now becoming more apparent.

Bronica SQAi, 110mm macro lens plus 1.4 converter, Fuji Velvia.

At f/16 I feel that this is beginning to look cluttered, the background competing with the subject. I prefer the first shot taken wide open, since it isolates the subject from the background. Sometimes it's better to compromise slightly on depth of field in order to achieve a more pictorial image, provided that most of the subject remains sharp.

plane of focus carefully can greatly help you to maximize your depth of field for the aperture you are using. For example, photographing a resting butterfly where its wings were in an upright position would require less depth of field if you kept the plane of focus parallel to the wings of the subject, rather than photographing it from the head back.

There are other important considerations to take into account when working at small apertures. The most obvious of these is the effect is has on the background. This is especially important at lower magnifications, where the surrounding vegetation competes with the subject and can often prove overpowering. Remember that magnification and the focal length of the lens also affect the background. Try not to adopt the standard approach of stopping your lens down to the smallest aperture. Check your depth of field preview and look carefully at the background, selecting the aperture which will give you enough depth of field to render your subject sharp and minimize background clutter. When working in natural light don't force yourself into using slower shutter speeds when it is not necessary to do so. Remember, the image you see through the viewfinder is going to appear differently on film unless you are photographing with the camera lens wide open.

Close-up Equipment

Supplementary lenses

The most economical way of entering close-up photography is to use supplementary lenses, or close-up lenses as they are frequently called. These are single element positive lenses that screw into the filter threads of your cameras lens (commonly referred to as the prime lens), and that can be used on either fixed or zoom lenses. The majority of supplementary lenses are designed to work with a standard lens, which is not the ideal choice for insect photography. They are more beneficial, producing greater magnifications, when used with short telephotos around the 150–200mm range. When attached to the prime lens they actually decrease the focal length slightly, but this allows the lens to focus closer than its normal working distance. Once in place, the lens will no longer focus at infinity. Supplementary lenses are generally manufactured in different powers, such as +1, +2 and +3: the greater the number, the higher the magnification. All the camera's automatic functions are maintained when using these lenses. There is no change in the exposure because they don't affect the light entering the lens.

There are however, some disadvantages with using supplementary lenses. First, they are really designed for low-level magnifications. Second, there will be a definite loss of image quality, especially with cheaper brands. (This becomes clearly visible in your images as the magnification increases.) To help improve the sharpness it is normally recommended to shoot at smaller apertures, and this will marginally improve the image quality. The amount of magnification obtainable is about half life-size when used in combination with a standard lens. It is not recommended to stack these cheaper lenses together. If you must, then attach the strongest lens first to the front of the prime lens.

DRINKER MOTH CATERPILLAR
Euthrix potatoria

I stopped the lens well down to help maintain reasonable image quality. These two element lenses produce very acceptable results, provided that you keep to smaller magnifications.

Mamiya 645, 150mm lens plus Pentax close-up lens, Fuji Velvia.

Pentax supplementary lens attached to a 150 mm short telephoto on the Mamiya 645.

Extension tubes for the Mamiya 645 and Bronica SQAi.

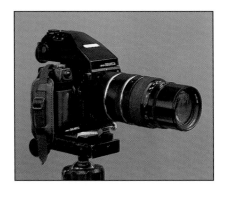

The Bronica SQAi with the 200mm lens and two extension tubes. I frequently use this type of set-up both on the Bronica and the Mamiya 645 for the larger dragonflies.

Extension tubes

Extension tubes are simply black hollow rings in various lengths inserted between the lens and camera body to increase the distance from the rear of lens to the film plane. They are one of the most useful close-up accessories you can possibly own. When used in combination with any lens, especially short telephotos, they allow the lens to focus closer than its normal minimum focusing distance. This is a useful advantage when photographing shy or wary insects such as dragonflies and butterflies. A large percentage of the photographs throughout this book are taken using extension tubes in combination with various focal length lenses. The greater the amount of extension added to a lens, the higher the magnification. There are drawbacks, however: as extension increases, the distance the light has to travel to reach the film plane also increases, and this in turn necessitates longer exposures. Furthermore, the distance between the front of the lens and the subject decreases as the magnification increases.

The amount of extension needed to achieve a certain magnification is dependent upon the focal length of the lens being used. For example, a 50mm lens requires 50mm of extension to reach life-size. If we double the focal length of the lens to 100mm, 50mm of extension gives us a maximum magnification of only half life-size, while at 200mm the magnification rate is a quarter life-size – the amount of extension needed to reach life-size increases proportionately with the focal length of the lens. Put another way, if we require a magnification of half life-size and we are using a 50mm lens, the amount of extension needed is 25mm. When working with longer focal length lenses, large amounts of extension become awkward to use: 200mm of extension is required to achieve life-size on a 200mm lens, and such a set-up is virtually impossible to work with comfortably.

Achieving sharp images with a set-up like this is a tall order, even for the most experienced photographer. Remember that the higher the magnification, the greater the risk of vibration, so that great care must be taken to ensure sharp images. Achieving magnifications of around half life-size is the limit when working extension tubes with short telephotos up to 200mm. This is more than adequate for most wary insects such as dragonflies. The formula for calculating magnification is:

Magnification = extension ÷ focal length of lens used.

Camera manufacturers such as Nikon, Canon and Pentax produce high-quality two-element lenses which are highly corrected and optically matched to certain lenses. These units are more expensive, but the image quality is far superior to the cheaper single-element lenses. However, you don't need to own any of these camera brands to use them, since they work on any make of lens provided that you have the correct step up/down ring where appropriate. If your interest in insect photography is only casual, then investing in a couple of high optical supplementary lenses would be more beneficial to you, and these are easily carried.

Photographic books are always full of calculations and formulas. Everybody quotes them, but in practice you will rarely ever need to know the precise magnification of a subject when its size in relation to the frame is clearly seen in the viewfinder.

The majority of extension tubes retain all the automatic functions of the lens and are usually sold in sets of three different lengths. For medium format, Bronica have two tubes for the SQAi and three for ETRSi formats. Mamiya also have three tubes, numbered 1, 2 and 3. The majority of all medium format cameras have extension in at least two sizes. Nikon and Canon and most camera manufacturers have an assortment of tubes for their own cameras, and there are also independent companies that manufacture extension tubes. They are not necessarily produced in the same sizes as your own camera's brand, but they will work in exactly the same way. Independent tubes are often sold in sets of three, although in recent years some of the larger camera companies have chosen to sell their tubes individually. Check before you buy that there is no vignetting at the corners of the frame when they are stacked together.

As we have already established, when adding extension to a lens there is a fall-off in light – as the distance between the lens and film plane increases, the light travelling through the lens has a greater distance to travel. The amount of light lost due to extension is not fixed, but varies according to the focal length of the lens being used. For example, adding a 25mm extension tube to a 200mm lens will produce a magnification of about one-eighth life-size. This has much less effect in terms of light loss and magnification than adding the same tube to a 50mm lens: this will produce a magnification of half life-size with a much greater effect on light loss. The TTL metering in your camera automatically compensates for this reduction in light without the need for any adjustment to the camera's metering system.

One of the advantages in using longer lenses with extension tubes is the greater working distance from the end of the lens to the subject. A 100mm lens will give you twice the working distance from the subject than a 50mm lens at the same magnification. This is a big advantage when trying to photograph larger insects. Remember, there are always trade-offs: a longer focal length lens will give you a greater working distance from a subject, but it will require more extension to deliver the same magnification.

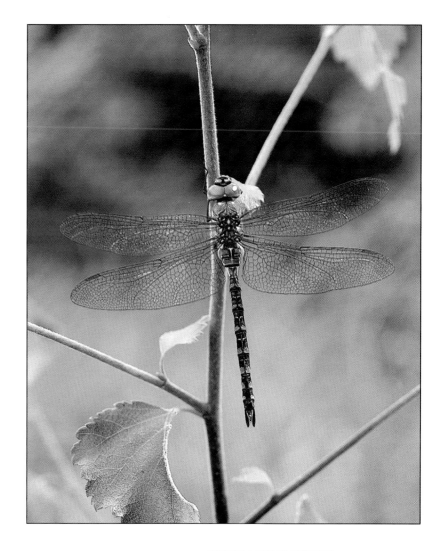

MIGRANT HAWKER
Aeshna mixta

I used a long lens on this immature migrant hawker at rest on a young birch tree to help reduce the amount of background coverage and increase my working distance.

Bronica SQAi, 200mm lens plus extension tubes, Fuji Provia F.

GARDEN ORB-WEB SPIDER
Araneus diadematus

Mamiya 645, 80mm macro lens, flash, Fuji Velvia.

Macro lenses works well in situations where you can increase or decrease magnification without having to stop to add or remove extension tubes. I was able to use full flash in this shot, because the sun acted as a fill-in for the background.

I use the square format more often now, as it gives me greater flexibility when cropping.

Bronica SQAi, 110mm macro lens.

Macro lenses

Many photographers believe that taking successful close-ups requires a macro lens. This is not necessarily the case, however. Many of the photographs in this book were taken with a variety of different lenses. If you plan on specializing in close-up photography I would indeed suggest that you purchase a macro lens, not necessarily because of the quality of its optics, but rather for the convenience of having the ability to photograph subjects from infinity to life-size without having to stop and change extension tubes. This can be a great advantage when photographing insects in the field.

Before we discuss the various types, it's worth mentioning the differences between an ordinary lens and a macro. The modern macro lenses are among the most highly corrected photographic lenses available today. The vast majority can focus from infinity down to life-size without the aid of any additional accessories. Advances in lens design mean that many of the modern macros for 35mm systems have internal focusing, with a floating element system that allows certain lenses to change their position inside the lens barrel – thus reducing the need to have large amounts of extension.

The majority of older macro lenses had their own built-in extension tube that expanded when the focusing ring was rotated. Many of these lenses were limited to a magnification of half life-size, and an additional extension ring was needed to increase magnification to 1:1. All macros are highly corrected for flatness of field, which really means edge-to-edge sharpness when filling the frame. Flatness of field is more important when photographing two-dimensional subjects such as documents, or for illustrations where you need to have sharpness right to the edge of the frame. When photographing three-dimensional subjects, as in nature, this slight softness at the edge due to the curvature of a normal lens is not relevant, since the subject does not normally occupy the entire frame from corner to corner.

Many of macro lenses for 35mm cameras come in different focal lengths, the most poplar choice being 50mm and 100mm, or 105mm in the case of Nikon. I wouldn't advise buying a 50mm for photographing insects, for a number of reasons. First, you probably already own a standard or zoom lens that covers this focal length. Second, working insects with a short focal length can be quite difficult and frustrating because of the distance between the lens and the subject – which is in most cases too close. Cautious insects such as

ASCALAPHID
Libelloides longicornis

These relatives of the ant lions are particularly photogenic insects. Like miniature dragonflies, they fly above the vegetation in sunshine, perching with their wings fully open. When totally at rest, the wings are closed completely over the body. I found this adult in a small alpine meadow in Switzerland. Once the sun reappeared, it opened its wings for a few moments. Speed is often important in these situations, and the macro makes it possible to frame shots quickly without having constantly to move the tripod. I used flash as the main light-source and to arrest movement. The sun acted as a fill-in, providing additional light to the background.

Mamiya 645, 80mm macro lens, flash, Fuji Velvia.

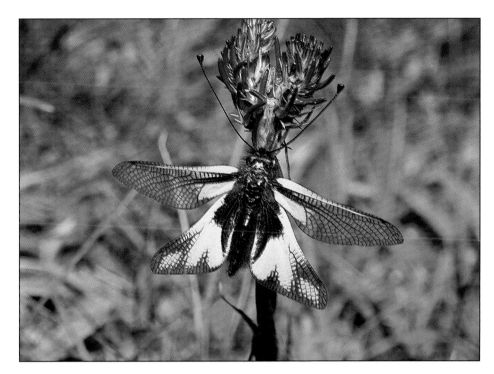

dragonflies tolerate few close approaches even from the most skilled photographers, especially on warm sunny days. The 100mm macro is probably the most common and widely used of all. It will give you twice the working distance of the 50mm, and this often means success rather than failure. In addition to this, it also has a narrower field of view, reducing the amount of background coverage.

In recent years longer focal length macros have been offered by a few manufacturers. Nikon have a 200mm, while Canon and Sigma both produce a 180mm. Having smaller maximum apertures with some macros is not necessarily a disadvantage, since most of the time you will be stopping the lens down. However, fast lenses do make it easier to focus, especially at higher magnifications. Macro lenses are not cheap, but if you're planning to do a lot of serious close-up photography, especially on insects or flowers, it's well worth considering one of the longer focal lengths. These macros are indeed extremely useful for many aspects of nature photography. They are often the best choice when you want to isolate a subject and control both background coverage and focus.

Medium format users have a more limited choice in terms of focal length and magnification. Bronica have brought out an up-dated macro for both the ETRSi and the SQAi, and both

lenses focus to life-size without the aid of any additional tubes. The 110mm macro for the SQAi is the macro I use most. Mamiya also have two macro lenses, the old and long-running 80mm for the 645 and the new 120mm 1:1.

Short telephotos

These are the most useful lenses you can possibly own. If you already have a lens in the 100-200mm range there's probably no point in duplicating that focal length in a macro unless you really feel that you can justify the expense. I often use lenses in combination with extension tubes in this range, especially when I'm photographing dragonflies and, occasionally, butterflies. In addition to the extra working distance, their narrower angle of view makes these lenses extremely useful for many other aspects of nature photography, especially when there is a need to isolate a subject or create a soft, diffused background. They are not suitable for smaller insects because of the amount of extension needed to give them 1:1 capability, while the awkwardness of trying to manage a long, heavy set-up is not really practical in the field.

Short telephotos are often under-rated for close-up work, mainly because many photographers nowadays already own a macro and tend to use it for most close-ups without ever

MAMIYA 645 WITH THE 150MM SHORT TELEPHOTO PLUS EXTENSION TUBE
My favourite combination with this format. I can increase or decrease the number of extension tubes depending on the subject.

GOLDEN-RINGED DRAGONFLY
Cordulegaster boltonii

This combination works extremely well for dragonflies, allowing you a greater working distance between the lens and subject.

Mamiya 645, 150mm lens plus extension tubes, fill-in flash, Fuji Velvia.

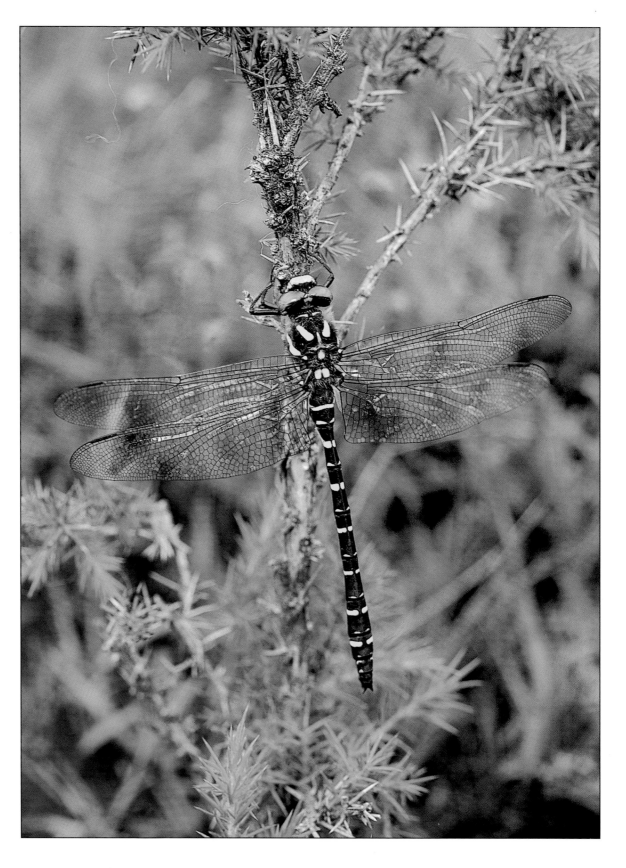

thinking about switching to another lens to evaluate the composition. There are times, even if you have the opportunity to get in close on a subject, when working at a greater distance with a longer lens may be a better choice in terms of perspective and background control.

Photographing wary insects with a short focal length lens can be a frustrating experience because of the close distance between the lens and subject: making slight adjustments at this range to focus and position invariably results in disturbing the surrounding vegetation and your subject. Using short telephotos eases these frustrations by allowing a greater lens-to-subject distance, reducing the risk of losing the insect and making adjustments easier to accomplish.

Using zoom lenses

The majority of photographers these days have at least one zoom in their lens collection. Advances in lens design and optics have no doubt convinced most remaining sceptics of the quality they can deliver. In the early days the optical quality of zooms was often a compromise, especially in terms of speed and image resolution. Modern zooms have come a long way in the last few years, most manufacturers using low dispersion glass. Many of the current zooms also have what is cleverly described by manufacturers as a macro facility. This seems to be the buzzword with regard to close-up photography (every lens that focuses a bit closer than normal is labelled as having macro capability), but never was a word in photography so misused. The majority of lenses offering this function are generally restricted to about a quarter life-size at the shortest focal length, which is a bit of a disadvantage. It is questionable whether the optical quality in this mode is any better than a high-quality diopter lens. If you already own a zoom lens, the easiest and most economical way of making it focus closer is to add a supplementary lens to it. Zoom lenses work well with supplementary lenses, especially the high-quality two-element units. One of the big advantages with using these lenses is that you can change the magnification by zooming in and out without the need to refocus the lens. If you are working to a budget, high quality close-up lenses would certainly be a good alternative. The image quality with the high-end dioptres is more than satisfactory, especially at lower magnifications.

DRONE FLY
Eristalis tenax

I took this shot with the zoom set around 100mm with the flash bracket. The quality is pretty good with these two element units.

Pentax LX, 80-200mm Zoom Pentax close-up lens, flash, Kodachrome 64.

Adding extension tubes to zooms is quite a different matter. All lenses including zooms will focus closer when an extension is added to them. Unlike supplementary lenses, zooms lose their ability to hold focus while zooming. This is because you are actually changing through different focal lengths as you zoom: you will either have to refocus the lens each time, or move the camera backwards/forwards to focus and maintain the magnification. Although zooms with extension tubes can be used in close-up photography, I don't really recommend them for photographing insects, mainly because they can be a bit slower to operate. Zooms tend to be much heaver than normal lenses, and adding additional weight to the lens puts a greater strain on the camera's mount.

Ways to Increase Magnification

Teleconverters

Using teleconverters in macro photography has become more popular in the last decade largely because of the advancements in optical design and lens technology. As a result of these innovative changes, many of the older methods such as reversing and stacking lenses to gain higher magnifications are not so often used today. Teleconverters are basically extension tubes containing optical elements that magnify the image in front of it. They are generally manufactured in two powers, 1.4x and 2x. Many manufacturers offer dedicated units that are computerized and optically colour-matched to their own range of lenses. These are obviously more expensive, but they maintain the optimum in terms of contrast and colour accuracy with the original lens and produce the best results on film.

I would always advise that you purchase your camera's own brand if you can. Independent manufacturers such as Tamron and Sigma also make multi-element units that are universal and can be used with any lens. They are much cheaper than the manufacturers' own brands, and they will produce excellent results if used properly. The main reason most photographers purchase a converter is to increase the focal length of the lens. When focused at infinity, adding a 2x converter will double the focal length of the lens and yet it will still retain the original minimum focusing distance. In terms of close-up photography we want to use converters in order to increase magnification.

There are many advantages in using converters, but as always there are trade-offs. All converters will effect the final image quality on film, although the modern units are so good these days that it's not as vital an issue as it was several years ago. If you want the best from your converter, use the best lens possible: a poor quality lens will produce a poor quality image, irrespective of the specification of the converter. Remember that when you place a converter in front of any lens it will also magnify any optical defects or aberrations, and this is why it's important to attach the best lenses possible when using these units. There is also a reduction in the intensity of light reaching the film, depending upon on the strength or power of the converter used. For example, a 1.4x added to a 200mm f/4 now becomes a 280mm f/5.6: there is a reduction of one stop. A 2x unit added to the 200mm f/4 now becomes a 400mm f/8, a two-stop reduction. Working with a 2x converter on a macro at life-size whose maximum aperture was f/4 now becomes f/8. This makes focusing a lot more difficult because of the reduction in light to the viewfinder.

Bronica SQAi 1.4x converter and the Mamiya 645 2x converter. A word of caution: the Mamiya 2x converter will not attach directly to either the 80mm or the 120mm macros without an extension tube placed between them. Independent units such as the Teleplus work fine with either macro.

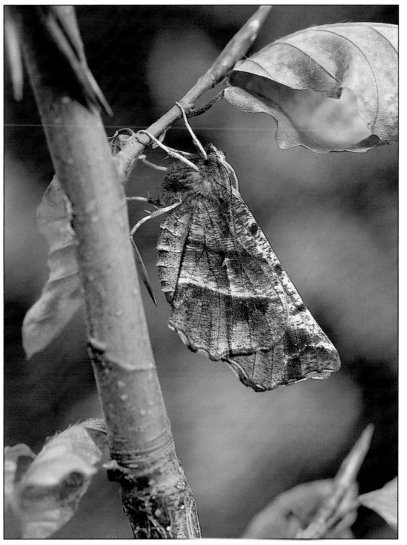

GREEN HAIRSTREAK
Callophrys rubi

*An extremely attractive butterfly,
which appears in late spring.
The males are territorial and
are usually found sitting on a
prominent piece of foliage or the
branch of a shrub. If disturbed,
they usually fly a short distance
and then return to the same spot.
This combination gives me a little
bit of extra working distance, while
at the same time reducing the
background coverage.*

Bronica, 110mm macro lens plus
1.4x converter, fill-in flash, Fuji Velvia.

EARLY THORN
Selenia dentaria

*The combination of the macro and
converter is useful when you need
a little extra working distance to
reduce the risk of hitting the
surrounding branches.*

Bronica, 110mm macro lens,
1.4x converter, fill-in flash, Fuji Velvia.

SEDGE OR CADDIS FLY
Limnephilus rhombicus

These insects inhabit ponds, lakes and canals. They are often avoided by many entomologists because of the difficulties in identifying species. They live as aquatic insects in constructed larval cases usually made from small stones and fragments of plant debris. They are quite nervous insects, and will usually fly away if the surrounding vegetation is disturbed.

Bronica SQAi, 110mm macro lens plus extension tube, 1.4x converter, fill-in flash, Fuji Velvia.

Many photographers tend to purchase the smaller 1.4x for to use with longer lenses, in order to keep both image degradation and light loss to an absolute minimum. If you are going to use your converter primarily to gain extra focal length, and occasionally in conjunction with your macro for high magnifications, I would recommend that you try to purchase your camera's own brand. The differences between them and independent units matter more regarding focal length extension than they do with high magnifications.

With medium format I have found myself increasingly using a converter attached to my macro lens in order to increase the working distance. I also find it useful in controlling background focus. The light loss is not really a big issue, since I am normally working at small apertures in order to gain depth of field.

BLUE-TAILED DAMSELFLY
Ischnura elegans

I only had the macro and the 2x converter with me when I saw this female at rest on the edge of a grass hummock. I used the converter to help increase my working distance and to control the background vegetation which was rather obtrusive.

Mamiya 645, 80mm macro lens plus 2x converter, Fuji Velvia.

Using teleconverters with macros for higher magnifications

When we use converters in macro photography we are basically looking to increase the magnification of the subject on film. In this context, therefore, we should refer to converters as multipliers. Combining these units with a macro is the easiest way to gain higher magnifications, and it is probably one of the most widely used methods today. Using independent units in conjunction with your camera's macro lens works extremely well, since these lenses are among the most highly corrected. You will also be using the converter with smaller apertures on the lens to gain extra depth of field, thus keeping image integrity at its optimum. Macros combined with converters deliver excellent results, provided that you apply the same meticulous approach to technique. Focusing at higher magnifications is critical: a fraction of movement of the camera or tripod head is enough to render the subject totally out of focus.

LEAF BEETLES
Plateumaris sericea

Trying to working with small insects and natural light becomes impossible at higher magnifications. The only effective method that works in these situations is to use flash.

Mamiya 645, 80mm macro lens plus extension tube and 2x converter, flash, Fuji Velvia.

The advantage with this combination is that both units are optically colour-matched. This is my most frequently used set-up. The optics are so good these days that there is no discernible difference between the macro used on its own or in combination with the smaller 1.4x converter.

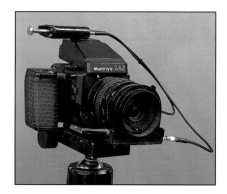

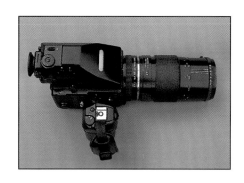

If you add a 2x converter to a 100mm 1:1 macro focused at infinity you double the focal length of the lens to 200mm and reduce the angle of view. Now focus the lens to life-size and add the converter: you double the magnification (not the focal length) to twice life-size. If you require additional magnification you can add an extension tube, although where you place it has a small effect on the magnification. Pacing the converter and extension tube in different positions will have an effect on the overall magnification and working distance between the lens and subject. If magnification is your main objective, place the additional extension next to the lens, followed by the converter: this arrangement will produce the highest magnification, as the converter magnifies everything in front of it. Reversing this arrangement produces a slightly lower magnification but increases the lens-to-subject distance slightly.

Reversing lenses for higher magnifications

One of the most commonly used techniques in the past for attaining magnifications higher than life-size was to reverse a standard or short focal-length lens. In practice these lenses are designed to give optimum performance under normal

This is one of my most frequently used combinations when I need to obtain magnifications higher than life-size. I can also use the 2x converter, which will increase the magnification rate further if required.

Bronica with 110mm macro lens, 1.4x converter and extension tube.

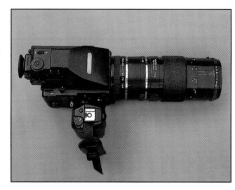

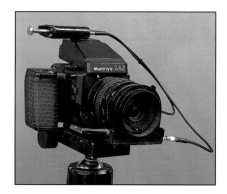

Mamiya 645 with 80mm macro lens reversed and the modified bellows plate and double cable release.

This set-up permits open aperture viewing.

LEAFHOPPER
Evacanthus interruptus

This brightly coloured leafhopper was extracting the liquid juices from a ragwort plant, giving me a little extra time to take the shot. Using a focusing rail and flash at these magnifications is a must.

Mamiya 645, 80mm macro lens reversed plus extension tube, flash, Fuji Velvia.

photographic conditions where the distance from the rear lens element to the film plane is shorter than the distance from the lens to the subject. When you add extension in this situation you are changing this relationship, especially as the magnification increases. The situation is now reversed: the lens-to-subject distance becomes shorter than the distance between the rear of the lens and the film plane. You can also add extension tubes to your reversed lens to increase magnification even further. Wide-angle lenses will produce much larger magnifications but are generally not recommended, although I have on occasions used them with acceptable results. For photographing at greater than life-size, camera manufacturers suggest that you reverse the lens to improve the optical quality of the lens and the image. Standard reversing rings are available from the majority of manufacturers for this purpose. There are some disadvantages in using this method, especially when photographing insects.

The biggest inconvenience is the loss of all automatic functions as a result of reversing the lens: you no longer have automatic metering and diaphragm coupling. You can in most cases use stop-down metering, but this is a nuisance and not really practical for most insect photography. Some camera manufacturers have produced an adaptor or 'z' ring. When connected to the rear lens mount, this makes it possible for you to have open aperture viewing using a double cable release: the first cable closes the diaphragm to the taking aperture, and the second fires the shutter. This helps to a point, but if you still want to use the meter you'll have to stop the lens down to the taking aperture: first take your reading, set it manually and then open up to view and focus. This is a non-starter for insects. It may work with plants and static subjects, but it's too slow and fiddly for active creatures. From a practical point of view the only way you can work this method is to forget the meter and resort to using flash. It is, in any case, impossible to focus properly at these higher magnifications without the use of a focusing rail, which gives you the ability to make fine adjustments.

In medium format Mamiya used to produce an auto bellows unit for the 645 format which permitted open aperture viewing prior to taking the picture. Nothing was then available to take advantage of this procedure when the lens was reversed, since all mechanical linkages were disengaged when it was removed from the bellows unit. When I examined the bellows unit closely, I realized that by removing the front plate of the auto bellows unit and turning

SOLITARY WASP
Ectemnius continuus

There are many species of solitary wasps. Most nest in the ground, although some species use hollow stems and decaying wood. They are not widely covered photographically due to their elusive nature.

Mamiya 645, 80mm macro lens reversed plus extension tube, flash, Fuji 50 RFP.

it around so that the linkages were facing the front rather than inside the bellows meant I could have open aperture viewing with the lens in a reversed position. This modification meant I could now use extension tubes (which were lighter and more convenient in terms of speed and ease of use) instead of bellows. This was a help in some cases, especially with static subjects, although it could still only be used selectively with insects. The vast majority of other medium format systems that employed electronic shutters could not function in this manner because of the loss of electrical contact between the lens and the camera body, which meant they were more restricted in the magnifications they could achieve.

In the 1980s, like many other macro photographers, I used this technique mainly for static subjects when I wanted to shown extreme close-ups of flowers and fungi beyond life-size. I did occasionally use it for small insects with some success during that time, primarily because there were no alternatives with medium format. It was also one of the accepted methods then of obtaining higher magnifications. However, I found it difficult and at times impossible to use with many of the larger insects, chiefly because of the close working distances and the loss of the automatic functions of the lens. It has some value in the studio with subjects that are fairly static, but I would not recommend this approach for high magnification work in the field unless you thrive on frustration and torture.

Bellows

In the last ten years bellows have fallen out of fashion, largely as a result of improvements in equipment design and optical advancements in teleconverters. It is now possible to achieve higher magnifications utilizing other combinations and methods while still maintaining speed and ease of use. I never considered a bellows unit as being practical in the field, for a variety of reasons. They are generally fragile, awkward to use and slow to operate. They are not really suitable for insect photography unless used in a studio.

MADAGASCAN COMET MOTH
Argema mittrei

Bellows are really practical only for studio work, although there are some units that are small, lightweight and can be used with care outdoors. There are other, easier methods of obtaining higher magnifications these days. They are quite fiddly to operate quickly and efficiently in the field.

Mamiya 645, 80mm macro, bellows,
flash, Fuji Velvia.

Having said that, however, I have used them very occasionally in the field combined with a double cable release and flash. Most bellows, unlike extension tubes, lack full automatic functions – another drawback, especially with moving subjects such as insects. Some of the units have open aperture viewing and work with a double cable release, but

the vast majority do not have total integration. They also have a double focusing rail to allow you to move the whole unit forwards and backwards without having to adjust your magnification. Short focal length macros are often reversed on the bellows, and magnifications around three times life-size are possible. Many photographers prefer to stack extension tubes or purchase a variable tube where possible. They are easily carried and provide full automation.

All the leading 35mm camera manufacturers offer bellows units. Medium format users also have a choice from Mamiya, Bronica and Hasselblad, but the weight is even more of a problem with this format.

Stacking lenses

Stacking lenses commonly means joining two lenses together in order to attain higher magnifications. It is, in principle, the same as adding one supplementary lens to another, only in this case you are using a high-quality lens in order to increase the magnification. Compared with stacking tubes on macros, it is one of the most effective methods of achieving higher magnifications and increased lens-to-subject distance. The main lens, which is commonly referred to as the prime lens, is attached to the camera in the normal way, and those between 100 and 200mm make the best prime lenses. The second lens (normally a standard or short focal-length unit) is acting as a high-quality supplementary: it is reversed and attached to the front element of the prime lens by means of an adaptor ring. You can make your own adaptor ring by using the appropriate filter or step-up rings and gluing them together.

One of the biggest advantages in using this method is that all of the camera's auto functions are maintained, as the prime lens is still connected to the camera body in the usual manner. Exposure is controlled by the aperture on the prime lens, which should ideally be set around f/16 to give reasonable depth of field. In contrast the reversed lens should have its aperture opened to the widest setting, since it plays no part in the exposure process. Every combination is different: you must experiment with various lens combinations until you find one that suits your purpose. You will experience some vignetting at the corners of the frame when using this method, the amount depending on the combinations used. One solution to the problem is to add extension between the camera body and the prime lens until

LARGE EMERALD
Geometra papilionaria

This combination produced a magnification over twice life-size. The drawback with this method is the vignetting at the corners, which can be severe with some lens combinations. It does seem to work better with 35mm rather than medium format.

Bronica SQAi, 200mm lens,
80mm reversed flash, Fuji Velvia.

it disappears. I have found that with some medium format lenses it is better to add a converter to reduce the vignetting. Keeping to realistic magnifications will also help. You will also need to use flash at these magnifications to freeze all motion, as the slightest current of air constitutes a veritable gale in the viewfinder.

In order to help eliminate flare, you can construct a small lens hood by removing the centre section of a spare rear lens cap and attaching it back into the lens bayonet. This will also give some protection to the delicate lens linkages. Be sure to check that the hood does not contribute to vignetting at the corners of the frame. Standard lenses around 50mm are the best for reversing, although using wide-angles will produce greater magnifications. If you want to know the magnification for a given lens combination, divide the focal length of the prime lens by the reversed lens: a 100mm prime lens with a 50mm standard lens reversed produces a magnification of twice life-size. Using this technique is it possible to achieve higher magnifications, depending upon

the lens combination. In practice, working in the field with magnifications in excess of 2:1 brings its own headaches and, to be honest, I rarely ever need extreme magnifications for the majority of subjects. The execution of your technique is tested to the limit when you work at these levels. What would be considered as minor focusing errors at low level close-ups become major disasters at these magnifications, so be prepared for a higher failure rate.

**BRONICA 200MM LENS
WITH AN 80MM STANDARD
LENS REVERSED**
I normally just tape the two lenses together, but if you want to experiment a lot with this technique you would be wiser to buy or make a male-to-male coupler ring.

CHAPTER EIGHT

Working with Flash

Flash is one of the most valuable accessories for the macro photographer if used correctly – in fact many photographs would be impossible to achieve without it. Natural-light photography accounts for a small percentage of photographs of insects: it is usually restricted to lower magnifications, and is dictated by weather conditions at the time. When you can't use natural light your only option is to use flash. There have always been mixed reactions about it, largely because of the difficulty in the past of having to calculate your exposures manually, with unpredictable results. Furthermore, many people dislike the effects flash produces, such as dark shadows and black backgrounds (see section on black backgrounds, p.59). The introduction of TTL flash was the turning point in terms of flash photography, removing many of the problems that photographers often found difficult to understand. It is not entirely fool-proof, however, and needs to be used carefully, especially in situations were there are large exposure differentials. Here are a few benefits of using flash:

MAMIYA 645 WITH FLASH BRACKET
This is my single flash set-up without the connecting leads. It is compatible with any camera system.

- It freezes movement of the subject and permits the use of slow fine-grained films such as Fuji Velvia or Kodachrome 64 with small apertures.

- It increases tonal contrast on film while adding additional sparkle to the image, especially in low lighting conditions.

- You can take photographs without the burden of using a tripod.

- You can use it in any situation and under any lighting conditions.

Here are some disadvantages:

- It can produce dark, unnatural backgrounds as a result of the fall-off in light from the gun.

- It can create harsh shadow areas as a result of the directional lighting caused by the use of a single unit.

This is an assortment of flash units that I currently use for macro photography. The smaller Metz is my most frequently used flash unit.

There are certainly more advantages than disadvantages in using flash, and most of my photography nowadays is carried out with TTL flash. I do still use manual flash in certain situations, especially when I am using my earlier Mamiya 645 Super which does not have this feature. I think it is essential as part of the process of understanding flash exposure that you know the principles involved in achieving the result using a manual set-up. I shall deal with these approaches separately.

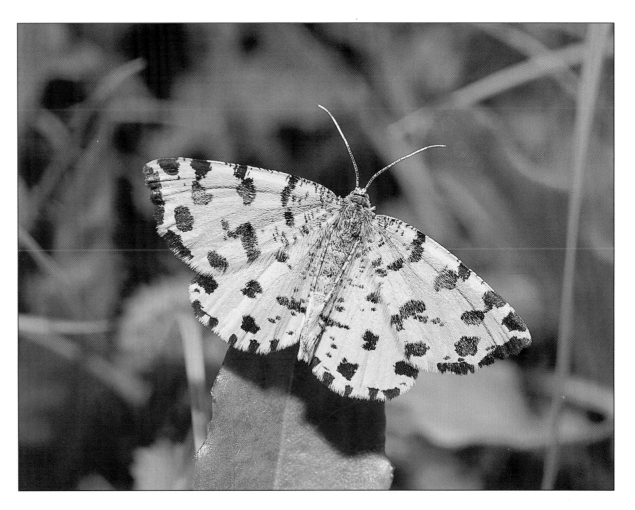

SPECKLED YELLOW
Pseudopanthera macularia

Day-flying moths can be difficult to approach on warm sunny days. I normally use a single flash on the bracket, and hand-hold the camera. My smaller Metz works best in these situations, producing a wider source of light with softer shadows. The flash also lit the background in this case, since it was close to the subject.

Mamiya 645, 80mm macro lens plus extension tubes, flash, Fuji Velvia.

Which types of flash unit work best

When using a manual flash set-up for macro photography it is not necessary to purchase large expensive units loaded with computerized functions: any make or brand of gun will work when connected to your camera via the hot shoe or flash sync socket. Basically there are two types of unit to consider – the large powerful hammer-head designed to work in normal photographic situations and the small compact unit which lacks the output power of the bigger guns.

The most suitable flash units for close-up and macro photography are the smaller lightweight guns which can be positioned close to the subject. You do however have to pay attention to the background distance with these units, as the fall-off in light is quite rapid compared with larger guns. When a small flash is positioned close to the subject the actual size of reflector appears large in comparison with the object you are photographing, and as a result it produces a more diffused, even light with softer shadows.

Using larger, more powerful, units presents several difficulties, the first being the weight factor and the second being the importance of holding it in the right position so that it lights the subject evenly. Remember that you have to carry this unit in the field and be able to operate it quickly and efficiently: large, heavy set-ups are cumbersome to carry and difficult to hold steady for long. Another disadvantage with using larger powerful units is that the majority of them need to be held further back from the subject, so producing a strong directional light-source with much harsher shadows. However, unlike the small lightweight guns the greater flash-to-subject distance means that the fall-off in light is less apparent with larger units: the background vegetation will consequently show less of a differential in terms of exposure. Working with higher magnifications where the lens may be be only a matter of centimetres from the subject can create problems in terms of trying to illuminate it evenly, because you will find that the end of the lens can sometimes obscure the light from the unit.

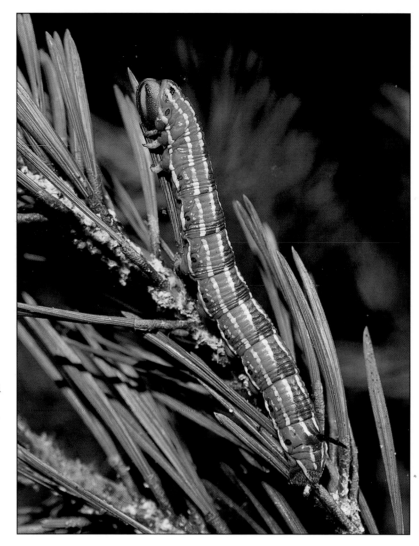

PINE HAWK-MOTH CATERPILLAR
Hyloicus pinastri

*The best position for the flash in
most situations is above the end
of the lens and about 45 degrees
to the subject. This will keep the
shadows to a minimum.*

Mamiya 645, 80mm macro lens plus
extension tube, flash, Fuji Velvia.

Ring flash units

Another type of flash unit commonly associated with close-up photography is the ring flash. I don't like them. They generally have a low guide-number, and lack the power to illuminate all but the closest of backgrounds. They also provide shadowless lighting, making pictures look flat and low in texture and detail. They are really best suited for intra-oral photography in dentistry and medicine. They are excellent for illuminating difficult areas such as inside the mouth, but have a limited use for photographing insects.

Flash position

Where you place the flash in relation to your subject will affect the final result on film. The most common position is above the lens at about 45 degrees to the subject: this is favoured by most photographers and produces the best results in most situations. It gives a pleasing balance in terms of shadows, keeping the majority of them to the back of the subject. Don't get hung up on trying to light every subject from its head back: it is worth noting that high axial lighting provides an acceptable compromise irrespective of the position of the subject.

Positioning the flash unit off the vertical axis to either side will greatly emphasize texture and detail, but the strong directional shadows don't make for a pleasing picture. I prefer to use only one flash when working most subjects,

GARDEN TIGER
Arctia caja

I came across this moth while photographing habitats using the larger RZ67. One of the advantages of this camera is the built-in bellows – like a large extension tube, allowing the camera to focus much closer than normal conventional cameras without the need for additional accessories. I don't normally use it for this type of work because of its bulk, but it does prove useful on occasions when I don't have the smaller format with me. I used manual fill-in flash to increase the contrast slightly.

Mamiya RZ67, 90mm lens, fill-in flash, Fuji Velvia.

although I do on occasion use a second to add light to the background. In my early days of experimenting with lighting positions I used an old set specimen of a butterfly pinned onto a plant leaf, and I played around with a small pair of spotlights looking at how the different lighting positions affected the image and the placement of shadows. This can be a useful exercise, as it gives you an insight into how the image may appear on film.

Working with manual flash

Working with flash is a major part of the insect photographer's armoury, and is essential with small insects at magnifications of life-size and above. There are many older cameras still in circulation that do not have the

benefits of TTL flash. In these cases exposure must be determined manually by running a test film. Until I purchased a Bronica SQAi, all of my flash exposures on my other two medium format systems were taken manually. I had a notebook that I kept with the relevant information for different magnifications and combinations. This has worked extremely well for years. Many of the pictures in this book have been taken using this method.

The easiest way to achieve a correct exposure when using a manual set-up is to find a mid-toned subject: use a short telephoto or a macro lens if you have one, and add extension to the telephoto or set the magnification to around half life-size on your macro. Make sure the flash gun is set to manual and on full power. Use the slowest film possible, such as Fuji

BUMBLE BEE
Bombus pascuorum

Bumble bees are social insects living above and below ground. This species often nests at the base of grasses or, occasionally, abandoned birds' nests. Photographing these active insects is more easily accomplished using flash. For this shot I used a single flash, mounted on the bracket.

Mamiya 645, 80mm macro lens plus extension tubes, flash, Fuji Velvia.

Velvia or Kodachrome, in order to maintain quality and sharpness. Pick a reference point – most people use the end of the lens, as it's easily remembered – and do not alter its position. Hold the unit from 10–15cm (4–6in) above the subject. Run a series of shots beginning at f/11 and at half-stop intervals until f/32. Analyse your film on a light box and select the best exposure. From your notes you should be able to tell which f-number was used. This becomes your reference point and aperture for the given combination. If you increase your magnification by adding extension and you move your flash gun accordingly (keeping it at the same angle and in line with your reference point) you will not have to make any further exposure tests, since you are compensating for the additional light-loss due to increased magnification by moving the flash in relation to the reference point. This principle works fine for all mid-toned subjects up to about 1:1. When you photograph subjects that

are not mid-toned you will need to increase or decrease the aperture or flash distance accordingly.

TTL flash

Most cameras now support TTL flash. It is without doubt one of the great advancements in camera electronics, eliminating the need for calculations regarding flash distance. When used correctly it produces perfectly exposed pictures, provided that the flash is within its output range. If your camera doesn't have it, however, don't panic. I worked with a manual system for years (and still do at times) with perfectly acceptable results. If you plan on doing a lot of close-up photography it is worth upgrading your camera body to incorporate this feature.

TTL flash works on the principle of reading the light reflected back from the subject at the film plane. A sensor in the body of the camera determines when sufficient light has reached the film for correct exposure, and relays a message back via the camera's electronics to the flash in order to cut the light. You can only use flash units that are specifically dedicated to your own particular camera brand. Most camera manufacturers make their own, but there are also independent companies that offer cheaper guns with the appropriate dedicated module to fit many different camera brands. Try to buy your own camera's unit, because it will have total integration with the camera. If you can't stretch the budget, make sure before you buy an independent gun that all functions work. For medium format, well-known companies such as Metz manufacture professional units that integrate via the appropriate SCA adapter with Hasselblad, Mamiya and Bronica.

Camera manufacturers would like you to think that having TTL flash capability will eliminate all your exposure problems. This, however, is not the case: you must apply the same care and attention when dealing with subjects that are lighter or darker than mid-tone, in order to avoid over- or under-exposure. If you need to make any adjustments to the exposure, you cannot alter your exposure (as you would with manual flash) by adjusting the aperture. Since the flash is the only lightsource, it will compensate by increasing or decreasing the light output accordingly. When you want to adjust the amount of light to the film you have only two options: to adjust either the auto exposure dial or the output on the flash unit. I would always run a few test shots to

MOTTLED BEAUTY
Alcis repandata

TTL flash is not fool-proof. If your subject is not mid-toned you need to compensate by adjusting the auto exposure dial on the camera – the easiest approach. This shot was taken at the meter's suggested reading, which produced an under-exposed shot.

Bronica SQAi, 110mm macro lens, flash, Fuji Velvia.

In this photograph the exposure was increased one stop from the suggested reading to render the subject at the correct value.

establish the correct compensation values for problem subjects such as pale butterflies and dark-coloured moths resting on light- and dark-coloured backgrounds (limestone rocks and so on).

Exposure problems can also arise when the subject is not in the centre of the viewfinder or occupies a smaller portion of the frame in comparison to the background. The camera's metering system (especially if it's a centre-weighted system) reacts to the larger background area, under- or over-exposing the subject. Top professional brands offer, in addition to centre-weighted readings, advanced metering modes such as matrix, which uses comparative analyses between different areas of the frame to evaluate the exposure. It's important to read both your camera's and the flash unit's instruction manuals to understand how they function together.

Fill-in flash

Fill-in flash is the combination of mixing flash with the ambient light (daylight) to provide additional light to the shadow areas of the picture. When used correctly it can add punch to an image, especially on dull, overcast days when the vibrancy in film colours can look flat and lack sparkle. It is also an effective means to controlling shadow detail in pictures. Unlike full flash, which makes up the total light output, fill-in flash works in harmony with the ambient exposure.

How to gauge the balance between flash and daylight is where many people get confused. One important factor to bear in mind when working with fill-in flash is that you are not using it to arrest movement, but rather to provide additional light to brighten the shadow areas of the picture. The key to success here is how to decide on the lighting ratio – in other words, how much light to add. In order to understand this concept you must think of flash in terms of stops. Many of the bigger brand names in flash have what's called automatic fill-in, where the unit works in conjunction with your camera body and decides the amount of flash output. You can alter the intensity of light by adjusting the compensation dial to fine-tune the balance. You will also need to run some tests with your own camera and flash set-up, changing the values by one-third increments to establish the preferred ratio. For example, when using Fuji Velvia and the Bronica SQAi with the SCA adapter and a Metz flash unit, I have the SCA control set to an ISO of 160. This reduces the light output by about one and a half stops, which works well for photographing moths in woodland conditions.

Fill-in flash has a more limited use in insect photography, largely because of subject movement. Photographing an

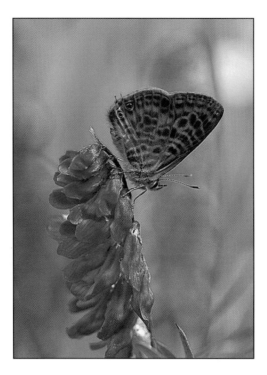

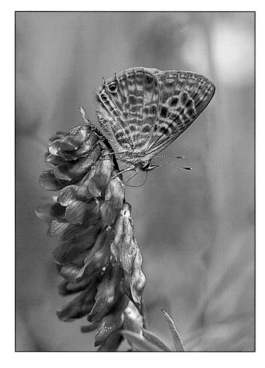

LANG'S SHORT-TAILED BLUE
Syntarucus pirithous

In the first shot this insect was in shadow while the background vegetation was lit by sunlight. In the second photograph I used fill-in flash to add light to the insect, giving a more pleasing result to the photograph.

Bronica SQAi, 110mm macro lens,
Fuji Velvia.

Bronica SQAi, 110mm macro lens, fill-in flash, Fuji Velvia.

insect with fill-in flash on an overcast day at half life-size with an ambient exposure of 1/8 second at f/16 is acceptable if the subject remains absolutely still. When it doesn't, any movement will register on the film, producing a second image commonly referred to as 'ghosting'. Some insects, damselflies in particular, have a reaction to the discharge of light from a flash, especially on dull days, and they will respond by moving their abdomen. Trying to pick your moment when everything is still will produce some acceptable results. I do, however, try to use this technique where possible, especially with other close-up subjects which are static, such as plants and fungi.

Macroflash systems

Some companies manufacture complete macroflash systems. If you're a keen do-it-yourself enthusiast, however, you can easily make your own set-up for considerably less than commercially made units, which are generally underpowered and overpriced. Some designs screw into the filter treads of the lens. I personally don't favour this idea, especially when using medium format, as it adds extra weight to the lens and puts additional pressure onto the lens mount. Most of these commercial systems perform reasonably well when working at high magnifications around life-size and above, because the flash units are positioned close to the subject and the

light source is large in comparison with the object being photographed. However, the fall-off in light when the flash is used at these distances will be more apparent, so backgrounds need to be fairly close.

The disadvantages of having this type of system becomes more apparent when you want to use a longer focal-length macro to increase your lens-to-subject distance, or when you are working at smaller magnifications. The flash units are now further away from the subject, and the output is not powerful enough to light the subject at small apertures. Since there is limited scope to move the flash units, you have to work at a wider aperture and therefore lose depth of field. Another disadvantage is that the lighting positions are often limited or fixed. This can be a bit of a handicap in some situations, especially if using longer focal-length macros or short telephotos with extension tubes.

NIKON SB-29 MACRO SPEEDLIGHT UNIT
If you happen to own a Nikon camera and want to purchase a commercial macro flash system; this unit in my opinion is currently the best on the market.

If you are fortunate enough to own a Nikon camera and want to invest in a commercially manufactured system, then look no further than the SB29 macroflash unit. In appearance only this at first seems similar to a ring flash. If money hangs heavy in your wallet this will certainly lighten the load. The unit has dual rotatable flash tubes, offering the choice of frontal or selected relief lighting. It is also possible to adjust the light output ratio of each unit, which is a useful feature.

Constructing your own macroflash bracket

Most standard flash brackets are generally unsuitable for macro photography because they do not allow the flash unit to be positioned close to the end of the lens, where the subject can be evenly illuminated. Having your flash positioned further back towards the camera body results in the lens partly obscuring the subject and the light from the flash creating a shadow. Attaching it to the hot shoe results in a parallax problem, as the lens is pointing at the subject while the flash is looking straight ahead. I have played around with different set-ups for years, trying to design the ultimate unit. To be honest, there is no single design that fulfils every expectation in every situation. For those of you who want to experiment I will give a brief outline of my own design, but I would also recommend you look at John Shaw's bracket: featured in his *Closeups in Nature* book published by Amphoto, it is simple in its construction and quite effective in the vast majority of situations.

The best material from which to construct your bracket is aluminium, because it's light and easily obtainable from most hardware supplies. Remember that the bracket is simply a means to hold the flash in the position you choose. My own particular design is constructed from a piece of round-section aluminium bar, which is formed into a circle and secured to the main block by grub screws. Two lengths of bar protrude from the main block. Attached to them is a movable platform which is fixed to the base of the camera body. The length of the bracket can be adjusted to suit any lens simply by loosening the screws underneath the block and sliding it forwards or backwards. There is provision for two arms that can hold two flash units if required, or it can be used with a single unit in any position.

This design allows the flash units to be moved into any position around the ring of the bracket, while still maintaining the flash-to-subject distance accurately. The front ring can be adjusted to variable lengths in order to accommodate different lenses. This design adds no additional weight to the lens, as it is attached to the camera body. I often use this set-up when working at higher magnifications in TTL mode with a single unit positioned above the lens. This design has worked well and seems adequate in most situations.

Using twin-flash set-ups

When working with manual twin-flash units it's better if you use a matched pair of guns. I have two old Olympus T32 flash units, which I bought cheaply, modifying the wiring so that I could connect the units directly to a small power pack on my belt. This gave me fast recycle times and about four times the number of flashes as standard rechargeable batteries. Having no batteries in the flash units kept the weight down as well. The advantage of these guns is that the

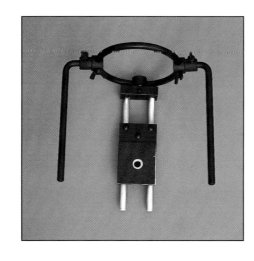
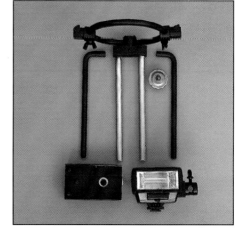

MY OWN CUSTOM FLASH BRACKET
I can use either a single or double flash units with this design. There is a screw that attaches it to the tripod socket on the camera base. The bracket can be adjusted in length to suit any lens, used with or without a motor drive and with any camera.

LARGE MARSH GRASSHOPPER
Stethophyma grossum

*I was walking across a small area
of bog in the New Forest
(Hampshire, England) on a cool,
wet morning when I found this
female resting on bog asphodel.
Since there was sufficient
vegetation close to the insect,
I was able to use full flash without
too much of the background
appearing dark.*

Mamiya 645, 80mm macro lens plus
extension tube, flash, Fuji Velvia.

FROGHOPPER
Aphrophora alni

At these magnifications there can be a high failure rate. I use small apertures to take several shots – ensuring that I get at least one reasonable image.

Mamiya 645, 80mm macro lens plus extension tubes and 2x converter, flash, Fuji Velvia.

power can be reduced on the units. I used one as the main light source and halved the power in the other to act as a fill-in when required. You can choose whatever make of flash units you want when working a manual system, as you won't have TTL flash capability. I used this set-up successfully for years for higher magnifications with the macro and the 2x converter, with excellent results.

Nowadays the majority of photographers use TTL flash for most of their close-ups. The principle is the same as previously described for working with a manual set-up, but you can't control the lighting ratio when using a twin TTL set-up as both units on discharge deliver equal amounts of light. If you wish to reduce or control the amount of light on the background, or as fill-in from the second unit, you can place a neutral density filter on the second unit: this will reduce the light by the appropriate number of stops.

One other point you need to be aware of when using twin-flash units is the double highlight that often appears in the eyes of some subjects. I try to avoid it if I can, as it is unnatural – some subjects accentuate it more than others. Insects such as beetles and the transparent wings of dragonflies are highly reflective and will on occasions produce flare or flash 'hot spots'. Some photographers use a diffuser over the flash or, as a temporary measure, tissue paper secured with an elastic band. This softens the light and removes some of the harshness, but it does reduce the output of your flash unit by at least a stop. There are commercially manufactured diffusers you can buy if you prefer this type of light.

Black backgrounds

One of the most common problems associated with using flash in close-up photography is the appearance of dark or black backgrounds. These are either a result of flash fall-off,

TWIN FLASH SET-UP ON THE MAMIYA 645
Both flash units (shown without connecting leads) can be adjusted to any position around the ring, as well as further back from the end of the lens if required.

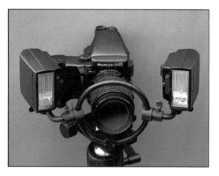

or because the surrounding vegetation is outside the range of the flash-to-light. Having a series of photographs of insects with a night sky is quite unnatural, and you should try to avoid it where possible. This is a bit of a contentious issue with some photographers. However, in natural history photography one should always strive to depict a creature in a picture which reflects its lifestyle. Since the majority of insects are diurnal, one should try to portray this. Many photographers choose to ignore this problem rather than trying to address it. I'm not saying that you can prevent a dark background in every case: you can't. There are, however, situations where you might be able to minimize its effect. You should as a rule, pay attention to the background of any picture as it can often work for or against you. For example, a soft, diffused background highlights the sharpness and detail in the subject, making it stand out. A cluttered background often competes with the main subject and creates a distraction that reduces the impact of the picture.

PURPLE EMPEROR
Apatura iris

These butterflies spend a vast majority of time at tree-top level, feeding on aphid honey dew. They will also descend to feed on the mineral salts contained in animal droppings. It is often possible to get closer to an insect when it is preoccupied with feeding. I was able to use full flash since the insect was on the ground. I kept the black background to the minimum by tilting the camera downwards slightly.

Mamiya 645, 150mm lens plus extension tubes, flash, Fuji Velvia.

Here are some suggestions that may help. First, you could try to place something directly behind the subject to allow the flash to illuminate it. This works fine for static subjects, but placing something behind a wary insect and at the same time trying to focus and take the shot is not so easily done.

You could also try placing a second, cordless, slaved flash unit aimed at the background and positioned at the same distance from the background as the main flash is from the subject. This would result in the background and subject being exposed equally. This is sometimes possible with insects such as moths or butterflies when they are at rest, but it can be tricky and awkward to do if the background is more than a few feet away.

Another possibility is to use a more powerful flash and hold the unit further back from the subject. By doing this we have increased the flash-to-subject distance so that the flash fall-off in light will extend further behind the subject than a small unit placed close-up. This results in the background vegetation showing less of an exposure differential from the main subject.

A further possibility is to keep the flash further back and open the aperture to compensate for the increased distance the flash has to travel. You will lose valuable depth of field, but if you are working at smaller magnifications you may get away with it. This approach shows less variation in the background and subject exposure.

PRIVET HAWK-MOTH
Sphinx ligustri

Since caterpillars aren't difficult to approach, I was able in this case to place a second flash unit behind the caterpillar to help add light to the branches of privet in the background.

Mamiya 645, 80mm macro lens plus extension tubes, flash, Fuji Velvia.

Photographing in Natural Light

NATURAL light has a unique and variable quality that cannot be reproduced by any artificial means. Its softness adds mood and atmosphere to a picture while, in contrast, its harsh directional rays can destroy the texture and finer details of a photograph. Our eyes are more efficient than film in resolving these contrasts, and this is only too apparent when we look at our efforts which are often disappointing when compared with the original image and our memory of it. As photographers we are subject to the limitations and constraints of film, which has a total contrast range of about five stops. Beyond this the shadows (or darker parts of the image) become under-exposed to the point of being unable to render detail, while at the other end of the scale over-exposure results in the highlights (or lighter parts of the image) burning out so that you lose the ability to show texture and detail.

The unpredictability of the weather and the climate throughout the seasons forces us frequently to compromise on what we would like to achieve and what is realistically possible. We cannot control it, of course, but we must learn to work with it to the best of our ability. Don't be quick to form opinions about the ideal conditions for taking photographs. There is no single lighting condition that is deemed perfect for all aspects of nature photography. The strong directional light favoured by landscape photographers would be disastrous for photographing plants. Dull overcast skies are not the ideal conditions for capturing action shots of birds. There is no doubt that for the vast majority of close-up work overcast conditions are by far the best compromise for the macro photographer. For a start it is much easier to render detail and the finer subtleties of an image when photographing in diffused conditions. An overcast sky simulates a large diffuser, producing the kind of soft even light that enhances the finer aspects of colour and texture. I much prefer to work in natural light where possible, especially with larger insects, but this is not always feasible for a variety of reasons.

BLUE-TAILED DAMSELFLY
Ischnura elegans

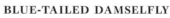

I had just taken a few shots of this teneral male while the sun was hidden behind a cloud. I was about to retreat when shafts of light appeared for a brief moment through a cloud break. I quickly refocused and managed a single shot before the light changed again. As you can see, shooting into the sun produces quite a different effect.

Bronica SQAi, 110mm macro lens plus 1.4x converter, Fuji Velvia.

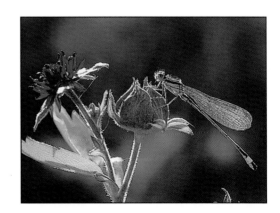

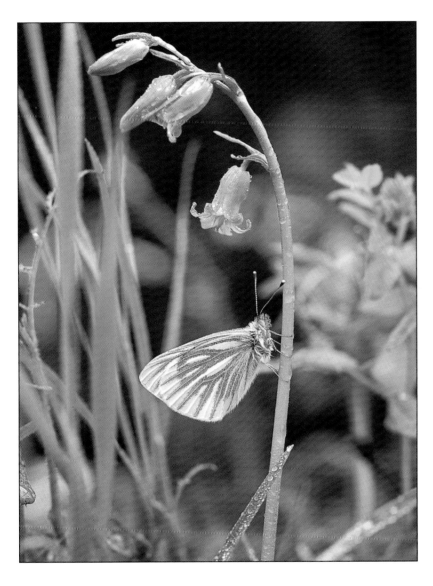

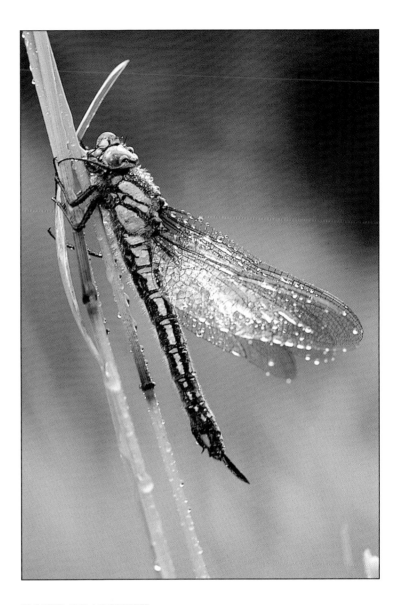

HAIRY DRAGONFLY
Brachytron pratense

I decided to head back to the car after getting soaked for most of the morning by heavy, intermittent showers. I found this female by the side of the track. The overcast cloud was heavy and there was a slight breeze, which meant that I had to compromise on the choice of aperture to keep my speed up. Since the insect was going nowhere, I had plenty of time to position the tripod and wait for the calmer moments.

Pentax LX, 100mm macro lens, Kodachrome 64.

GREEN-VEINED WHITE
Pieris napi

Working in early morning can often be quite productive. There was slight overnight dew, which I felt added to this picture.

Bronica SQAi, 110mm macro lens, Fuji Velvia.

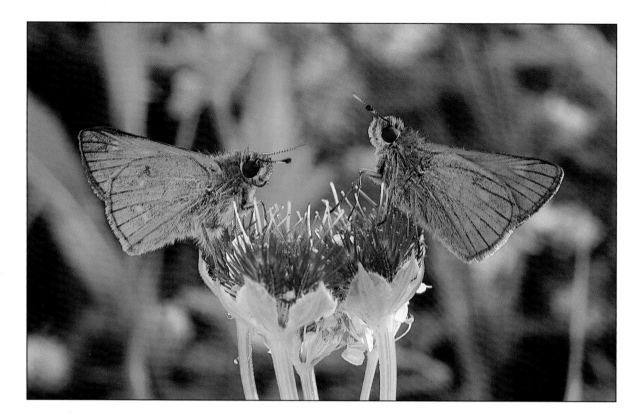

LARGE SKIPPERS
Ochlodes venata

I came across this pair of skippers in late evening when the sun was low in the sky. This part of the day is always a good time to work. Most of the sun's harshness has given way to softer, warmer light. I would have liked to diffuse the background vegetation further, but I didn't have a longer lens with me.

Mamiya 645, 150mm lens plus extension tubes, Fuji Velvia.

Dealing with the elements

One of the biggest problems you face when photographing insects in natural light is movement. This comes in two forms: wind and subject. I don't have any magic formulas or quick fixes for either, except perseverance. Finding sheltered spots away from the wind is generally the best approach – you will find that most insects, like photographers, also look for sheltered areas. Getting up early in the morning or photographing late in the evening does help in some cases, as the wind often tends to be calmer at these times of the day. Don't be put off by overcast days or light rain: some of my best photographs have been taken in such conditions. Persistent heavy rain is uncomfortable to work in, but it can on occasions prove rewarding. I have often found dragonflies grounded due to the weather and saturated with water droplets: these unpleasant conditions can often make interesting photographs. Pictures that reflect mood and the changing weather give a more realistic account of how subjects cope in their environment.

Photographing insects in clear skies when the light is hard and directional is often fraught with difficulty. Many species seek shelter from the intense midday heat and reappear later

on in the afternoon when temperatures are slightly cooler. However, early morning or late evening when the sun is softer and not as intense can create situations in which you can shoot insects into the light – often with pleasing results. Be careful regarding the position of your lens in relation to the sun, as it can often produce flare, something that is not always noticeable when working wide open.

Subject movement

Insect movement is generally associated with temperature changes. Increased heat stimulates greater activity, such as feeding and flight. It's difficult to offer solutions other than to use flash or to choose the time of day when they show the least activity. On bright sunny days insects are at their most active: they thrive in these conditions and are extremely wary of approaching photographers. In these situations their reaction time can be lightning-quick. Remember that all insects are cold-blooded, their speed and agility largely depending upon temperature and sunlight. Stalking them in hot conditions can be difficult and at times frustrating. Working in sunlight brings its own problems regarding contrast and shadows. If you must work in the middle of the

day, look for subjects that are perched high or isolated from nearby vegetation, so keeping shadows to a minimum. Use a longer lens to allow yourself a greater working distance: the narrower angle of view will help reduce the area of background coverage. There will always be situations where this is not possible, and using flash as a light fill-in to reduce the harshness in the shadow areas is another solution.

I often work early in the morning, before the sun begins to heat the land. The majority of larger insects, such as butterflies and dragonflies, will have settled from the night before low down among the vegetation where the temperature is usually a couple of degrees warmer. At this time of the day they are generally more amenable to approach with a tripod. If you want to develop as a insect photographer you must strive to go beyond the run-of-the-mill stock shots of subjects photographed in the same setting with straight flash, often with dark backgrounds. Such repetition does little to encourage one's creative ability.

Natural light is not practical for all insect photography, of course. It works well for larger species up to around three-quarters lifesize. Beyond this, however, wind, longer shutter speeds and increased light-loss due to larger magnifications all create problems.

Getting to know a few of your local nature reserves or other similar areas is a great advantage, because you become familiar with the hot spots where insects often rest. There is a national nature reserve close to my home where I spend a lot of my time studying and recording insects for various research projects. I'm always amazed, year after year, to find successive generations of species occupying the same few areas within the reserve. Only when you begin to analyse the position of these microhabitats with regard to shelter and sunlight does it become clear why this is the case.

Successful insect photography equals knowledge gained over time spent in the field: that's my formula!

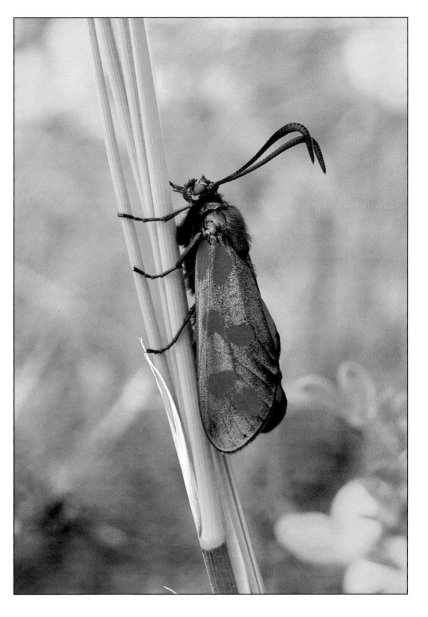

SIX-SPOT BURNET MOTH
Zygaena filipendulae

There is often a slight breeze in coastal localities that can be annoying at times, especially when you're photographing in natural light. I could have used flash with this burnet moth, but felt it would spoil the effect. I took a roll of film in anticipation that I would get one acceptable picture.

Mamiya 645, 80mm macro lens plus extension tubes, Fuji Velvia.

Composition and Design

Being totally familiar with your techniques and equipment is fundamental to producing correctly exposed photographs. Learning to recognize key features that help create a picture from the confusion around you is perhaps more difficult than you might think. Our own personal ideas influence our decisions about what we photograph and how we portray it. The most important reason for taking a picture is for your own pleasure and satisfaction: you have control over what to include and what to leave out. Composition is all about decisions, individual perceptions and compromise – trying to include too much in a photograph often leads to confusion and dilutes the impact of the final image. Many strong and pictorial photographs often stem from a simple approach. Light, perspective and the choice of lens are all important components in the design of an image, and they will naturally influence the final result.

My early years as an aspiring photographer were frequently spent in the company of fellow photographers at my local camera club, where I was fortunate to have help from many experienced people, both amateur and professional. Their advice and guidance was extremely valuable in my development as a photographer. None of us particularly likes hearing evaluations and comments regarding our work. Judging, in my opinion, is a personal impression, and largely a reflection of what appeals to the individual: personal bias will undoubtedly come into play. Having the ability consistently to produce strong and powerful images that have viewers gasping is what separates great photographers from merely good ones. Some would say there's a certain amount of luck involved in producing a great photograph, and to a point that's probably true, but you can undoubtedly encourage success by creating the conditions which help produce it. After that, it's up to you.

SCALLOPED HOOK-TIP
Falcaria lacertinaria

I had been doing some survey work on moths at a cut-over bog. When I returned the following morning, I noticed this adult resting on the underside of this birch leaf a few feet from the light trap. Its structure and resting posture blend naturally with the leaves of the tree, making it incredibly cryptic.

Bronica SQAi, 110mm macro lens, fill-in flash, Fuji Velvia.

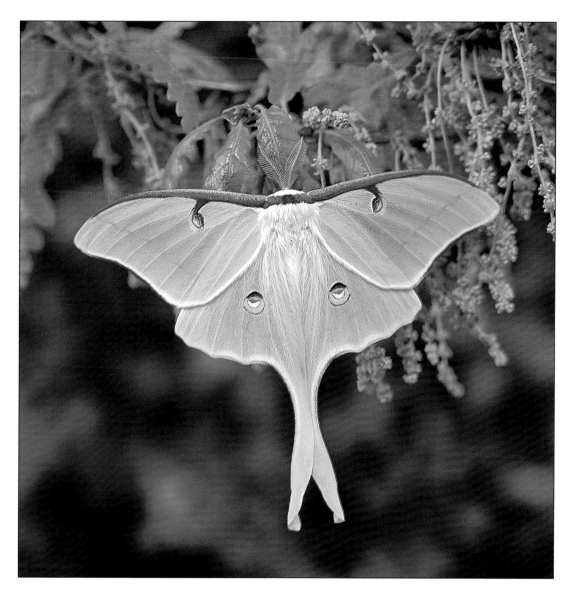

AMERICAN MOON MOTH
Actias luna

An attractive species belonging to a family commonly known as moon moths because of their large eyespots. It's always worth looking at isolating different parts of a subject if they are strong enough to work as an individual picture.

Bronica SQAi, 110mm macro lens, fill-in flash, Fuji Velvia.

LAPPET MOTH
Gastropacha quercifolia

*When I first saw this species
I thought it had potential, yet my
initial shots looked very ordinary
in the viewfinder and didn't
convey what I had hoped for.
I changed the camera angle to
emphasize a greater diagonal
aspect to the picture and felt this
produced a much stronger
visual image.*

**Mamiya 645, 80mm macro lens plus
extension tubes, fill-in flash, Fuji Velvia.**

Developing an eye for composition

Close-up photography often reveals a world of shapes and patterns that in some cases are beyond the range of our normal vision. The general perception of people regarding insects is usually one of fear, which is a natural, conditioned response. Yet when we explore their world it becomes quite apparent that many are indeed creatures of great beauty and diversity, rich in colour, texture and detail. Exploring with a camera the individual structures that make up the entire insect can be fascinating and productive. Being a technically competent photographer is essential in order to produce good photographs, but developing an eye for composition and the essential components necessary to create a stunning image is equally important. This is not something you glean from a book, but rather a skill acquired over a long period of time. Learning to recognize the key components that make for an interesting composition takes time and practice. What often works with one subject doesn't with another. Examine the structures and textures of insects: don't be afraid to isolate component parts of a subject, because they often make interesting photographs in their own right.

One of the (many) difficulties about photographing insects is that you rarely get the time to study and evaluate different compositions and how the various components gel to make the final photograph. Decisions have to be made quickly regarding the content of the photograph – whether, say, you want to integrate the subject with its environment or to isolate it from its surrounding habitat. You must also decide whether the peripheral vegetation contributes to the aesthetic value of the photograph or detracts from the final result. The rule of thirds – which is a series of imaginary lines that divide the viewfinder horizontally and vertically – dictates that in order to achieve maximum impact you should place the subject (or part of it) in one of the four key positions where the lines within the frame intersect. These rules aren't set in tablets of stone but are merely a guide to help you. Don't get hung up on the theories, but use your

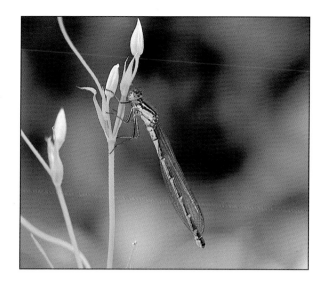

COMMON BLUE DAMSELFLY
Enallagma cyathigerum

I find the square format handy for quickly snatched opportunities, especially when you don't get time to frame every shot the way you would like to. I only managed two shots of this immature female damselfly before it flew off. If you compare the two pictures, I think you'll agree that a vertical composition lends itself better to longer-bodied insects.

Bronica SQAi, 110mm macro lens plus 1.4x converter, Fuji Velvia.

experience and judgement as to where the main components in the frame should be. It is not essential that every picture should conform to these criteria.

Applying these principles to insects is a lot more difficult than to other photographic disciplines. When conditions are warm and sunny, insects rarely remain static for more than a few moments. Central placement of a subject within the frame is often regarded as not the most effective in terms of compositional impact, but in close-ups these rules are frequently broken for a variety of reasons. Magnification, position of the subject, depth of field and keeping the camera parallel to the subject all have a bearing on the final composition. Most photographers are happy to get a sharp, properly exposed image, and for the majority of situations this is all that you can expect.

There will be occasions (usually when you least expect it) where you have an obliging subject that will allow you time to experiment. Use these opportunities to look at different compositions and viewpoints. If you have to use flash, try placing it in different positions so you can see how the lighting affects the image. The choice of lens also has an impact on appearance. If your subject is close to a cluttered background, using a longer lens in combination with extension tubes may help isolate it from its surroundings. The narrower angle of view reduces the amount of background vegetation included in the frame. Try not to over-fill the subject in the frame: it's nice if you can include some surrounding habitat, and this also makes it easier to crop the image if required. Many good pictorial images of insects are a component part of the total picture rather that all of it. Keep an open mind when framing and composing. Don't forget to explore the subject in both formats: some photographers habitually shoot in the horizontal position, and this can be a bit restrictive – especially with many long-bodied insects such as hawker dragonflies, which tend to look aesthetically better in an upright composition. Always make a habit of rotating the camera through 90 degrees and look at how it affects the subject and other components within the frame. Indeed, don't feel that you have to shoot the picture either vertically or horizontally – there are many other positions that are intermediate. If you're not sure, shoot both and make a selection later when you view the processed films. It's often stated that vertical photographs convey greater impact, but do look at the shape and structure of the subject: this is often the best indication as to the choice of format.

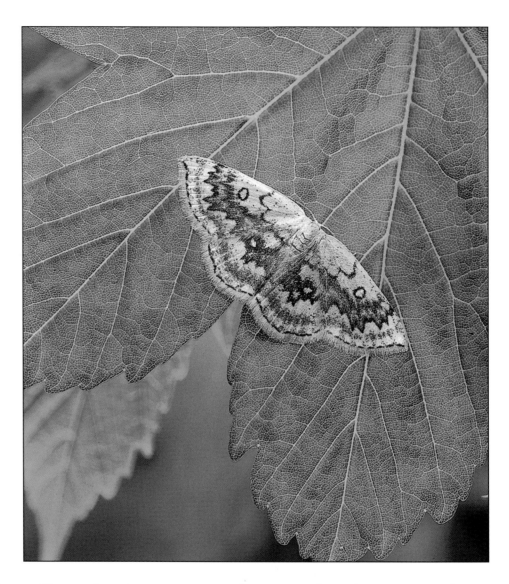

MOCHA
Clyclophora annularia

Some of the geometrid moths habitually rest on the underside of the leaves of trees. In this case the veining and texture of the leaf adds to the overall quality of the image.

Bronica SQAi, 110mm macro lens,
Fuji Velvia.

Good pictures are a result of time, effort and patience, as well as the ability to visualize the result in your mind before you push the shutter. Keep the content simple and clutter-free if you can. Always remember that being a technically competent photographer does not automatically guarantee that you will achieve successful pictures. It is only one part of the photographic process: an understanding of the subject is equally important.

Having the artistic ability to see and create stunning images is what we all want to achieve. There are many good photographers about these days, the vast majority of them producing technically excellent, well-composed, photographs. There are, however, a few who have demonstrated through their work an exceptional ability to amalgamate technical expertise and artistic creativity, to a level that we all would like to emulate. Stephen Dalton and John Shaw are two who stand out above the rest by virtue of their passion, commitment and dedication to achieving technical and pictorial excellence. Stephen Dalton's pioneering work on high-speed flash and portrayal of insects and other subjects is the benchmark in natural history circles throughout the world. John Shaw's knowledge and understanding of nature and its subjects is equally clearly reflected in his stunning images. We all need inspiration from time to time – it's what keeps us motivated to improve our own ability. Looking at other people's work in books and magazines is an important part of the development process for everyone: learning from others helps to shape our own thoughts and visions.

Operating in the Field

ONE of the most common mistakes that photographers make when taking up insect photography is trying to cover everything at once. This is not the best approach: you end up doing everything badly. As an active entomologist I have, throughout the chapters of this book, tried to emphasize the importance of understanding the habits and behaviour of the subjects you're photographing. This is essential if you want to produce good photographs. I have found no shortcuts or quick solutions: it takes time to perfect your techniques. Concentrate on one group of insects at a time: this will help you gain experience and confidence, and it will increase your ability to produce better photographs.

I usually plan my photographic trips in advance, so that when I arrive at a location I know what I'm going to concentrate on for that day. The weather is obviously a vital factor, and it greatly influences my decision on what I can do. In the early stages of your development as a macro photographer you will experiment with different methods. Initial enthusiasm often overrides any systematic approach prior to taking the photograph. Before you push the shutter at the first insect you see, there are other factors you should consider. One of the most common mistakes made by inexperienced photographers is the sudden appearance of blades of grass or other bits of vegetation in the photograph that seemed not to be in the viewfinder at the time the picture was composed. Stopping down the lens to the taking aperture prior to tripping the shutter often reveals a lot of hidden extras that would not otherwise be apparent. Remember that you are not viewing the image at its taking aperture – what you see in the viewfinder is different from what the final image will look like on film. It's a good

WOOD TIGER
Parasemia plantaginis

I photographed this species in the first picture with the aperture wide open: what I saw in the viewfinder appeared exactly on film. In the second photo the aperture was set at f/16. As you can see, the image I was seeing in the viewfinder was quite different to what would actually appear on film.

Bronica SQAi, 110mm macro lens, Fuji Velvia.

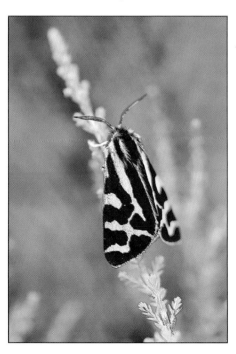
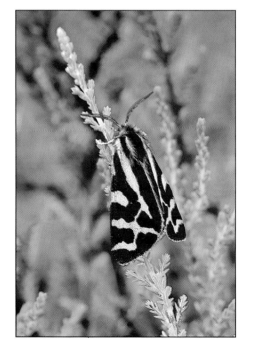

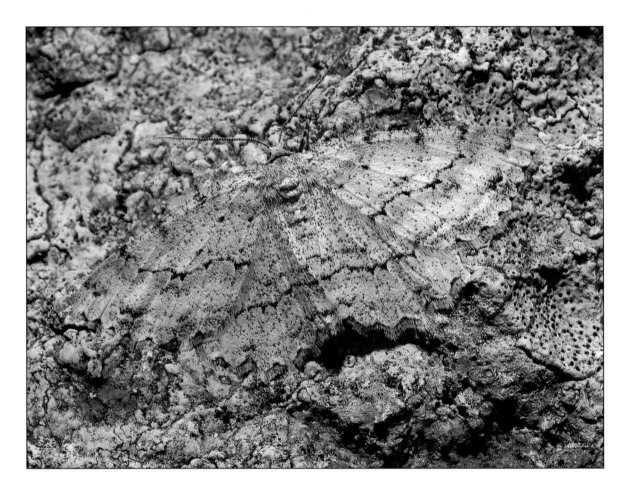

SMALL ENGRAILED
Ectropis crepuscularia

A question of being in the right place at the right time. I was photographing butterflies in the limestone uplands of Co. Fermanagh, Northern Ireland, when I stopped to rest for a short time beside this rocky outcrop. I had set my backpack down beside me and found this freshly emerged moth resting on the rock. Subjects that rest flat against rocks don't pose any problems regarding the plane of focus, but you should be careful regarding the exposure readings of rocks. I increased the camera's suggested reading by 1 stop to render the subject at the correct exposure.

Mamiya 645, 80mm macro lens, Fuji Velvia.

principle to have a routine before you take a shot. I have a quick checklist that I go through (usually on automatic pilot):

- When I've located a suitable subject I look at its position in relation to the sun, where relevant.

- A quick scan of the insect tells me if it has sustained any damage, such as torn wings: if so, I will not usually peruse the subject any further unless it's extremely rare. Photographs tend to highlight any abnormalities by drawing your attention to the defect.

- I also look for any foreground distractions that are likely to encroach or appear on the final image. I will try to avoid them by altering the camera angle if I can.

- When using flash and small apertures on overcast days, subjects that are isolated from nearby vegetation generally suffer from flash fall-off, resulting in dark or black backgrounds. I usually try to avoid these situations.

- I always look at the subject's ideal plane of focus to maximize depth of field, adjusting the camera back so that it's parallel to it.

- Last, but not least, I always check the depth of field lever before I push the shutter. In my early days I paid the price many times in the excitement of trying to get the image, failing to see grass stalks and other bits of vegetation appearing on my slides. As your level of experience increases you will become better at recognizing potential opportunities and the ingredients that make a pleasing composition. You will also become more critical about your photographs and about the standard that you want to achieve.

Carrying equipment
One of the most common problems facing any nature photographer when working in the field is knowing what to carry and what to leave behind. We all burden ourselves

with too much equipment (myself included), trying to anticipate every possibility. I have a few different backpacks: all are capable of carrying a single medium format system comprising several lenses and various accessories, including flash guns etc, the whole thing weighing around 28lb when fully loaded. When I was in my 20s I also carried a 35mm system in a custom-adapted rucksack, along with a Mamiya 645 outfit, and I didn't feel the strain. As I've got older the burden has naturally become heavier (or so my back tells me), and I am much more conscious about what I take with me into the field. Walking short distances of a few miles with your backpack doesn't seem too bad, especially if you're stopping frequently to look at subjects, but carrying a large pack along with a tripod for most of the day can certainly drain your energy – especially as you may also have water and a light lunch in there as well. Be selective and plan your trips carefully, choosing your equipment according to your objectives. You will feel the better for it, especially when you're out for most of the day.

Photographic backpacks (designing your own)

I always found it difficult to get a photographic backpack that could accommodate two formats at once and yet allow me quick access to any camera or lens. One solution to the problem is to buy a top quality rucksack with a supporting frame that opens with a zip, suitcase style. This exposes the inside of the rucksack, allowing you to view the whole compartment at once. What you need to do now is fill the aperture of the rucksack with hard sponge or foam, I have found the type normally used in the construction of suites of furniture ideal for the job. If you go to an upholsterer who covers or manufactures suites you can obtain the foam in block form. It's usually sold in sizes around 60cm (2ft) square and generally 10cm (4in) deep. First mark the outline of the rucksack on the block and cut to shape: you can also put a plain layer 2.5cm (1in) thick on the base of the compartment first to protect the bottom of the equipment. Set all of the equipment you want to include onto the foam block inside the pack and draw an outline round each component. You can then cut out the centres using either an electric bread knife or (a much better solution) a hot wire – similar to a cheese wire except that it has an electrical current passed through it and cuts a very smooth neat aperture. Simply insert the individual pieces of equipment into their compartments. This not only offers good protection, but

means that when you need quick access to a lens or some other accessory you can view everything immediately. You can also make additional inserts to hold different systems or combinations. It is also a much cheaper alternative to the very expensive professional bags, which are often a bit overpriced. Good high-quality rucksacks offer all the protection that a camera bag can, since they are designed to be waterproof and to protect contents from damage in the mountains. They are certainly worth considering as a much cheaper alternative if you're on a budget.

Useful accessories

I carry a small reflector such as a lasolite or a small rectangular card. I find them very useful when photographing static subjects, especially when you need to bounce light into the shadow area of a picture. However, I find them more difficult to use when photographing active subjects, such as insects that rarely settle for more than a few moments. Any additional movement such as trying to place a reflector is likely to result in a quick departure. They can be useful in some situations, however, especially where the subject is at rest.

One of the most useful items that I acquired from my son's repertoire of castaways was his knee pads. Working low to the ground, especially on hard uneven terrain, takes its toll on your knees. I have found these extremely useful for working on hard or wet surfaces: it eliminates the discomfort of having your whole weight bearing down on the knee cap and stops those irritating little stones and other bits of debris from leaving a painful impression on your skin. They also protect your trousers from getting scuffed and wet. Another useful item is a pair waterproof leggings, which are extremely handy especially when photographing at ground level in wetland habitats.

One of my custom-made bags with an insert to accommodate two medium format systems, the Mamiya 645 for close-ups and the Mamiya RZ67 for habitats. You can make up various combinations to suit different formats.

Photographing Abroad

TODAY'S ease of travel to destinations all round the world prompts more and more people to go further afield in search of new subjects to photograph. Planning a successful trip takes time to research and organize. Picking a destination without giving thought to your aims and objectives is not, in my opinion, the best approach. You can waste a great deal of time, not to mention money, for very little reward. It always pays to carry out some research prior to embarking on any photographic trip abroad. Most professionals plan their trips carefully and well in advance, so that they can make the best use of their time during their stay: they know exactly what they want to see and where to go. When travelling to foreign destinations to photograph insects it's important to find out about locations as well as the flight periods of the subjects you're interested in. Reading the appropriate literature in advance will undoubtedly increase your chances of success.

When photographing abroad I always take a note of the locality, date, grid reference (where possible) and abundance of the subject. This will prove helpful should you decide at some time in the future to return to the area. The date also serves as a useful reminder of the flight period of your subjects and the time of your visit. You may also find it beneficial to write up your trips and share them with other fellow photographers and entomologists, who are usually happy to exchange information about other localities with you. Professionals generally have their own sources for information, and some share sites and localities with others in return for information. However, in recent times the competition has become so intense that many professionals are becoming more conscious about sharing. Many amateurs often find it difficult to obtain information at this level because they generally operate in isolation. Joining

CLOUDED APOLLO
Parnassius mnemosyne

Working abroad is always an exciting challenge, because you're never quite sure what you're going to find. Since there was ample sunlight, I used a monopod and my flash bracket to photograph this resting adult in a small alpine meadow near Brigg in Switzerland.

Mamiya 645, 150mm lens plus extension tubes, flash, Fuji Velvia.

CHEQUERED BLUE
Scolitantides orion

Many of these alpine habitats are so rich in both plant and invertebrate communities that you could spend your entire trip in the one habitat without needing to venture beyond it. I found this species in the same area in late afternoon. These habitats often contain a profusion of insects, which are generally much easier to find due to their abundance. The majority of species tend to settle much quicker in higher altitudes if there is no sun – and the evenings are often cooler, too.

Mamiya 645, 80mm macro lens plus
extension tube, Fuji Velvia.

photographic tours is an excellent way to meet fellow photographers and to see new areas. If you're impressed, you can always go back under your own steam another time.

Airline restrictions

One of the most difficult problems facing travelling photographers these days is the weight restrictions imposed by airlines on the amount of hand luggage that you can take into the cabin. It takes very little equipment to exceed the regulations of around 7kg (3¼lb). They are sometimes a little flexible but not nearly enough to accommodate the weight encountered in most photographers' bags. Getting round this problem is becoming increasingly difficult. The vast majority of photographers are reluctant to condemn their valuable equipment to the luggage hold, even if it's inside their suitcase. Can you imagine the anguish of arriving at your destination and discovering that your suitcase, which has all your vital lenses and accessories in it, has been lost or damaged. This happened to a friend of mine: although his equipment was forwarded onto him, he lost the first two days of his trip as a result of the mix up. I always carry the important items on board in a photographic bag that's within

the regulation size for the overhead cabin lockers. The weight of my medium format equipment, however, always exceeds the stated amount. Many photographers, myself included, use a photographic vest which will hold smaller lenses, usually all of my film out of its boxes and other bits and pieces that I can squeeze in. It may well convey a lack of style on my part to other passengers dressed in an attire that reflects their destination, but a little discomfort is a small price to pay for peace of mind.

The other major concern for every photographer when working abroad is film. I always take mine on board and politely ask the security people for a hand search. Although changes in airline policy are more than likely in the light of events regarding airline terrorism (which will no doubt make it even tougher for photographers and their equipment), I must say that so far I have been extremely fortunate and have only ever been refused hand searches on a few flights. I know from speaking to other photographers that their requests are generally denied. Having your film X-rayed a couple of times at a low power does not as a rule affect slow speed films. Be aware, however, that increased scanning has a cumulative effect on film.

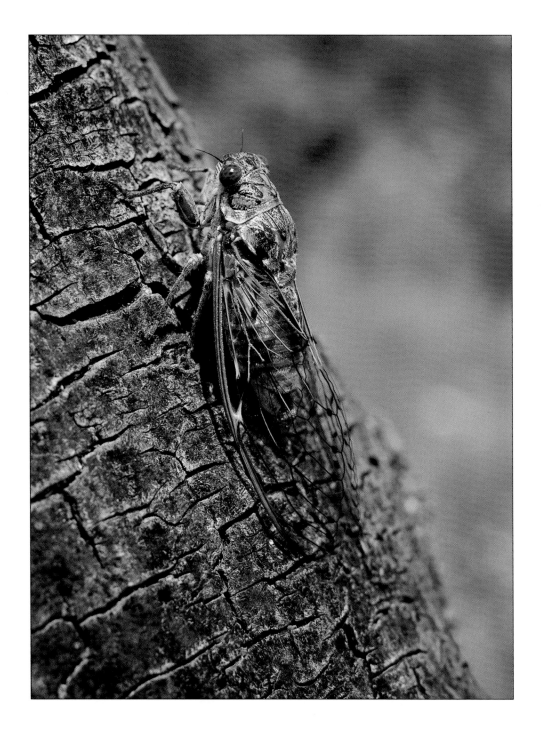

CICADA
Cicadi orni

These insects create one of the most familiar sounds in the Mediterranean, yet they are rarely seen. I photographed this resting adult while in Yugoslavia on a photographic trip. They often stop singing just when you get close enough to see them. If you wait for a short while they normally start again, but they blend so incredibly well with their surroundings that spotting them is often difficult, even when you are close up.

Mamiya 645, 80 mm macro lens plus extension tube, fill-in flash, Fuji Velvia.

Checklist

- Before travelling abroad make a list of what equipment you need. Be sensible, as it can become a problem when trying to take it on board the aircraft.

- Finish or remove any film in your camera prior to travel: you may need to open the back if asked at airport security.

- Clean your equipment and check the lenses at all apertures and shutter speeds, as well as replacing the batteries in the camera, motor drive and flash units.

- Select the film types and set ISO speeds on the appropriate backs if using medium format. I once made the mistake of using a print film in a back that I normally keep for Fuji Velvia, and then forgot to change the ISO back a couple of weeks later when I needed an extra back.

- I also carry additional batteries for the camera, flash gun and motor drive, plus a spare back and flash unit in case of failure.

- Test the flash leads and clean the contacts. Other useful bits include spare cable release, scissors, small screwdriver kit, black tape and tweezers.

- I always take plenty of film with me, as roll film is very difficult to obtain in many countries. We all tend to get carried away a bit when photographing abroad: you will often find that there are more subjects to cover than you have time or film to cope with.

- For most of my foreign photographic trips I tend to concentrate on a few specific groups, such as butterflies, moths or plants. This approach means you're more focused on your objectives and less likely to become sidetracked, which is often difficult to avoid when surrounded by so many interesting subjects.

- It's a good idea to store your unused film in a fridge or cooler bag, and take out only what you'll need for that day, returning your exposed films to the fridge. I would be cautious about buying film from small kiosks and shops in hot climates, as the film is usually more expensive and its storage conditions are always questionable.

- Finally, when travelling abroad to photograph insects it's a good idea to take a couple of the general insect field guides with you. These will prove very useful, not only in terms of identification but in giving you an indication of the commonly encountered species, their flight periods and habitat preferences.

SOUTHERN SWALLOWTAIL
Papilio alexanor

Visiting any of the Mediterranean islands in the early part of the year is always rewarding. Much of the dry, burnt, rocky fields we are so accustomed to seeing in early summer are transformed into a profusion of flowers with an abundance of insects. You don't have to photograph every insect at close quarters: it's nice to include the surrounding habitat sometimes as well, to indicate the type of environment it normally occurs in.

Mamiya 645, 45mm lens, Fuji Velvia.

SOUTHERN SWALLOWTAIL
Papilio alexanor

I photographed this feeding adult below in an adjacent field later in the evening.

Mamiya 645, 150 mm lens plus extension tube, fill-in flash, Fuji Velvia.

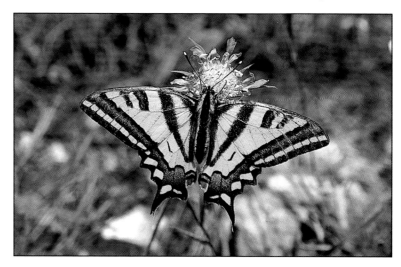

Introduction

ALL insects are cold-blooded, which means that temperature plays an important part in their daily lives. Their general survival and essential activities such as feeding and courtship are all controlled by the weather. Climate, habitat and foodplants are the major factors that restrict species to a particular country or terrain. A good place to start looking for subjects is your own back garden, where there are many kinds of insects to photograph and experiment with. Some species are extremely adaptable and can exist in a wide variety of habitats including towns, cities and urban gardens. However, the vast majority of species are more exact in their requirements. Generally restricted by the availability of their foodplants, they are therefore not usually found outside their preferred habitat.

Most insects have a tolerance zone (or 't zone' as it's often called). This of course varies with different groups of insects. The warmer the conditions, the more active insects are and the less accommodating they will be to an enthusiastic photographer. Successful natural history photography is a combination of two apprenticeships – your ability first as a naturalist and second as a photographer. You will find that the two are inextricably linked.

The following chapters contain information on the most popular insect groups that are frequently sought after by photographers. I have also included useful information about their biology and lifecycles, as well as suggestions on how to locate them and advice on the photographic equipment I currently use. It is, however, beyond the scope of this book to discuss in greater depth the habits and requirements of individual species or groups. There are many other natural history publications available that provide more comprehensive knowledge on all of the insect groups discussed in this book. I have included at the end of each chapter a recommended reading list that should prove useful with regard to identification and distribution of many of the most popular species.

BROAD-BORDERED BEE HAWK-MOTH
Hemaris fuciformis

These day-flying bumble bee mimics are often seen during sunny weather visiting various flowers and can be extremely difficult to approach when on the move. They are occasionally found at rest in overcast weather.

Bronica SQAi, 110mm macro lens plus 1.4x converter, Fuji Velvia.

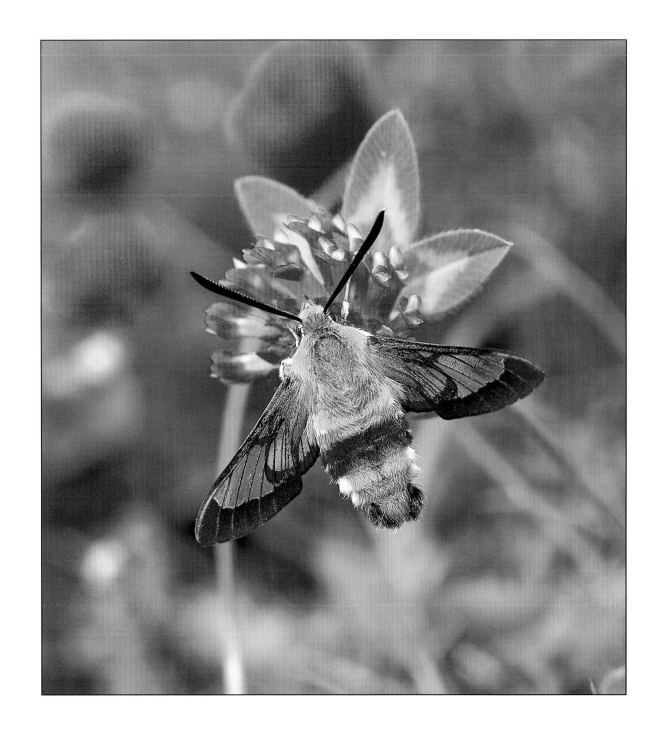

Dragonflies

OFTEN referred to as the jewels of the air, dragonflies are commonly associated with the warm, sunny days of summer. Their speed and agility are unequalled in the insect world. Their large compound eyes have 360 degree vision and are well-placed for spotting approaching photographers. Understanding their lifecycle and habits can help create photographic opportunities if you are prepared learn about their biology and behaviour. Although the majority of people think of dragonflies as terrestrial, they are essentially aquatic insects: most of their life is spent under the water in a variety of different habitats. The winged adults, which we commonly refer to as dragonflies, are only a brief stage of a remarkable lifecycle. They can spend (depending on the species) from one to four years under water in ponds, lakes and rivers. On reaching maturity they leave the water (generally under the cover of darkness or early morning), by crawling up a reed or suitable stem from which they undergo this remarkable transformation.

Dragonflies are subdivided into two groups, Anisoptera (dragonflies) and Zygoptera (damselflies). The former are commonly referred to as true dragonflies: large and robust, these fast fliers are often seen away from water. They are extremely wary, and difficult at times to approach. Damselflies, in contrast, are much more delicate in structure, less agile than their larger cousins and more colonial in their habits.

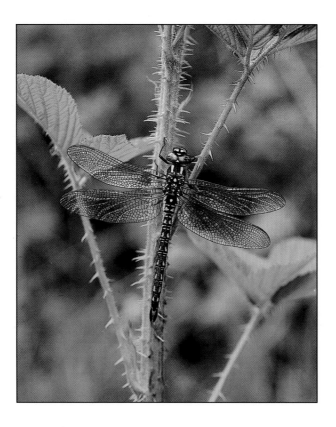

HAIRY DRAGONFLY
Brachytron pratense

This is a spring species found in fens, canals and small lakes. Getting to know a habitat well is often the key to success. I watched the activity of several adults at a small pool for a while. The terrain made it difficult work with a tripod, so I used the monopod to pursue this male, which settled only briefly.

Bronica SQAi, 110mm macro lens plus 1.4x converter, Fuji Velvia.

COMMON HAWKER
Aeshna juncea

Dragonflies spend the vast majority of their life below water. They are highly efficient predators and will eat any insect that comes within striking distance. This adult has captured an early instar damselfly. I constructed a small tank for this type of photography and positioned two flash units, one at either side of the glass tank.

Mamiya 645, 80mm macro lens plus extension tube, flash, Fuji Velvia.

The largest dragonflies are commonly referred to as hawkers, due to their tireless patrols which often take place at tree-top level: they consume their prey, which consists mainly of midges and other small insects, on the wing. These large dragonflies rarely settle when the weather is warm and sunny, although during overcast conditions they often perch among the foliage of trees. In upland areas where trees are scarce or absent, they settle among the ground vegetation, frequently near the water's edge.

The smaller dragonflies are known as darters and skimmers. Their behaviour is somewhat different, in that they prefer to perch often on a prominent reed or stem at the margin of a small pool or pond, making short sorties from their perches to attack other males that encroach on their territory. They are much more commonly encountered than hawkers, and frequently found in good numbers around small pools and the surrounding habitat. It is possible to entice some species to perch in a particular spot, where you can have your camera ready and pre-focused, if you push a stick or some other prominent piece of vegetation into the ground at the edge of a small pool.

Damselflies are much smaller, slender insects than their larger relatives. Their flight is generally weaker, and they prefer the sheltered spots around the water's edge, where they can be seen more frequently in larger numbers. They are usually the first insects that photographers become acquainted with, and are probably the best subjects to experiment with photographically. Damselflies are much more tolerant of approaching photographers, especially on days when the temperature is slightly on the cooler side.

Where to find dragonflies

Dragonflies spend the majority of their adult life at or close to water, but not every type of water habitat will support them. Most favour ponds, bogs, marshes, rivers and small lakes. Many species are restricted by their habitat requirements and therefore seldom found outside their preferred terrain. Everyone knows of a small bog or lake in their neighbourhood: these are the first places to look. Producing consistently good images of these insects can be difficult and at times frustrating. I have spent many years in the field with this group, both in a photographic and

81

BROAD-BODIED CHASER
Libellula depressa

I pushed this stick into the ground at a small pool which had a lot of dragonfly activity. I kept low to the ground and pre-focused on the stick. This female chaser eventually perched on it briefly, before a patrolling male molested her.

Mamiya 645, 210mm lens plus extension tubes, fill-in flash, Fuji Velvia.

EMERALD DAMSELFLY
Lestes sponsa

Damselflies are generally more approachable than their larger relatives. I was able to use the tripod for this resting male due to the overcast conditions. I also used fill-in flash to raise the contrast of the film slightly.

Bronica SQAi, 110mm macro lens plus 1.4x converter, fill-in flash, Fuji Velvia.

scientific capacity, and they are for me without doubt the most fascinating of all insects. Understanding their behaviour is fundamental for anyone hoping to create photographic opportunities.

Dragonflies start to emerge from late spring onwards, with the peak of activity during early summer. You must visit your locality frequently to see which species are present and, most important, to learn where the 'hot spots' are. This will prove invaluable at other times when weather conditions are not so good. I prefer to photograph in overcast conditions when they are often at rest or perched high in the vegetation. This is a much better approach, but it does take practice and persistence to locate them. On dull rainy days the majority of these insects are grounded and settle low

down into the vegetation, where they will shelter during periods of inactivity. Searching the vegetation carefully around the water's edge is often a good place to start. You have to acquire the skill of being able to spot resting insects among the vegetation, and this takes time to learn. When the weather is windy or heavily overcast they often seek sheltered spots with tree cover, further away from water. As your experience grows you will get to know the right areas to look. The larger dragonflies are not capable of instant flight after long periods of rest. Like a plane warming its engines prior to take off, they must raise their body temperature before becoming airborne. They achieve this by flexing their large thoracic muscles and vibrating their wings until the flight temperature is attained. Smaller species including damselflies require less of a warm-up period.

BRACKAGH MOSS
National Nature Reserve

*These linear bog pools are among
the richest types of habitats for
dragonflies: most will contain
a good selection of species.*

Bronica SQAi, 40mm lens, Fuji Velvia.

SHOMERE POOL
*Small lakes and ponds also
contain many interesting and often
rare species. It's worth checking
your surrounding area for
possible sites.*

Bronica SQAi, 40mm lens, Fuji Velvia.

Damselflies, unlike dragonflies, are generally easier to locate, as they frequently settle together in numbers among reeds and other grassy vegetation at the edge of the water. They generally prefer sheltered areas with tall vegetation, even well away from water. If you find a few single adults it is most likely that others will be present in larger numbers. Insects are more vulnerable to predation when the weather is inclement, due to their inability to fly because of cooler air temperatures. Dragonflies are no exception, but some species are easier to find than others. This is largely due to their behaviour: it is important to watch dragonflies and become familiar with their habits, because perseverance eventually does pay off. The most successful pictures are often those that have been taken by naturalists and entomologists, who have a deeper understanding of insect behaviour.

Photographing the aquatic stages of dragonflies is a challenge, and it can be time-consuming searching different aquatic habitats for the larvae. These generally live either among the weed or in the detritus at the bottom of the pond. A sturdy pond net and a small garden sieve are usually adequate for finding the vast majority of them. If you plan on keeping some species at home they need to be separated into individual tanks with some of their habitat in the bottom. They can be fed on bloodworms and other small aquatic invertebrates.

Photographic tips

Many of the images of dragonflies and other insects published in books and magazines depict them in unnatural resting postures or in artificially created set-ups which do not reflect the habits of the species, and to the experienced entomologist this is quite apparent. Know your natural history! Obtaining good photographs can be incredibly time-consuming, and there is no one solution or technique that works in all situations. We all strive to find pictorial images in our photography. There is no magic formula: it requires

BEAUTIFUL DEMOISELLE
Calopteryx virgo

Dragonfly larvae are extremely variable and are well worth recording photographically. The best time to find most species is in early spring when many are fully grown.

Mamiya 645, 80mm macro lens plus extension tubes, flash, Fuji Velvia.

IRISH DAMSELFLIES
Coenagrion lunulatum

I used the monopod to photograph these mating damselflies. It's much easier to manoeuvre into position, especially when the terrain doesn't lend itself to using a tripod.

Pentax LX, 100mm macro lens, Kodachrome 64.

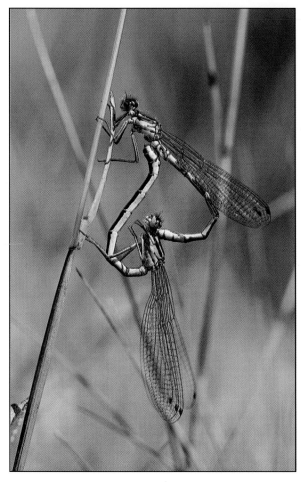

dedication and perseverance and above all an ability to see creative opportunities. Many photographers fail by adopting the same regimented approach to their work, and this does little to expand their creative skills or vision. The end result is a series of record shots with little variation in style or originality. Only when you are confident in your technique can you concentrate all your efforts into the structure and composition of the image. Learn from others and look at their work. My approach and techniques work for me: I have used them for the last 15 years. They may not all work for you, but they will hopefully provide a baseline from which you can experiment and develop your own style and approach.

Using natural light

I prefer this approach where possible for dragonflies. When conditions are favourable it can provide good opportunities for images that reflect their natural environment. It is really only practicable for magnifications below life-size, so it does work well with this group of insects. I always try to use a tripod, or occasionally a monopod if the terrain is difficult. Hand-holding the camera in these situations is not practical. As you are often working in overcast conditions or even light rain, your shutter speeds will almost certainly be at the lower end of the scale. Don't be put off by the weather, however. Many photographers feel that they should only be

taking pictures in ideal conditions, but what are ideal conditions? Blazing sunshine? Chasing dragonflies in the heat of midday is in my opinion far from ideal.

The best approach I have found for this group is short telephotos and extension tubes. I have in recent times started to use the 110mm macro for the Bronica, along with the 1.4x converter, and this combination is giving me some excellent results. The increase in working distance and the reduced angle of view help in some situations to control obtrusive backgrounds. If you don't own a macro don't worry: extension tubes and short telephotos work just as well. It is more important to have a good technique than an expensive macro.

My favourite combination when using telephotos is usually a 150mm, or in some cases a 200mm, with extension tubes. This gives a greater working distance between the lens and the subject – especially important when photographing the larger dragonflies. If you want to photograph at magnifications beyond half life-size it becomes more cumbersome using longer focal-length lenses because of the large amount of extension needed to achieve life-size. I often place a 1.4x converter behind a single extension tube on the 200mm telephoto for the Bronica, which is another alternative for gaining extra magnification without having to stack additional extension tubes. Using longer lenses when employing a tripod means you are less likely to disturb the vegetation around the subject, which would almost certainly be the case if you were using a short focal-length lens. Since larger dragonflies need to warm up before they can fly, photographing them in early morning when they are less active is often a better approach. If you don't have a short telephoto and you are considering purchasing one, you should consider (if your budget can stretch), a long focal-length macro such as Nikon's 200mm, or the 180mm from Canon and Sigma. All would prove extremely useful with these shy and wary insects. The lenses would also serve as a nice high-quality telephoto as well.

I got into the habit, from my early days with medium format, of working with a cable release to help eliminate any possible vibration. The terrain is rarely ever ideal: even the contact of your finger on the shutter button will almost certainly perpetuate this problem at slower speeds. Locking up the mirror is recommended where possible, especially with medium format cameras that have focal plane shutters.

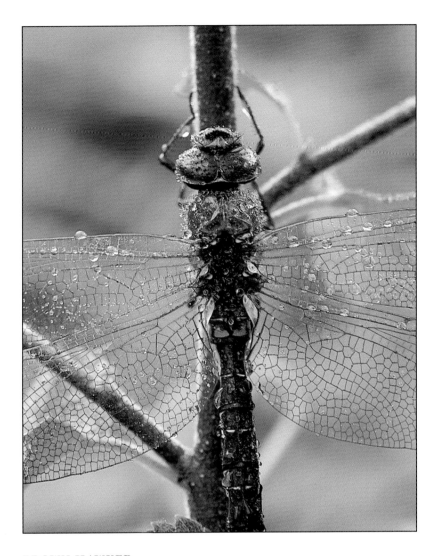

BROWN HAWKER
Aeshna grandis

Early morning or after rain are good times to look for adults that have been grounded. This male was perched among several birches at the edge of a pool. There had been a few heavy showers throughout the early part of the afternoon. As the light was fairly poor, I used Provia rather than Velvia to gain an extra stop in speed. I also used a longer lens to keep the background vegetation as diffused as possible.

Bronica SQAi, 200 mm lens plus extension tubes, Fuji Provia F.

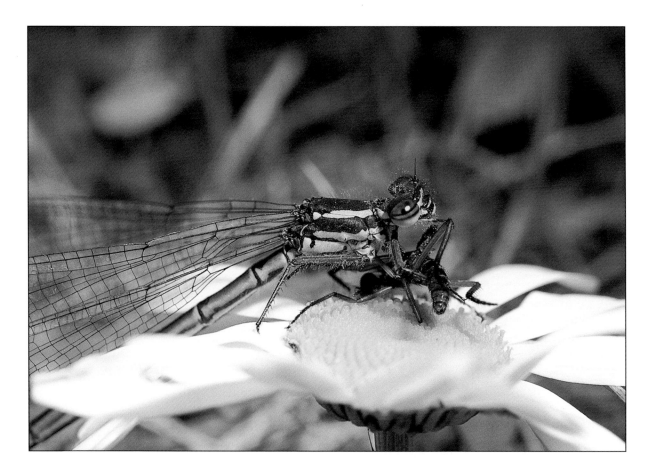

LARGE RED DAMSELFLY
Pyrrhosoma nymphula

This species is one of the most common damselflies found throughout all types of still and flowing water. I used the monopod for extra support as well as flash to arrest any movement from the subject.

Pentax LX, 100mm macro lens, flash, Kodachrome 64.

Remember that as you magnify the image you also magnify your capacity for making errors.

Flash

I try to avoid using full flash when photographing portraits of adult dragonflies, for a variety of reasons. It can often cause unsightly highlights on the shiny reflective wings. The fall-off in light produces dark backgrounds, giving the impression that the insect is nocturnal in it habits. It often requires a closer approach to get the flash within its output range, which makes working off a tripod extremely difficult to do. Full flash has some advantages if used sensibly and selectively, especially in situations where you need to arrest movement or to obtain higher magnifications. I normally use only one flash unit positioned close to the end of the lens on my custom-made bracket. Fill-in flash is more useful for controlling contrast and shadow detail: I tend to favour this approach more with these insects, as it adds sparkle to the image especially on dull, overcast days when the light is

poor. Dragonflies present the biggest challenge to the insect photographer. Disappointment can be high, so expect the waste paper bin to claim more of your photographs than you.

Interesting aspects of their lifecycle to photograph

- The emergence sequence of difference species is an interesting challenge to capture. Many species undergo their transformation at night or early morning. Visiting sites at this time can prove rewarding.

- The larval stage is fascinating to photograph. You will need to construct a small tank for photography.

- Many species, on emergence, are a different colour from the mature insect. This is commonly referred to as the immature, or teneral, phase. It is worth recording these transitional colour forms.

HAIRY DRAGONFLY
Brachytron pratense

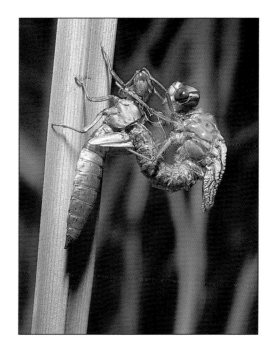

This sequence shows the entire procedure from leaving the water to emergence as a teneral winged adult. I used flash to freeze the movement of the insect.

The larval skin splits at the top of the thorax, and the insect partially withdraws the upper part of its abdomen and rests head-downwards for a short while to harden the legs.

The insect lifts itself up and withdraws the rest of its abdomen.

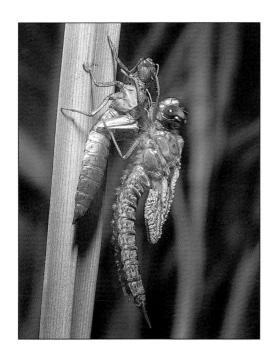

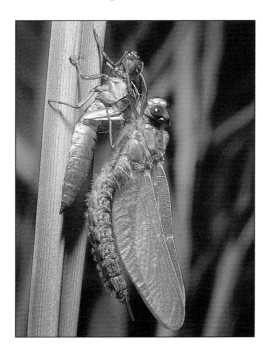

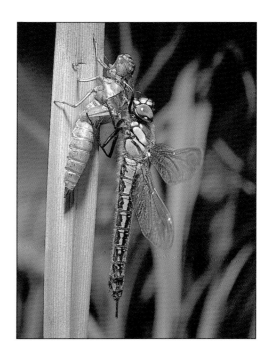

Fluid is now pumped down through the wings to expand them.

This shot shows the wing expansion.

The immature adult.

Mamiya 645, 80mm macro lens plus extension tube, flash, Fuji Velvia.

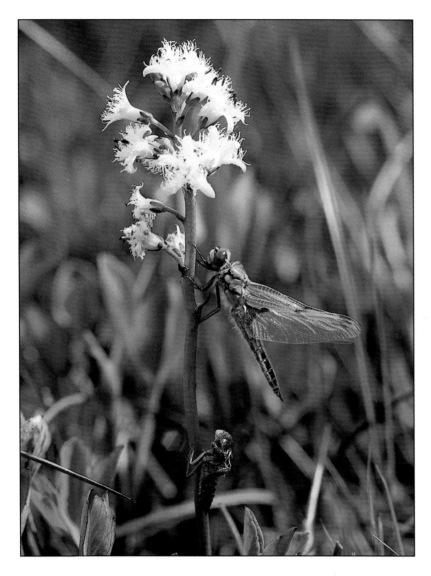

FOUR-SPOTTED CHASER
Libellula quadrimaculata

Many of the larger dragonflies emerge under the cover of darkness. However, some species like this chaser emerge early in the morning. If you visit a site early, look at the vegetation around the margins of a pool – it's quite likely that you will find a few individuals. This newly emerged adult was photographed around 8am: its wings are still not quite dry. You can see that the larval exuvia is still attached to the stem of bogbean.

Mamiya 645, 80mm macro lens plus extension tube, Fuji Velvia.

Tips & suggestions

- Check the areas near your home for a suitable habitat where dragonflies are likely to occur. If you are unsure where to look, or if you find it difficult to locate an area, try obtaining information from your local natural history group.

- When you find a suitable locality, explore it thoroughly. Look for sheltered spots close to the water, and pay attention to where the sun is in relation to these areas at different times of the day.

- Look for smaller pools where insects will be restricted in their patrols, making them easier to photograph.

- Search slowly and look carefully at the vegetation in these areas on days when the weather conditions are not ideal for flight. Adults often rest low to the ground where the temperature can be a couple of degrees warmer.

- If you locate an adult, avoid the temptation to rush in quickly. If the temperature is above the threshold needed for flight it will have the ability to fly instantly and the opportunity will be lost.

- Try not to make sudden movements. Keep as low to the vegetation as you can, and avoid offering your silhouette against the sky – this highlights your movements even more. Don't place yourself between the insect and the sunlight, because it will either reorientate itself or fly off.

- Males defending territories may frequently leave a prominent perch to chase off rival males. Be patient, because they often return to the same spot.

- Try to visit sites early in the morning before things heat up.

- Check your depth of field preview lever, and look carefully at the background and surrounding vegetation before you push the shutter.

- Try to keep the camera's back parallel to the subject to maximize your depth of field.

Useful contacts & societies

Below is a list of societies involved in the welfare and protection of dragonflies in the United Kingdom, Europe and America. They should be able to provide information on regional societies and member groups in your own country.

The British Dragonfly Society
BDS Secretary, The Haywain, Hollywater Road, Bordon, Hampshire GU35 0AD, United Kingdom
Website: www.dragonflysoc.org.uk

International Odonatological Foundation, Societas Internationalis Odonatologica (S.I.O.)
B. Kiauta, Editor of Odonatologica, Post Office Box 256, NL-3720 AG, Bilthoven, The Netherlands

Worldwide Dragonfly Association
Jill Silsby, WDA Secretary, 1 Haydn Avenue, Purley, Surrey CR8 4AG, United Kingdom
E-mail: jsilsby1@aol.com
Website: http://powell.colgate.edu/wda/dragonfly.htm

The Dragonfly Society of the Americas
c/o Thomas Donnelly, 2091 Partridge Lane, Binghamton, New York 13903, USA
E-mail: tdonnel@binghamton.edu
Website: http://www.afn.org/~iori/dsaintro.html

Dragonfly Research Institute
PO Box 147100, Gainesville, FL31614, USA

Reference books

Brooks, S. **Field Guide to the Dragonflies & Damselflies of Great Britain & Ireland** (British Wildlife Publishing)

Merritt, R., Moore N.W., Eversham B.C. **Atlas of the Dragonflies of Britain & Europe** (Natural Environment Research Council H.M. Stationery Office)

Powell, D. **A Guide to the Dragonflies of Great Britain** (Arlequin Press UK.)

Askew, R.R. **The Dragonflies of Europe** (Harley Books)

Gibbons, B. **Dragonflies and Damselflies of Britain and Northern Europe** (Country Life Books)

Needham J.G., Westfall M.J., May M.L. **The Dragonflies of North America** (IORI: Gainesville, Florida)

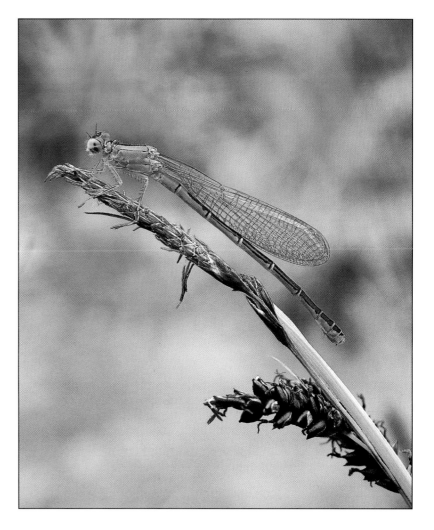

SCARCE BLUE-TAILED DAMSELFLY
Ischnura pumilio

The female of this species is a beautiful shade of orange when newly emerged. Like the vast majority of dragonflies it loses its teneral or immature colouring as it matures. I was photographing marsh orchids at a disused quarry when I found this immature adult. There was a lot of background clutter so I chose my aperture carefully to retain overall sharpness in the insect and to keep the background as diffused as possible.

Bronica SQAi, 110mm macro lens, Fuji Velvia.

Portfolio

DRAGONFLIES

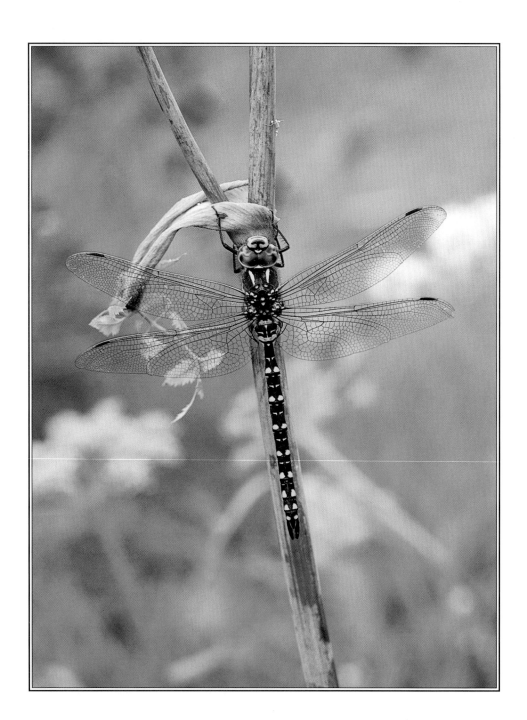

COMMON HAWKER
Aeshna juncea

The hawkers are the most impressive of all dragonflies. This species is found mainly in upland and lowland acidic pools, lakes and flushes. I spotted this male on a regular beat, feeding in a sheltered meadow in early evening. He settled occasionally when the sun disappeared for a while. I was rather fortunate when he perched about 20 yards away in the vegetation. I watched through binoculars and waited for several minutes before I approached him.

Mamiya 645, 150mm lens plus extension
tubes, fill-in flash, Fuji Velvia.

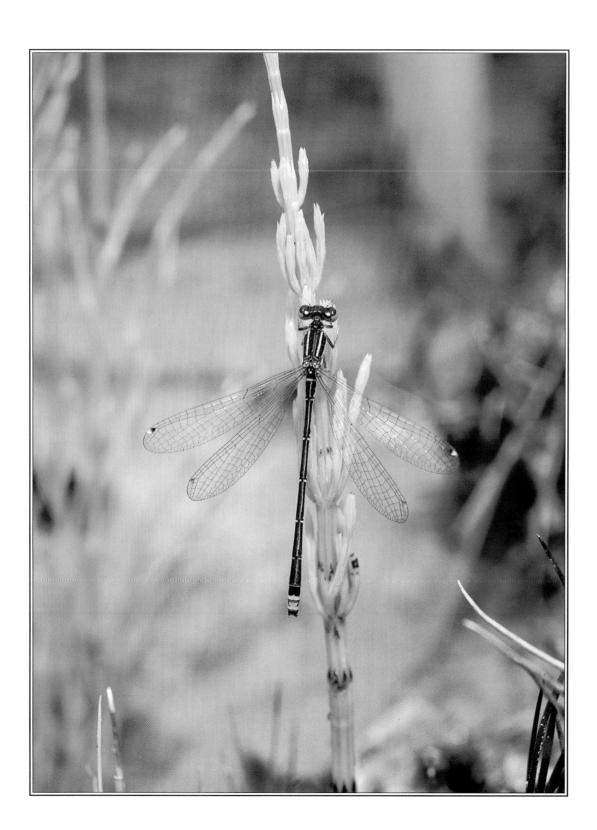

**SCARCE BLUE-TAILED
DAMSELFLY**
Ischnura pumilio

*This small damselfly has a
preference for shallow water and
small pools and flushes. It is often
linked to active workings such as
quarries etc. I photographed this
mature male at an old, disused
quarry in late afternoon.
The weather was quite overcast
so I used fill-in flash to add a
little vibrancy to the image.*

Mamiya 645, 150mm lens plus extension
tubes, fill-in flash, Fuji Velvia.

CLUB-TAILED DRAGONFLY
Gomphus vulgatissimus

This attractive species is found mainly in slow-flowing rivers, although it does breed in lakes and ponds in Europe. For this shot I was in the right place at the right time, coming across this freshly emerged insect while taking habitat photographs. The larger camera is a little more awkward to use in these situations, but the insect was fairly approachable and its wings were still quite delicate. Since I had the waist-level finder on, I used a hand-held meter to take a reading and allowed for the extension of the bellows on the camera.

Mamiya RZ67, 140mm macro lens plus extension tube, fill-in flash, Fuji Velvia.

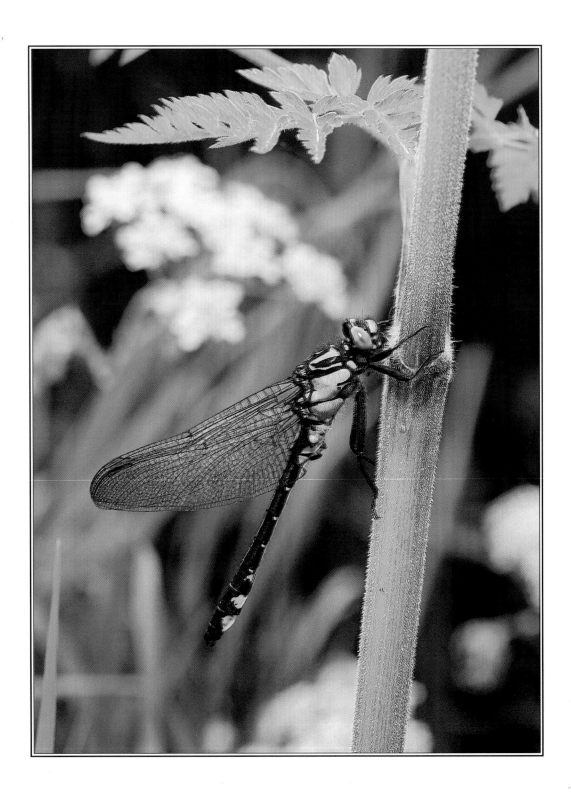

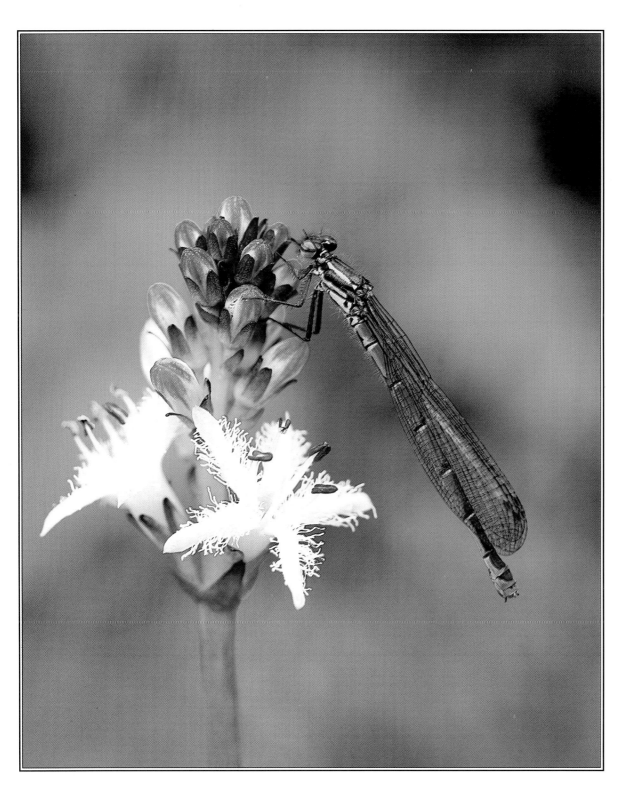

LARGE RED DAMSELFLY
Pyrrhosoma nymphula

This species is one of the most attractive damselflies. It was one of those days when you feel everything has gone right for a change. Visiting the pool on an extremely calm evening in early May, when the bog bean was in full flower, I saw this adult perched several feet in front of me. I approached slowly, taking a shot slightly further back than I wanted to be just in case it flew. I was able to get in closer and isolate the subject by shooting back towards the bank, avoiding other flowers to keep the background clear and diffused.

Bronica SQAi, 110mm macro lens plus
1.4x converter, Fuji Velvia.

KEELED SKIMMER
Orthetrum coerulescens

This species belongs to the family commonly referred to as skimmers. The males develop this characteristic blue pruinescence on the upper surface of the abdomen. They often perch at small pools and seepages, usually in bog land, waiting for visiting females. This male patrolled a small pool and frequently perched on the ground vegetation, which made it difficult for me to get right down because of the wet sphagnum. I forced this small branch into the edge of the pool where the male had set up territory and retreated a few yards. Within a short time he came and perched on the branch.

Bronica SQAi, 110mm macro lens plus
1.4x converter, Fuji Velvia.

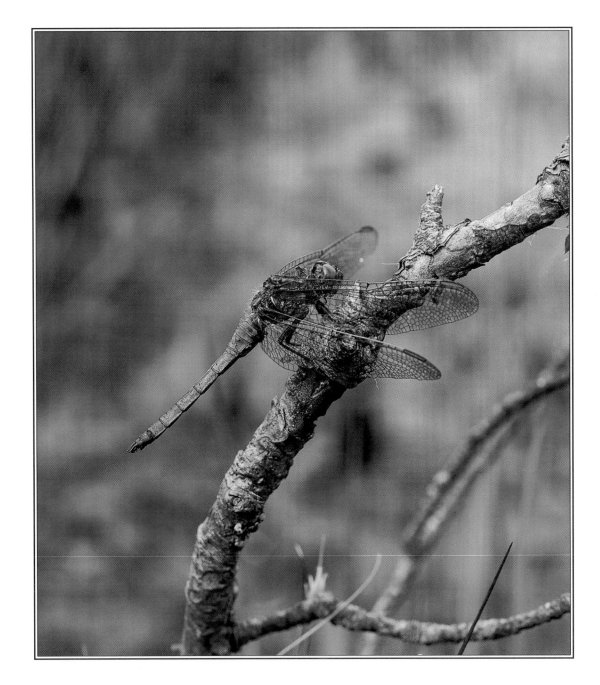

WHITE-FACED DARTER LARVA
Leucorrhinia dubia

I have a particular fondness for this larval shot since it was among the first photographs I took in my homemade tank. I used a single flash, in this case positioned overhead.

Mamiya 645, 80mm macro lens plus extension tubes, flash, Fuji Velvia.

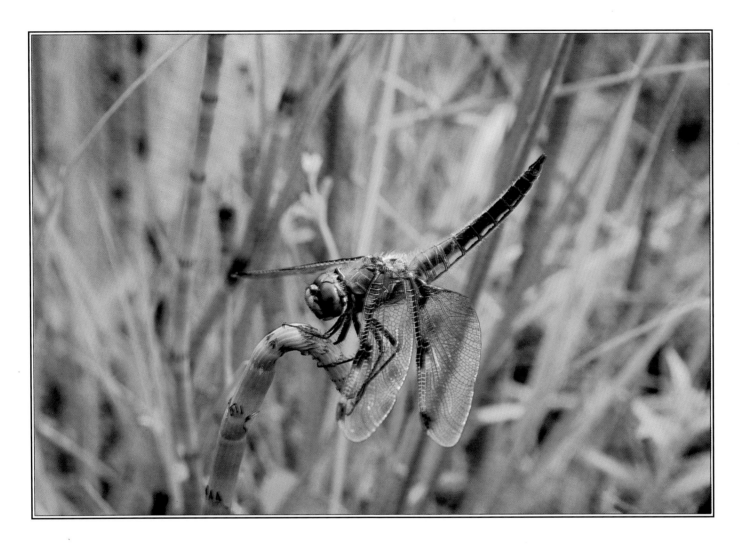

FOUR-SPOTTED CHASER
Libellula quadrimaculata

A spring species found often in large numbers in many different habitats. This male had set up territory at this small pool where he would make frequent patrols around the perimeter and return to the same perch. I positioned myself between the horsetails and waited. I used the motor drive and electronic cable release to make the shot.

Mamiya 645, 150mm lens plus extension tubes, Fuji Velvia.

BLACK DARTER
Sympetrum danae

I wanted to diffuse the willowherb in the background as much as possible as I felt it was quite overpowering. Even with the 200mm it was difficult to isolate the subject completely, as the background was pretty close to the insect. I kept the aperture to the minimum to retain just enough depth of field to keep this immature male sharp.

Bronica SQAi, 200mm lens plus extension tubes, fill-in flash, Fuji Velvia.

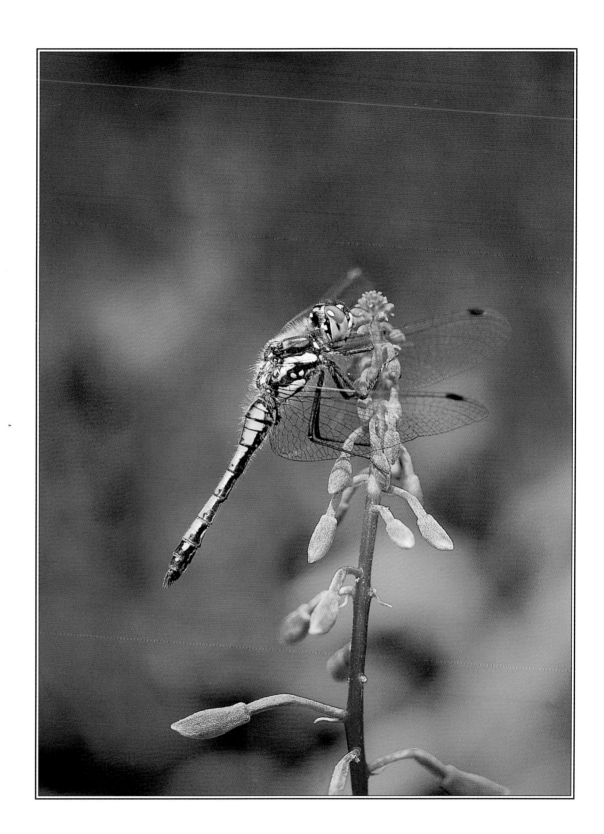

EMERALD DAMSELFLY
Lestes sponsa

The cut-over bog lands are in their prime in late June, when there is often a profusion of yellow as a result of the flowering bog asphodel. It was just beginning to rain when I photographed this mature male – as you can see from the tiny water droplets on its rear legs.

Mamiya 645, 150mm lens plus extension tubes, Fuji 50D.

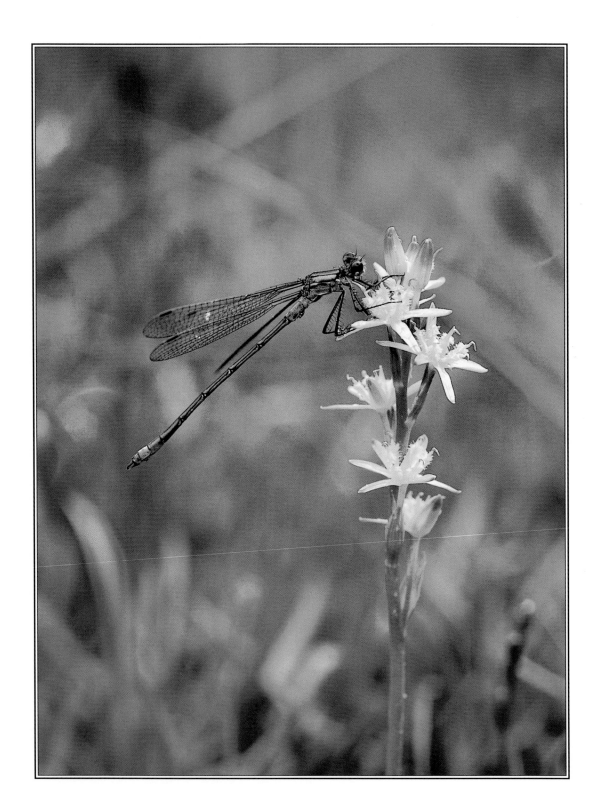

SOUTHERN HAWKER
Aeshna cyanea

The larvae of dragonflies are quite different in terms of size and structure to damselflies. They make interesting subjects. Tank photography can at times be extremely demanding, because it requires a lot of prior preparation.

Mamiya 645, 80mm macro lens plus extension tube, flash, Fuji Velvia.

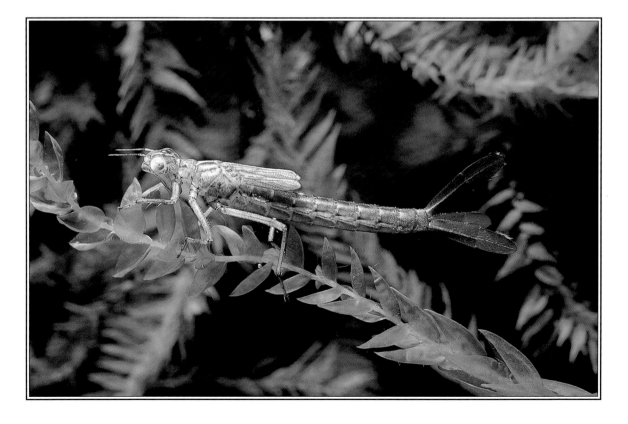

IRISH DAMSELFLY
Coenagrion Lunulatum

Damselfly larvae are a lot more delicate and fragile than their larger cousins. Some species breed in garden ponds, so this is a good place to start looking. The best time is in early spring before they emerge as winged adults.

Mamiya 645, 80mm macro lens plus extension tubes, flash, Fuji Velvia.

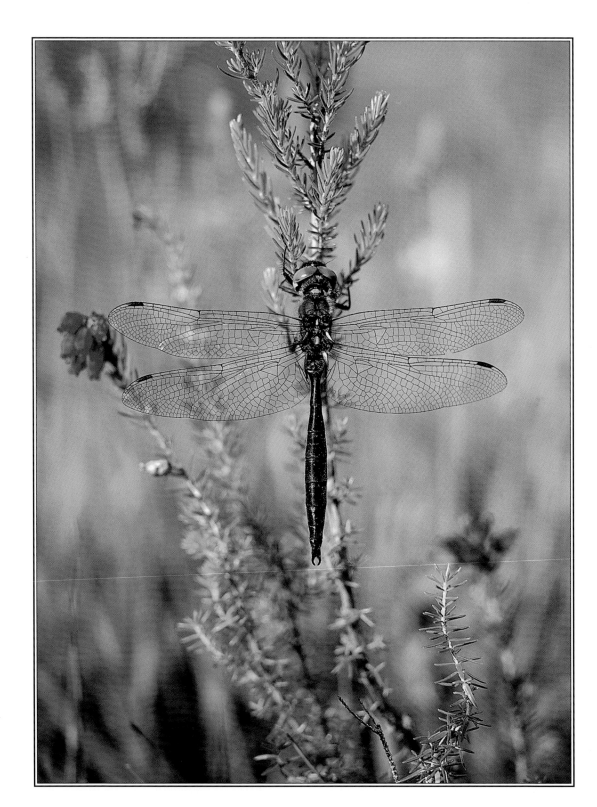

NORTHERN EMERALD
Somatochlora arctica

I was extremely fortunate to get a recent photograph of this elusive species. My only other picture dates back to the late 1980s. I was running a dragonfly workshop for recorders in southern Ireland at a location were this species has been found, and I was rather lucky to see and photograph it.

Bronica SQAi, 200mm lens plus extension tubes, Fuji Velvia.

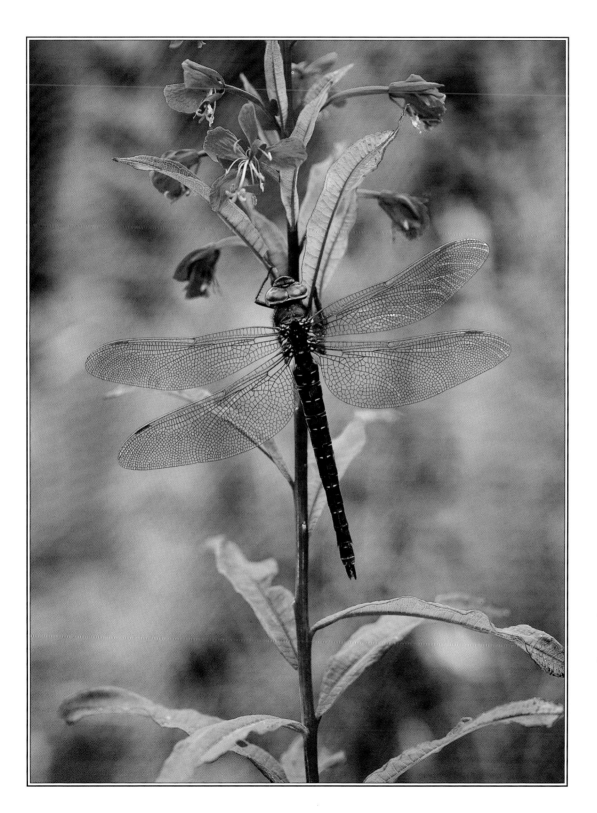

BROWN HAWKER
Aeshna grandis

This female landed several feet from me in a patch of willowherb beside a large pool. I chose the larger lens to increase the working distance since the insect was fairly active. I just managed a single shot before it flew away - only to be captured by a patrolling male.

Bronica SQAi, 200mm lens plus extension tubes, Fuji Velvia.

VARIABLE DAMSELFLY
Coenagrion pulchellum

This is one of the blue damselflies most commonly encountered during early spring.
I photographed this mature male using the monopod, and lay almost on my chest to get the camera down to ground level, keeping the camera back parallel to the body of the insect.

Pentax LX, 100mm macro lens, Kodachrome 64.

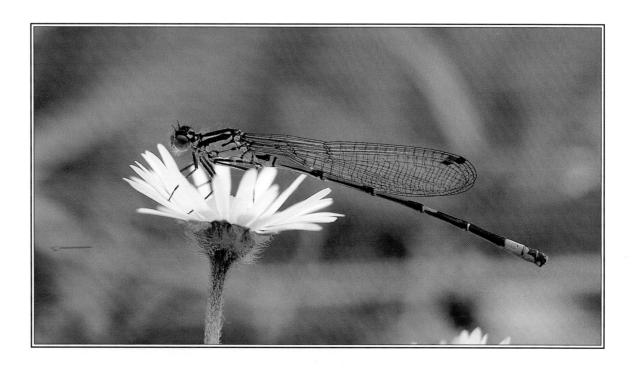

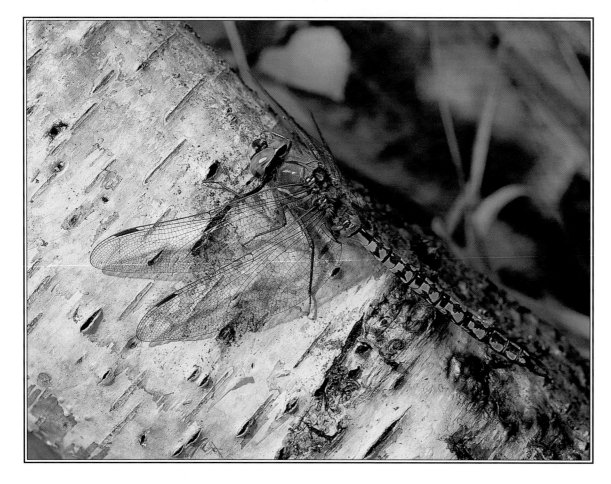

AZURE HAWKER
Aeshna caerulea

I visited a national nature reserve in Scotland specifically to see and photograph this insect. After a long sit in the car (which is often the case when you visit Scotland), the weather improved for a short time and there was a hive of activity in the sheltered parts of the site. I used the 210mm purely to increase the working distance – and hopefully tip the balance in my favour – with this basking male on a birch trunk.

Mamiya 645, 210mm lens plus extension tubes, Fuji Velvia.

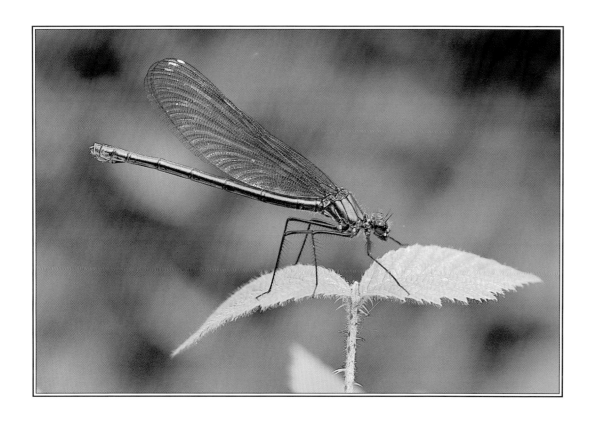

BANDED DEMOISELLE
Calopteryx splendens

This species emerges in early summer and is fairly abundant along slower stretches of rivers and canal banks throughout the season. I prefer to use natural light if possible for these insects, as their iridescent wings often pick up highlights from the flash.

Bronica SQAi, 110mm macro lens plus 1.4x converter, Fuji Velvia.

SCARCE CHASER
Libellula fulva

When opportunities arise to photograph scarcer species I often strive to get something on film rather than trying to produce a work of art. This is exactly what I did in this case. I used a longer lens to increase my chances and fill-in flash to add sparkle to the image. Sometimes this is all you can realistically hope to achieve.

Mamiya 645, 210mm lens plus extension tubes, fill-in flash, Fuji Velvia.

SCARCE BLUE-TAILED DAMSELFLY
Ischnura pumilio

The picture illustrated on page 89 shows this insect in its teneral phase. On reaching maturity it develops a lovely apple green colour. This female was at rest low down among the vegetation, which made it difficult to get the camera back parallel to the insect's entire body.

Mamiya 645, 150mm lens plus extension tubes, fill-in flash, Fuji Velvia.

CHAPTER FOURTEEN
Butterflies

BUTTERFLIES are without doubt the most popular and best loved of all insects. Everyone who visits the countryside regards them with great affection and admires them for their beauty and elegance. They are highly colourful creatures, with a fascinating lifecycle that has been widely studied throughout the world. With moths they form the second largest insect group, known scientifically as Lepidoptera, of which there are over 165,000 species documented worldwide. Butterflies, like moths, have a close association with plants, not only in terms of obtaining nectar, but also as a food source throughout the larval stage in their lifecycle. This relationship, along with temperature and climate, is one of the major factors controlling their distribution.

From a scientific point of view there are no major differences between butterflies and moths: this is an artificially created distinction with little scientific standing. It is commonly believed that butterflies fly by day and moths by night, but there are many exceptions to this rule. A sizeable number of moths fly during the day, and many more of them can be seen on the wing during the early evening. The differences between the two are not always clear-cut, and there is no one diagnostic feature that distinguishes all butterflies from moths – although it may help with idenfitication to know that all butterflies have club-shaped antennae. Moths are usually more variable, with males generally having more elaborate shapes.

BLACK HAIRSTREAK
Satyrium pruni

An attractive species, which spends a lot of its time at rest on the leaves of ash trees and blackthorn, its foodplant. In common with many hairstreaks they are not as easily frightened as some other species. I took the entire roll of film on this adult, as they tend to move and fidget a lot.

Mamiya 645, 80mm macro lens plus extension tubes, Fuji Velvia.

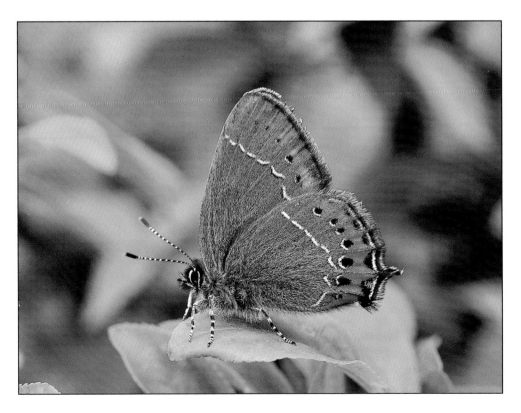

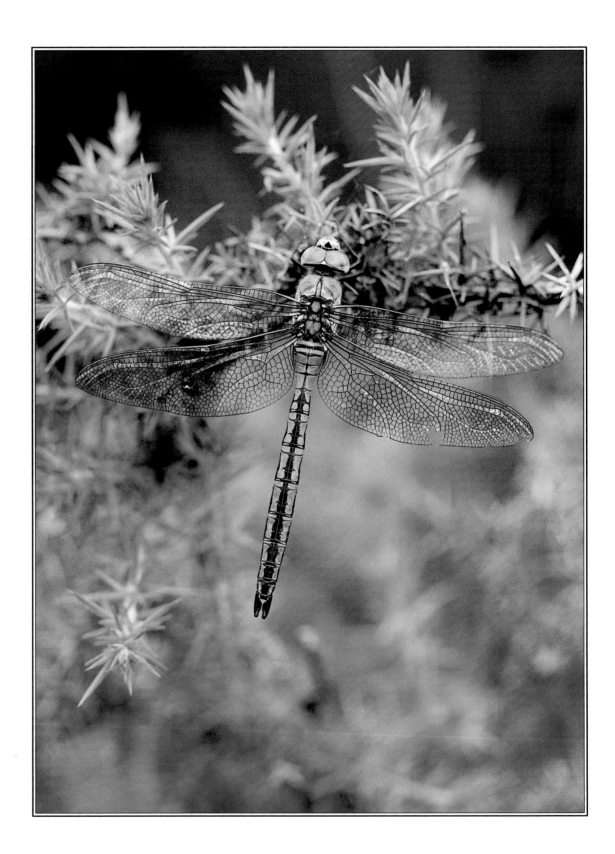

EMPEROR DRAGONFLY
Anax imperator

I spent four hours at a small pond waiting for an opportunity to get a shot of this male, the most impressive of all the larger dragonflies. The vegetation around the pond was very short, which meant that the insect was forced to rest a few feet from the ground. I used the longer lens to increase my chances and to diffuse the background of gorse, which would have been a distraction.

Mamiya 645, 210mm lens plus extension tubes, Fuji Velvia.

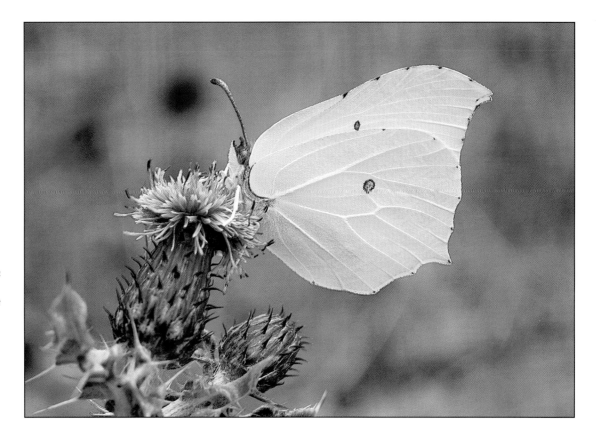

BRIMSTONE
Gonepteryx rhamni

Brimstones are one of the most attractive and long-lived of the European butterflies. They first appear in early spring and reappear in mid-summer, although they can be found in virtually any month right through until late autumn. This species always rests with its wings closed. I photographed this adult using natural light, which creates a softer atmosphere to the picture.

Mamiya 645, 150mm lens plus extension tubes, Fuji Velvia.

In recent years people's attitudes towards the environment have changed, and there is now a greater emphasis on the preservation of the animal and plant life that inhabits our countryside. Butterflies were the most sought-after insects by many early collectors. Thankfully the nets and jam jars from the early part of the last century have now largely given way to the camera, which is a more interesting and rewarding way to capture them. Many aspects of their behaviour and lifecycle can be better gleaned from images captured on film than from specimens in a collection, which has little use outside the storage rooms of a museum.

Photographers both amateur and professional share this passion and enthusiasm, and many travel widely to other countries in search of new species to add to their expanding collection. Our first encounter with butterflies is usually in the garden, where many common species frequently visit the flowers to sip nectar. Others are less often seen and are not normally encountered outside their preferred habitats. Their lifecycle is a remarkable one, in that they undergo a complete metamorphosis – a scarcely credible, dramatic and total change in their body structure. There are four distinct stages to their lifecycle: egg (or ovum), caterpillar (or larva), chrysalis (or pupa) and adult (or imago). We shall deal with the caterpillar stage for both butterflies and moths as a separate chapter, because they are extremely interesting and variable in both shape and size, and they are, moreover, highly photogenic in their own right.

Butterflies are usually seen from the beginning of spring and throughout the summer months until the start of autumn. There are a few species that hibernate as adults throughout the winter months and reappear in early spring for a short period in order to mate. Some species produce only a single generation, while others have two or more in a season. Butterflies, like other insects, are vulnerable to attack from predators such as birds throughout all stages in their lifecycle. They have evolved various defensive strategies to help avoid capture. Their erratic flight behaviour and brightly coloured wings (which often contain an array of spots, along with various other conspicuous markings) help to divert a predator away from the important parts, such as the head and body. Not all butterflies rest with their wings open: some species show only the underside when normally at rest. There are many different families, each with its own peculiar characteristics and behaviour.

SMALL TORTOISESHELL
Aglais urticae

*This species is one of the most poplar
and well-loved butterflies, and the
most familiar in the garden. It is often
the first butterfly that photographers
experiment with, due to its abundance
in a wide variety of habitats. I have
a few buddleia bushes in the garden,
and every summer they gather in large
numbers to gorge themselves in
preparation for hibernation.*

Bronica SQAi, 110mm macro lens, Fuji Velvia.

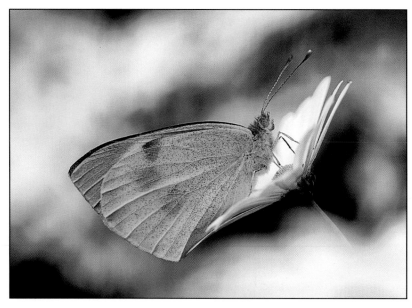

LARGE WHITE
Pieris brassicae

*This species is perhaps the least-liked of our butterflies
due to its choice of foodplants (brassicas) from which it
takes its name. I found this adult while watering the
garden late one evening. I purposely kept the lens low
and close to the foreground in order to help isolate the
flower and to create this diffused effect in the
foreground. The camera back needed to be absolutely
parallel to the wings of the insect as I needed to shoot
wide open to maintain the effect. The exposure time
was around half a second as the light was quite low.*

Bronica SQAi, 110mm macro lens, fill-in flash, Fuji Velvia.

Where to find butterflies

One of the easiest and most accessible places to watch and photograph butterflies is your own garden, particularly if it has the plants and shrubs to attract them. These environments are also good places to watch and to experiment with your techniques. Garden habitats support only a limited number of species, most of which are passing through usually in search of females or to feed and rest. As you become more experienced with identification and your techniques, you will wish to see other species and visit different habitats. Most butterflies, in common with many other insects, are restricted by the distribution and abundance of their foodplants. Areas where the grass and vegetation have been left uncut, such as country lanes, roadside verges and old, disused quarries, all contain

interesting species. Grassy hillsides, downland and embankments where flowers grow also support a rich diversity, while fritillaries, hairstreaks and many other butterflies can be found in woodland clearings. Coastal habitats are also very productive: those with a rich diversity of ground flora have the largest number of species. No matter were you live, or the nature of your surroundings, there will be areas to explore and species to see.

To be successful at finding your subjects requires time, effort and a good understanding of their requirements. There's no point in looking for a woodland species like the purple emperor in coastal habitats – you just won't find it. Locating individuals on bright sunny days is not difficult, since most species are flying then, but this brings its own problems in

getting close, especially when they are active. In poor weather they naturally become more difficult to locate, since they usually seek shelter low down among the foliage. Training your eyes to focus on the ground and examine the vegetation is the key to success, but it does take time and persistence. Remember, their survival depends on their ability to merge into their surroundings. Don't expect to be successful on every occasion: there will inevitably be many blank days with very little to show for your efforts.

Photographic tips

Beginners wanting to experiment with various techniques often use butterflies as their entry point to the world of insect photography. I believe that those making the transition from general photography are at a greater disadvantage than those who have a natural history background. First, they have to familiarise themselves with the methods and equipment. Second, learning about the subjects and their often complex behaviour is perhaps the most difficult part of all.

Butterflies by nature are generally wary insects. They react to sudden movements, and fly readily if the surrounding vegetation is disturbed. Some species are a lot more nervous and cautious than others. The time of day, temperature and the nature of the species are all important factors to consider. You need to be familiar with the various flight periods of species, and the areas where they are likely to occur: this will be governed by their habitat requirements and the abundance of their foodplants. You should always approach your subjects slowly, coming from behind and in a straight line. If the insect is basking, pause and wait a few moments before moving closer. Butterflies often do this in early morning in order to raise their body temperature for flight, so they are not usually in a hurry to move unless disturbed. Avoid wearing brightly coloured clothes as this will emphasize your movements. I always wear dark-coloured clothing when working any subject in the field.

Many species have a regular beat within a habitat. The males of some species often select a spot (a prominent piece of vegetation or sometimes a small sunny area on the ground) to wait for approaching females. They will return to it time and again. Others show a preference for certain flowers, which they visit regularly to obtain nectar. Observation is the key to success: recognising which plants are visited by different individuals will provide you with the opportunities

KILLARD POINT NATIONAL NATURE RESERVE
Coastal habitats are naturally rich in butterflies. These areas are well worth the effort to explore and will prove rewarding, not only in terms of butterflies but many other insects, too.

Mamiya 645, 45mm lens, Fuji Velvia.

DISUSED RAILWAY MEADOW
Areas such as these, where nature is left to its own devices, will produce good numbers of species.

Mamiya RZ67, 50mm lens, Fuji Velvia.

PEACOCK
Inachis io

Some butterflies habitually rest on stones or the ground in order to gain extra heat, especially in early morning or late afternoon. As this adult was resting on the ground I was able to hand-hold using the flash bracket.

Mamiya 645, 150mm lens plus extension tubes, flash, Fuji Velvia.

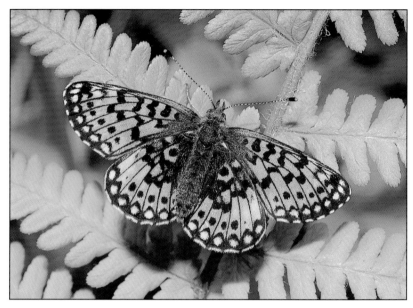

SMALL PEARL-BORDERED FRITILLARY
Boloria selene

Species that keep their wings horizontal when resting or feeding make it easier to keep the entire image sharp. I hand-held this shot, using the flash bracket and making the wings the plane of focus.

Mamiya 645, 150mm lens plus extension tubes, flash, Fuji Velvia.

you're looking for. Many species are easier to approach when preoccupied with feeding, their wings often held in a horizontal position which helps with focusing. Others keep them at 45 degrees, which can make it difficult to keep the wing tips and the body in complete focus at the same time. In these situations you should make sure that the head and body are sharp, at the expense of the wing tips being slightly soft. Some of the hairstreaks, unfortunately, keep their wings closed all of the time.

Don't allow your shadow to fall on your subject, or it will quickly fly off. You will find that a useful solution when the sun is directly behind you is to approach the insect from the opposite side and take the picture upside down – it's then just a matter of rotating the slide the opposite way up in the mount. You'll find that this method works particularly well for subjects that are resting on the ground and when you are hand-holding the camera with flash.

Learning to recognize the shots that are worth pursuing comes with practice. Species that are on the move constantly searching for females rarely settle for more than a minute and pose the biggest problems. By the time you have worked your way in they have flown. Those that have settled to feed tend to stay for a few moments before moving on.

Using natural light

Many of the techniques outlined in the previous chapter apply equally to butterflies. Photographing in natural light is more successful during overcast conditions when most species are resting due to the absence of sunlight and cooler temperatures. Using natural light means working with a tripod, as the shutter speeds with slower films are going to be below the threshold for hand-holding the camera. You can of course use faster film, but I personally don't favour this approach. Temperature is the controlling factor in the lives of

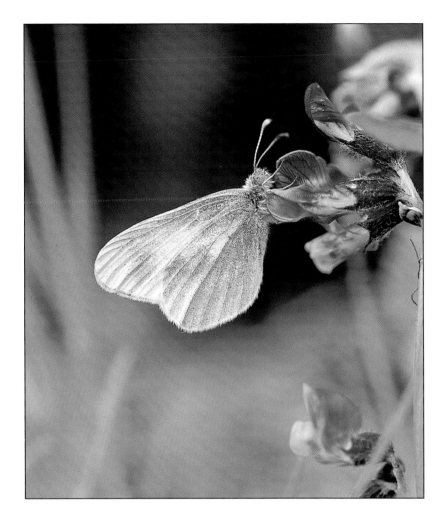

WOOD WHITE
Leptidea sinapis

There is a quality about natural light that is virtually impossible to reproduce artificially. Overcast light works particularly well with white butterflies, conveying a soft, moody atmosphere to the picture. I used the 1.4x converter to increase my working distance and to reduce the angle of view on the background vegetation.

Bronica SQAi, 110mm macro lens plus
1.4x converter, Fuji Velvia.

insects, and cool and wet conditions confine them to the vegetation. These are good opportunities to get close without the fear of their taking flight.

Early summer is often the best time for natural light photography, as species are more abundant and not too difficult to find. The larger butterflies are much easier to spot among the vegetation than many other insects. I use a short telephoto (such as 150mm) with extension tubes and the 110mm macro, which is useful for smaller species. This approach works well in most situations if conditions are reasonably calm. Most species rest with their wings closed in poor weather, and keeping the camera back parallel to the insect's wings helps to maximize the depth of field for the aperture selected. The narrow angle of view with longer lenses also helps to reduce the amount of clutter from background vegetation, which can often be a distraction.

One of the disadvantages in working with natural light is wind movement, which can be extremely frustrating at times: you have the subject framed and the lightest of breezes looks like a gale in the viewfinder. Fortunately heavily overcast days tend to be fairly calm, making it possible to use slower speeds. There will be some failures, so don't be mean on film. Some photographers prefer to watch for calm periods through the viewfinder and pick their moment. I generally prefer to raise the mirror and look at the subject. I use an electronic release connected to the motordrive, and can rattle off several shots with out having to manually cock the shutter and raise the mirror each time.

Flash
I try, where possible, to avoid situations that will produce dark or black backgrounds as a result of using flash. It often means picking subjects that have enough surrounding

vegetation to receive some light from the flash during exposure. This is not always straightforward, because there are many factors beyond your control. Weather and temperature are the two that dictate your approach. Bright sunny days and high temperatures mean increased activity for butterflies, and using a tripod can prove extremely difficult. Using the flash bracket and the stalking approach is one option. This will give you greater freedom, and the sunlight will act as a second flash, helping to fill in the background. Fill-in flash is a further possibility with subjects that are at rest or that remain reasonably still. You can try to time your exposures between moments when they are static, but this is a bit hit-and-miss. You need to be conscious at all times where your shadow falls in relation to the insect: butterflies have a habit of orientating themselves directly in line with the sun, making it difficult for you to approach closely without blocking the light.

SOUTHERN WHITE ADMIRAL
Ladoga reducta

Photographing emergence sequences can be very much hit-and-miss. You can't always predict with absolute accuracy when your subject is going to emerge. When the pupa is close to emergence it usually darkens, and the wings of the adult insect are often visible.

Bronica SQAi, 110mm macro lens, fill-in flash, Fuji Velvia.

The insect remains in this position until its wings harden off.

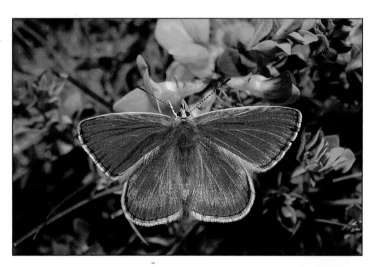

The adult insect at rest.

COMMON BLUE
Polyommatus icarus

When your subject has sufficient background vegetation close to it, as in this case, you can use flash as the main light source.

Mamiya 645, 150mm lens plus extension tubes, flash, Fuji Velvia.

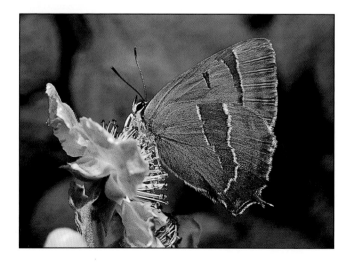

BROWN HAIRSTREAK
Thecla betulae

This is regarded by many as the most attractive of the hairstreaks found in Britain. It is an elusive species, more difficult to find than to photograph. This adult was resting on bramble when I found it in early evening. I was able to use fill-in flash, because the adult's movements were minimal.

Mamiya 645, 150mm lens plus extension tubes, fill-in flash, Fuji Velvia.

Interesting aspects of their lifecycle to photograph

- The emergence sequence in butterflies is always extremely interesting and well worth recording. It is by far the most fascinating part of their lifecycle.

- It is always worthwhile trying to photograph both the males and females of each species. Many look the same, but families such as the blues often have different coloured females.

Tips & suggestions

Many of the tips and suggestions for dragonflies equally apply to butterflies.

- Experiment first with species that visit your garden. This will help you become accustomed to your equipment and techniques.

- Encourage butterflies to visit your garden by planting suitable flowers and shrubs.

- Find out from your local natural history society which species occur in your area and other locations.

- Explore areas such as roadside verges, woodland rides, clearings and coastal habitats where the vegetation is uncut and where flowers grow abundantly.

- Don't confine your photography to warm sunny conditions.

- Explore sites thoroughly, and get to know where the best areas are for butterflies. Your chances of finding resting adults on poorer days will be increased if you know where to look.

- Always check the paths and tracks where the vegetation is short: some species bask on the warm bare ground early in the morning.

Useful contacts & societies

Below is a list of societies involved in the welfare and protection of butterflies and moths in the United Kingdom, Europe and America. They should be able to provide information on regional societies and member groups in your own country.

Butterfly Conservation, Head Office: Manor Yard, East Lulworth, Wareham, Dorset BH20 5QP UK
E-mail: info@butterfly-conservation.org
Website: www.butterfly-conservation.org

Societas Europaea Lepidopterologica (SEL)
c/o Nils Kristensen, President
Department of Entomology Zoological Museum,
Universitetsparken 15, DK-2100 Copenhagen, Denmark
E-mail: npkristens@zmuc.ku.dk

North American Butterfly Association, Inc. (NABA)
4 Delaware Road, Morristown, New Jersey 07960
E-mail: naba@naba.org
Website: http://www.naba.org/index.html

Reference books

Asher, J., Warren, M., Fox, R., Harding, P., Jeffcoate, G. Jeffcoate, S. **The Millennium Atlas of Butterflies in Britain and Ireland** (Oxford University Press)

Tolman, T. **Collins Field Guide to the Butterflies of Britain and Europe** (Collins)

Tolman, T. **Photographic Guide to Butterflies of Britain and Europe** (Oxford University Press)

Opler, P.A. **Peterson First Guide to Butterflies & Moths** (Houghton Mifflin Co USA)

Scott, J.A. **Butterflies of North America (A Natural History & Field Guide)** (Stanford University Press)

Portfolio

BUTTERFLIES

COMMA
Polygonia c-album

Some butterflies are naturally more cautious than others. I found it difficult to use the tripod with this species, and my first attempt failed. However, I was fortunate that it didn't fly far before it settled again. I switched to the monopod and the flash bracket.

Bronica SQAi, 110mm macro lens plus 1.4x converter, fill-in flash, Fuji Velvia.

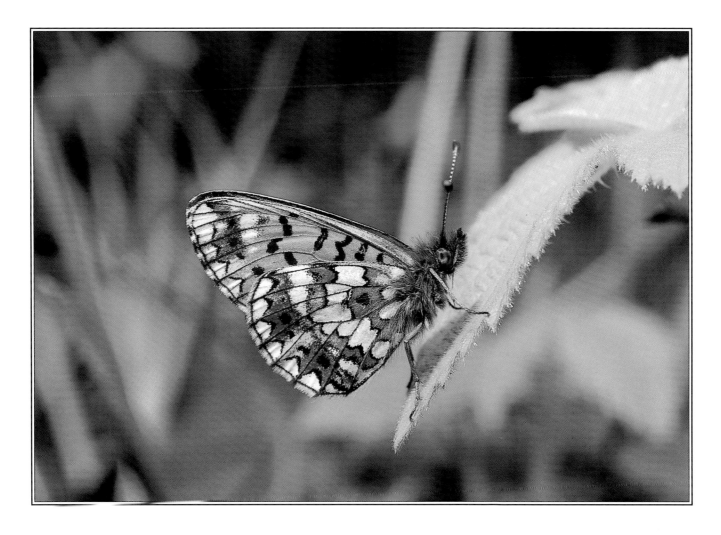

**SMALL PEARL-BORDERED
FRITILLARY**
Boloria selene

*I like to photograph early in the
morning when things are that little
bit cooler. When you are working
in woodland areas it is often a
good idea to use fill-in flash to
add sparkle to the image.*

**Mamiya 645, 150mm lens plus extension
tubes, fill-in flash, Fuji Velvia.**

117

HOLLY BLUE
Celastrina argiolus

Being in the right place at the right time is often the key to getting a successful picture. In this case I was photographing in an old oak woodland which had a large number of holly trees scattered throughout the area. I noticed this insect a short distance away, fluttering around the ground vegetation. I didn't want to use flash as I know from past experience that it often produces a highly reflective sheen on the wings of this species.

Mamiya 645, 150mm lens plus extension tubes, Fuji Velvia.

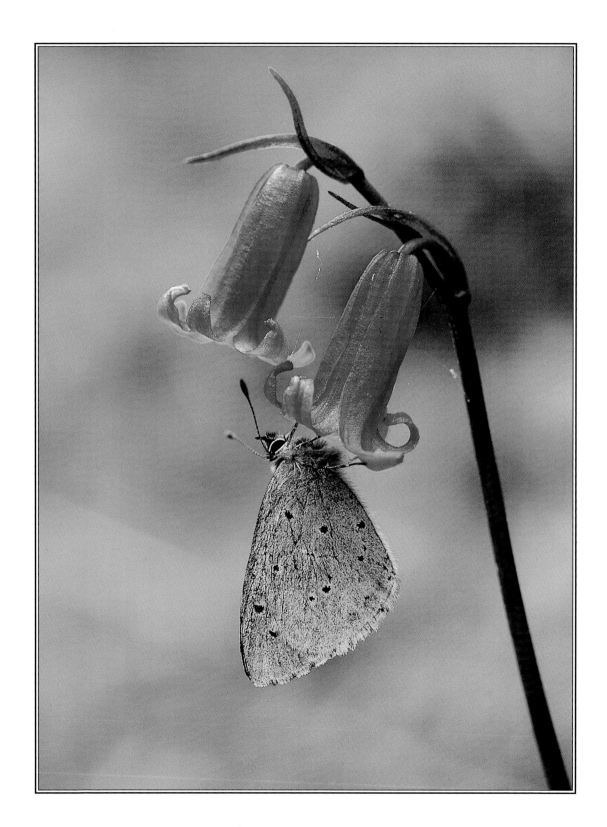

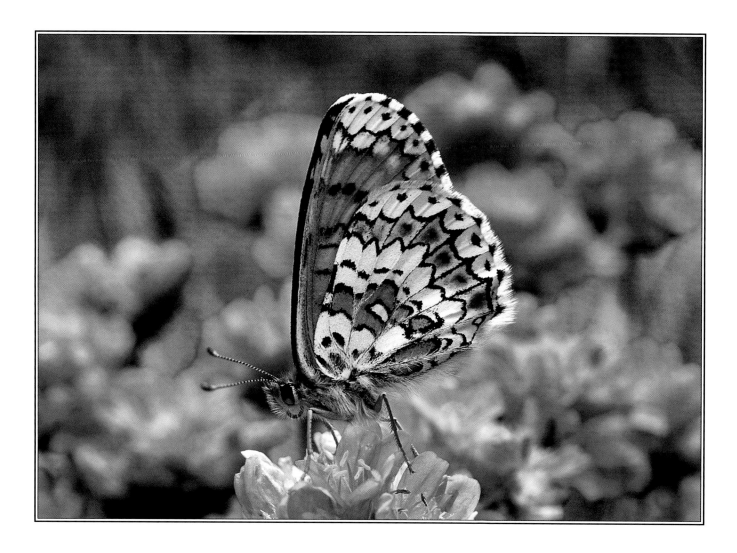

GLANVILLE FRITILLARY
Melitaea cinxia

This is regarded by many as the most attractive of the fritillaries. I have photographed it many times, yet I find it hard to resist when an opportunity presents itself. I found it easier to use the monopod, especially as the adults were quite active.

Mamiya 645, 150mm lens plus extension tubes, Fuji Velvia.

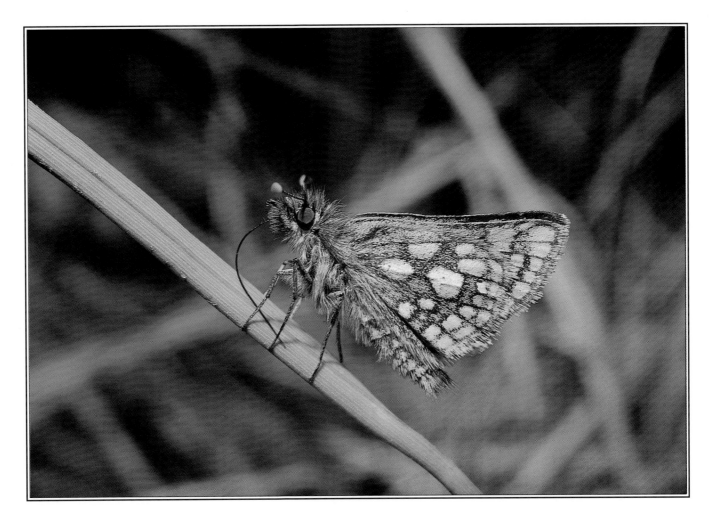

CHEQUERED SKIPPER
Carterocephalus palaemon

*I was walking up a mountain
track in the village of Kandersteg,
Switzerland, when I came across
a small meadow which had an
abundance of insects. This skipper
was actually sipping the water on
the grass stems. I used the
monopod with the flash bracket,
because the subject was quite
active and settling only for
brief periods.*

Mamiya 645, 150mm lens plus extension
tubes, fill-in flash, Fuji Velvia.

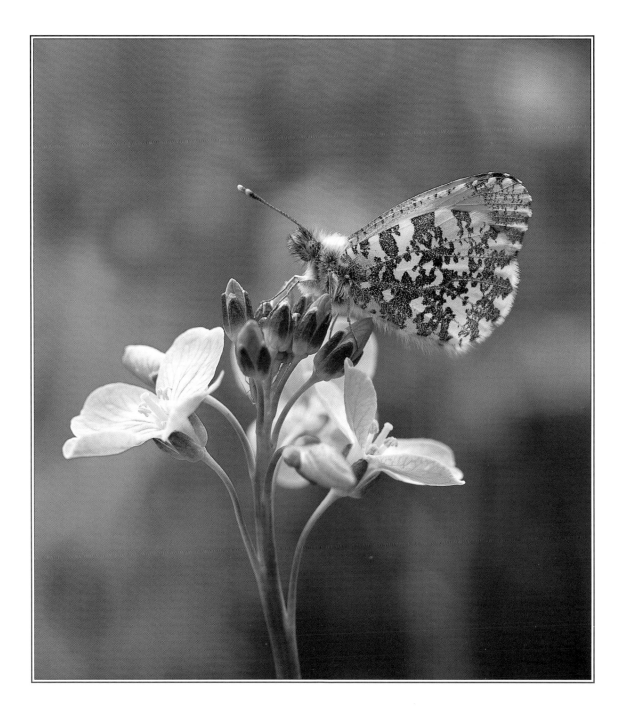

ORANGE-TIP
Anthocharis cardamines

Male orange-tips are one of the first butterflies to appear in early spring. They are a familiar sight fluttering along the hedgerows and in wet grassy meadows where the foodplant – lady's smock (Cardamine pratensis) – flowers. I always make a point of trying to improve on the previous year's pictures. I photographed this adult in early evening in a small, wet meadow near my home.

Bronica SQAi, 110mm macro lens 1.4x converter, fill-in flash, Fuji Velvia.

SPECKLED WOOD
Pararge aegeria

This photograph I regard as pure luck rather than observation on my part. I had been photographing mayflies along the river at my home when I flushed this adult virtually from under my feet on the way back to the car. As it was well into the evening it flew only a few yards into a clump of greater stitchwort. I managed a single shot before it departed – much to my frustration.

Pentax LX, 100mm macro lens, Kodachrome 64.

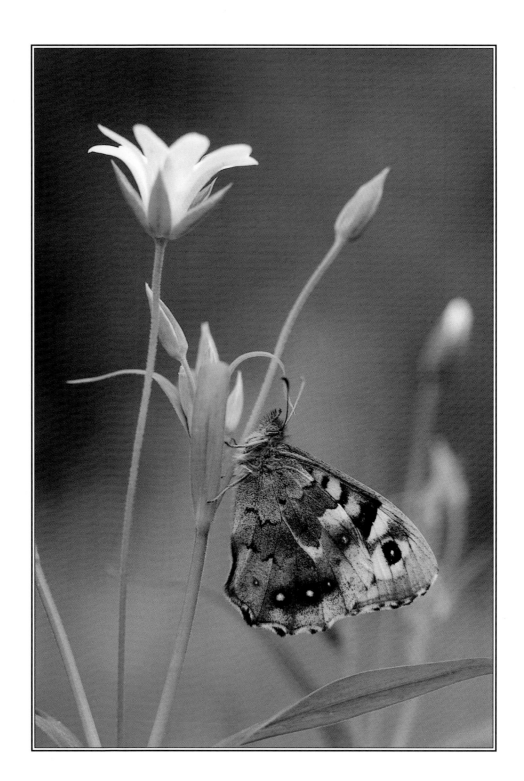

MOUNTAIN CLOUDED YELLOW
Colias phicomone

There was a profusion of these insects in a small alpine meadow in the village of Brigg, Switzerland, along with many other species. I was there to photograph orchids, but unfortunately got sidetracked (as you often do) when faced with so much to see. The weather was overcast and everything was grounded. I photographed this resting adult with the tripod and fill-flash.

Mamiya 645, 150mm lens plus extension tubes, fill-in flash, Fuji Velvia.

PURPLE HAIRSTREAK
Neozephyrus quercus

This hairstreak is frequently overlooked because of its secretive nature. The adults spend most of their time higher up in the trees. I photographed this adult at rest in evening sunshine, and this produced a warm glow to the underside of its wings.

Mamiya 645, 150mm lens plus extension tubes, Fuji Velvia.

GREEN UNDERSIDE BLUE
Glaucopsyche melanops

Photographing insects during the day in the Mediterranean area brings its own problems, and I often ventured out in the late evening when temperatures were that bit cooler. I found this resting adult along a small track in a shady area outside the village of Kassiopi in Corfu.

Mamiya 645, 80mm macro lens plus extension tubes, Fuji Velvia.

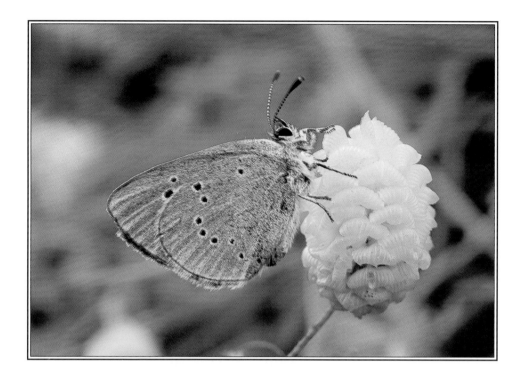

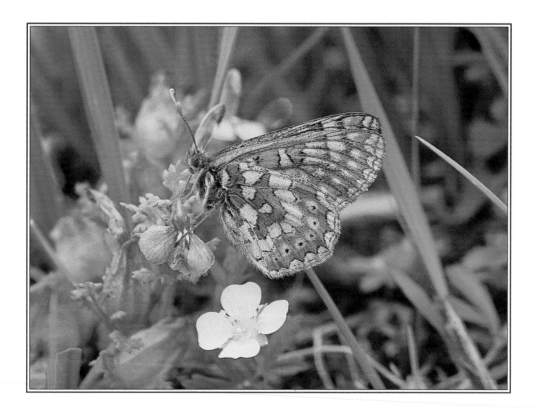

MARSH FRITILLARY
Euphydryas aurinia

This wetland species has suffered a dramatic decline throughout Europe. It is now protected under European legislation in order to preserve its remaining sites. I have photographed this species many times in Ireland – one of its remaining strongholds. I was looking for damselflies when I found this adult in early morning. I was able to approach quite easily, and used the tripod and natural light.

Mamiya 645, 80mm macro lens plus extension tube, Fuji Velvia.

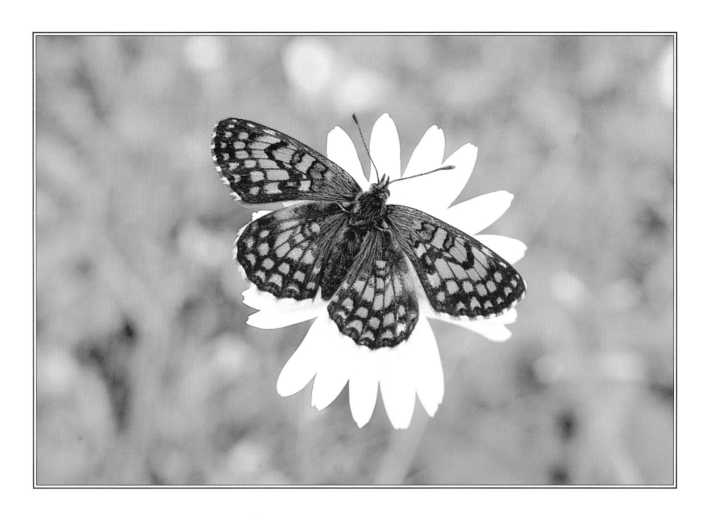

HEATH FRITILLARY
Melitaea athalia

This attractive fritillary favours habitats that have been cleared or burnt. They prefer to bask for long periods of time and fly only in sunshine. Since this adult was preoccupied with feeding, I was able approach fairly closely. I kept the camera back parallel to the insect's wings and chose a wider aperture to control the background vegetation below.

Mamiya 645, 150mm lens plus extension tubes, Fuji Velvia.

GREEN-VEINED WHITES
Pieris napi

Although often mistaken by many for a cabbage white, this attractive insect is one of the first species to appear in early spring. I had to lie flat on my chest to get this shot, as the adults were so close to the ground. I used the monopod with the camera turned at a right angle so that I could keep the camera parallel with their wings.

Mamiya 645, 150mm lens plus extension tubes, Fuji Velvia.

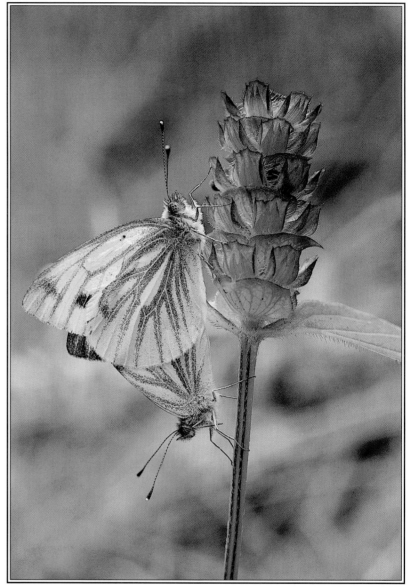

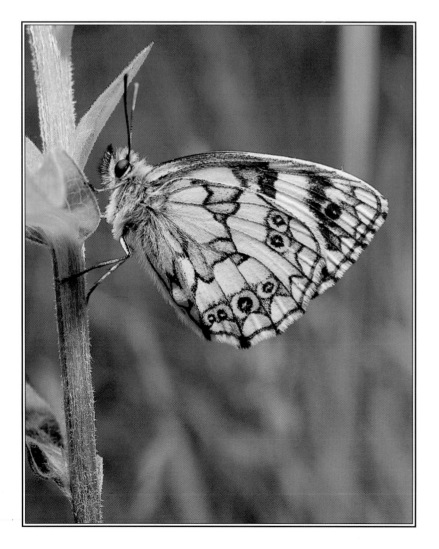

MARBLED WHITE
Melanargia galathea

An attractive insect commonly associated with the chalk downland of southern England. It often rests on flowers and the heads of grasses.

Mamiya 645, 150mm lens plus extension tubes, Fuji Velvia.

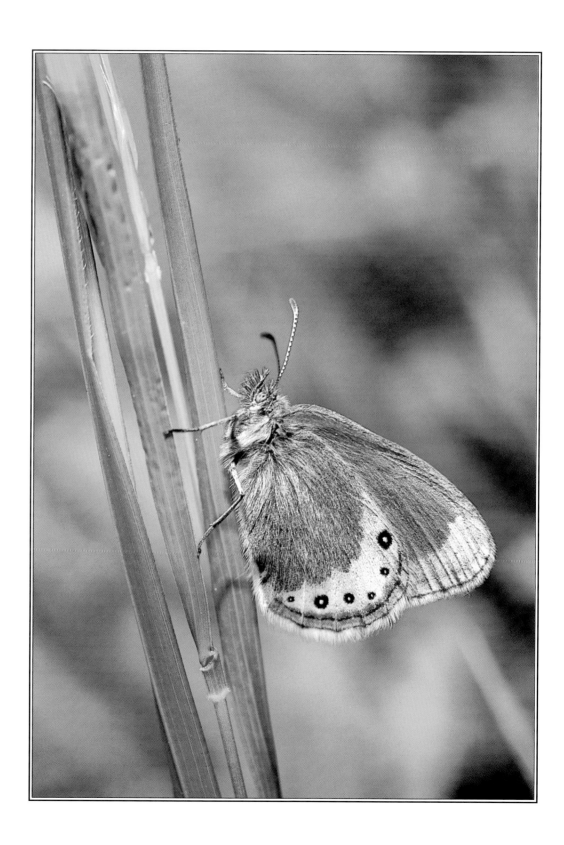

ALPINE HEATH
Coenonympha gardetta

One of the prettiest of the heath species, and fairly common in the alpine meadows in Switzerland, where I photographed this adult in early evening.

Mamiya 645, 150mm lens plus extension tubes, fill-in flash, Fuji Velvia.

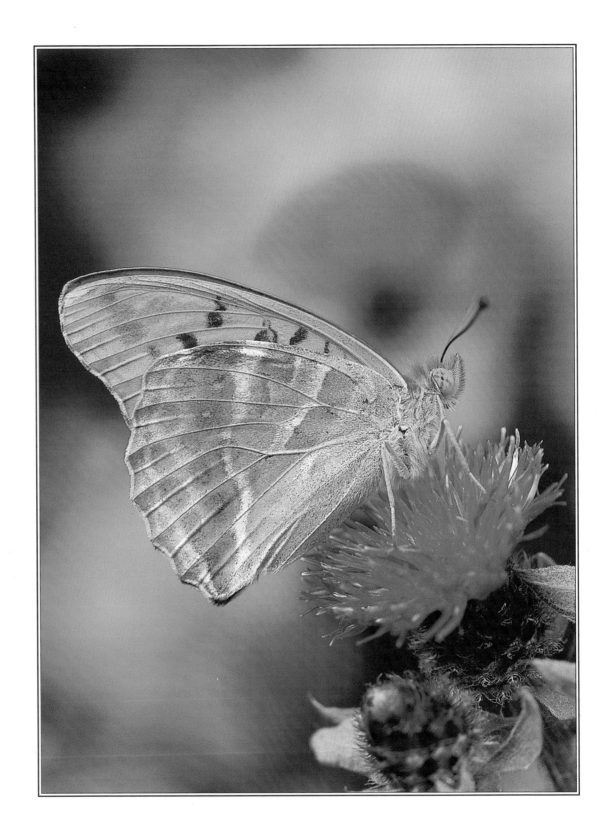

SILVER-WASHED FRITILLARY
Argynnis paphia

One of the largest fritillaries in Europe, found commonly in woodlands during the summer months. It has a fondness for thistles and the flowers of bramble, where it is often seen feeding.

Bronica SQAi, 110mm macro lens plus 1.4x converter, fill-in flash, Fuji Velvia.

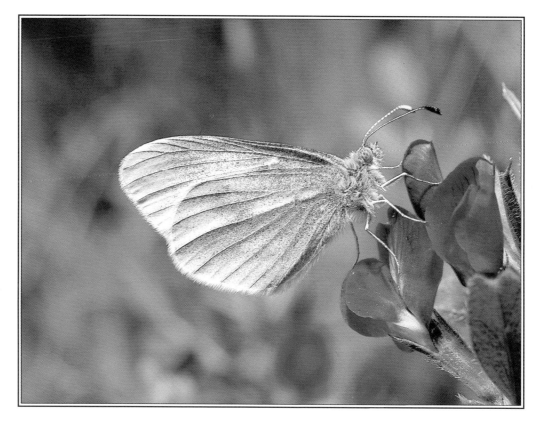

REAL'S WOOD WHITE
Leptidea reali

A rather small, dainty species with a slow, floppy flight, frequently seen along pathways in woodlands and roadside verges from late spring onwards. The species is easily approached when temperatures are cooler. I photographed this resting adult in late afternoon with a tripod and flash bracket.

Mamiya 645, 80mm macro lens plus extension tubes, fill-in flash, Fuji Velvia.

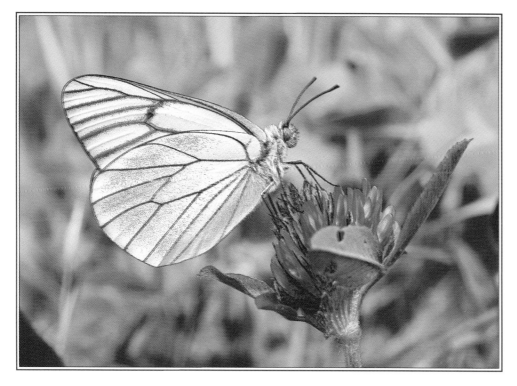

BLACK-VEINED WHITE
Aporia crataegi

An attractive insect, commonly found in many parts of central Europe. They are not as easily alarmed as some other species, and will tolerate a fairly close approach. The scales on the wings are often lost, making them appear transparent and highlighting the distinctive black veining.

Mamiya 645, 150mm lens plus extension tubes, fill-in flash, Fuji Velvia.

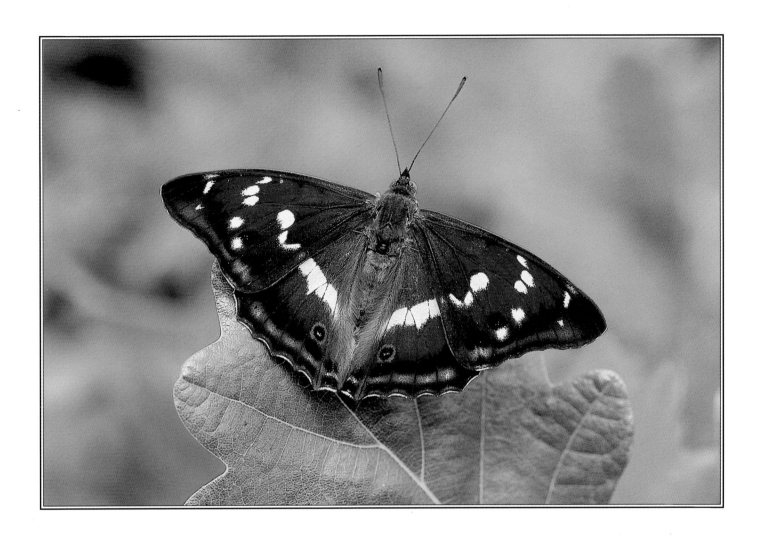

PURPLE EMPEROR
Apatura iris

One of the most impressive, although elusive, woodland butterflies found in Europe. Much of their time is spent at tree-top level, but males come down to feed on animal droppings and carrion. The purple sheen is the refraction of the light through the scales, which varies in its intensity depending on the angle of the wings and their position in relation to the sun. Natural light is best if you want to highlight the purple sheen on the wings.

Bronica SQAi, 110mm macro lens plus 1.4x converter, Fuji Velvia.

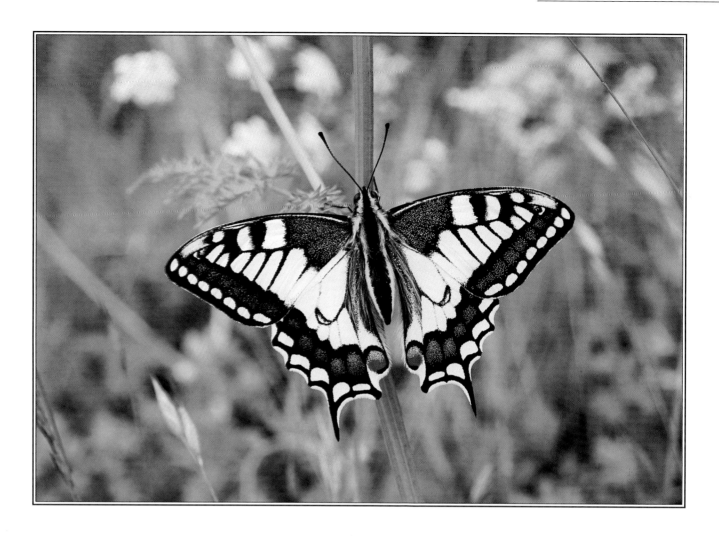

SWALLOWTAIL
Papilio machaon

One of the most striking and distinctive butterflies, eagerly sought after by photographers for its great beauty. It is a common sight in flowery meadows throughout much of Europe from late April onwards. I photographed this resting adult in France in early evening.

Mamiya 645, 150mm lens plus extension tubes, Fuji Velvia.

Moths

MOTHS have always been relatively neglected when compared with their daytime cousins, butterflies. They are deemed by the vast majority of people to be small brown furry creatures that eat holes in clothes or crush themselves against your windscreen during the warm humid evenings of summer. Yet this perception is unfounded: their beauty and diversity is unequalled in the insect world. While it is true to say that many species are dark-coloured, they are – as I hope to prove in these pages – far from being dull or boring. Their colour and size make them wonderful subjects both for study and for photography.

Not all moths fly under the cover of darkness. Many can be seen during the daytime, often in similar habitats to butterflies. Many species, such as the tigers and burnets, have striking colouration, while others, in total contrast, have subdued colours and structures which imitate dead and withered leaves. Species that are brightly coloured often fly openly in the daytime. Their warning colouration serves to remind predators that they are distasteful, contain harmful toxic substances and are to be avoided. Other moths use mimicry to aid protection: imitating aggressive insects such as wasps and hornets gives them the freedom to fly freely during the daytime. However, the majority of moths opt for concealment during the day, sheltering from direct sunlight and preferring to rest on tree trunks, branches, the underside of leaves or among ground vegetation.

There are many more species of moths in the world than there are butterflies. It is true to say that butterflies receive more attention than any other insect group, chiefly because they are day-flying and brightly coloured. Moths, on the other hand, have been rather neglected by many, including wildlife photographers, largely because of their nocturnal habits and the difficulties encountered when trying to understand their habits and behaviour.

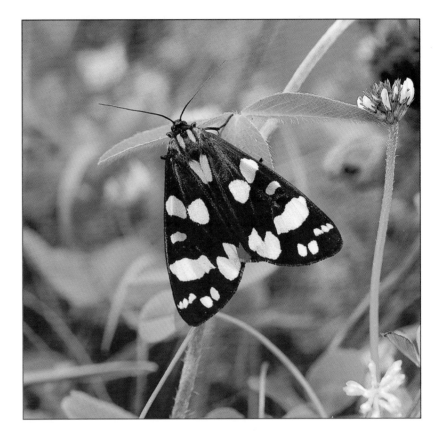

SCARLET TIGER
Callimopha dominula

A striking moth with scarlet red underwings which is found throughout Europe, favouring damp woodland clearings. Although often seen by day, it is a wary insect. The weather was very overcast, so I added fill-in flash to increase the contrast slightly.

Bronica SQAi, 110mm macro lens, fill-in flash, Fuji Velvia.

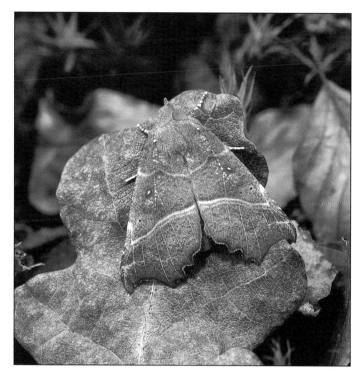

HERALD MOTH
Scoliopteryx libatrix

An attractive species that resembles a withered leaf. It emerges in the autumn and enters hibernation until the following spring.

Bronica SQAi, 110mm macro lens, fill-in flash, Fuji Velvia.

GREEN ARCHES
Anaplectoides prasina

An attractive woodland species, nocturnal in its habits. Its cryptic colouration blends beautifully with lichens on the trunks and branches of trees. Working in shaded woodland means your shutter speeds are likely to be long, so a good solid tripod is essential for this type of photography.

Bronica SQAi, 110mm macro lens, Fuji Velvia.

HEATHLAND, REHAGHY
Bogs and heaths are very productive habitats for moths as well as other insects. Your local natural history society will give you the locations of sites in your area.

Bronica SQAi, 40mm lens, Fuji Velvia.

CROM ESTATE
Woodlands contain the biggest diversity of species. You should investigate all the woodland habitats in your area, since many of them should have a good number.

Bronica SQAi, 40mm lens, Fuji Velvia.

The life cycle of moths is the same as that of butterflies. Both undergo a complete metamorphosis – unlike dragonflies, which lack the pupal stage. Like butterflies, most moths spend the winter months protected in a pupal case or cocoon, although there are some species that choose to over-winter as an egg or larva. Moths generally pupate below the ground in the soil, often at the base of the foodplant or in the fissures of bark in a tree. Some of the day-flying species form protective cocoons spun among the vegetation above ground. While butterflies are generally seasonal, moths can be found throughout the year. However, the vast majority occur from spring until late autumn.

Where to find moths

Moths are found in almost every type of environment, from woodland to suburban gardens. While the vast majority are nocturnal, a surprising number fly by day. Some of the best places to look for day-flying species are coastal habitats where the brightly coloured burnets can be abundant in early summer. Walking through vegetation will often flush resting adults from their hiding places down among the foliage. The majority of species will not fly too far until they settle again, so watching where they land will create opportunities for photography. Other species that rest by day in woodland habitats can be more difficult to find: they require experience and knowledge, plus diligent searching. Many moths rely totally upon their cryptic colouration and camouflage to avoid detection and so survive, and this accounts for their elusive nature. Examining tree trunks carefully will often prove productive, but the disruptive colouration of many geometrids helps them to blend beautifully with their surroundings and makes them extremely difficult to find when at rest. Searching woodland habitats can be tedious work at times, often with all too little reward for your labour.

Exploring areas such as heaths and bogs can also prove beneficial, as a reasonable number of species that exist in these locations fly during the day – especially the males. Carefully searching the vegetation on overcast days will often yield a resting adult. Moths that usually fly by day in sunshine are often grounded when the weather is poor. In these situations they are more approachable than butterflies, provided that you don't disturb the vegetation around them too much. Searching old fence posts in upland mountainous areas is also useful, since tree cover in these regions is usually scarce, forcing species to rest on whatever is

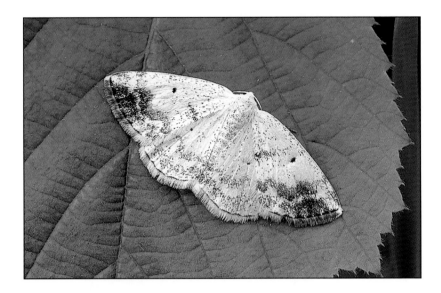

CLOUDED SILVER
Lomographa temerata

A small pretty geometrid that occurs in woodland and hedgerows. I flushed this adult during the day from vegetation along a woodland track. It flew a short distance and then settled again. I under-exposed half a stop from the TTL reading to prevent the delicate pattern in the paler areas of the wings from over-exposing slightly.

Bronica SQAi, 110mm macro lens, Fuji Velvia.

available. Some species by nature rest on rocks, so these should always be examined.

There are other methods which can be productive and provide opportunities for photography. It has long been known, for instance, that moths are attracted to light – we have all witnessed this phenomenon, especially in our homes where they have been drawn to the lights in the house at dusk. Using a bright outside light in a porch or against a white reflective wall is one method for attracting common species, especially during the hot humid evenings of summer when they are more abundant. If you leave it to the morning, however, you must rise early, before the sun forces them to seek cover.

Entomologists who study moths in their natural habitats use portable actinic light units and the more powerful mains-powered mercury vapour light traps to attract species for scientific study, such as ascertaining the distribution of species in a particular area or habitat. When conditions are right these units can attract large numbers of moths.

COMMON MARBLED CARPET
Chloroclysta truncata

This common moth is found in a wide variety of habitats, including urban areas. I was doing some fieldwork at a reserve near my home, and when I returned in early morning to examine the actinic trap I found the adult at rest on a nearby birch trunk. I routinely check the surrounding vegetation and tree trunks in the vicinity for resting adults.

Bronica SQAi, 110mm macro lens, fill-in flash, Fuji Velvia.

However, a percentage often get damaged, or the scales get rubbed on the wings when entering the trap making them unsuitable for photography. Many people run traps in their garden, and this can be extremely productive, depending on where you live. The other disadvantage (for those that enjoy the comfort of their bed) is that you have to rise extremely early in the morning to examine the catch in the trap before many of them escape or the sun raises the internal temperature, making the moths extremely agitated. I always take my camera equipment with me when I'm doing fieldwork on this group, as there are many good photographic opportunities to be had with species that have not entered the trap but frequently settle in their natural resting positions in the surrounding vegetation or on the trunks of adjacent trees. I have obtained many interesting photographs by searching the nearby trees and the vegetation.

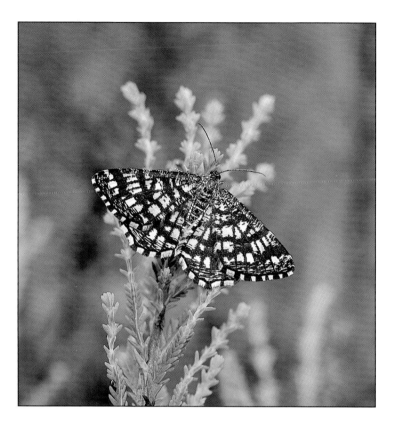

LATTICED HEATH
Semiothisa clathrata

A small attractive species that flies during the day in sunshine and is found in a variety of different habitats, especially open woodland and heathland. The moth has a skittish nature and can be difficult to approach in sunshine. I found this adult at rest in early evening in overcast light.

Bronica SQAi, 110mm macro lens, fill-in flash, Fuji Velvia.

Photographing tips

Moths, unlike butterflies, are generally easy to photograph – with the exception of some of the daytime species which can be incredibly active and, at times, difficult to keep up with. Most species remain reasonably still unless disturbed. Small moths like the geometrids are quite attractive: many are cryptic and blend incredibly well with their surroundings, although they are generally of a skittish nature and are easily frightened. They also have the ability to fly instantly when disturbed, spiralling up into the air until out of view, much to the annoyance of the photographer. The larger moths lack the capability of instant flight and therefore require a warming up period to raise their body temperature: they do this by vibrating their wings until the temperature for flight

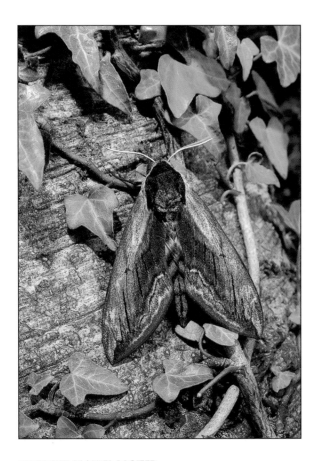

PRIVET HAWK-MOTH
Sphinx ligustri

A large, striking moth with pink hind wings, found mainly in woodland and sometimes gardens. I needed a long shutter speed for this shot, and took photos with and without flash. The shots with flash were more vibrant compared with the natural light photographs, which lacked contrast. A solid tripod was essential.

Mamiya 645, 80mm macro lens, Fuji Velvia.

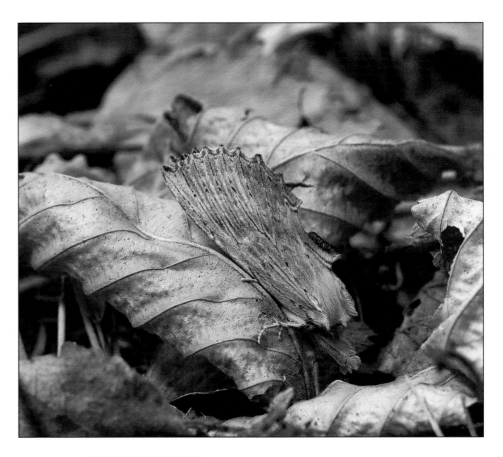

PALE PROMINENT
Pterostoma palpina

Working in woodland shade or overcast conditions is impossible without the use of a tripod. Many species of moth habitually rest among the leaves and ground vegetation. I photographed this resting adult after it settled in the leaf litter near the actinic light trap. A 4 second exposure was needed to gain enough depth of field to keep the whole insect sharp.

Bronica SQAi, 110mm macro lens, fill-in flash, Fuji Velvia.

is achieved. Once a moth has been disturbed and has initiated this procedure it cannot usually be reversed, and the moth will then fly.

The secret is not to disturb or touch adults when at rest. Moths lose their scales easily if handled, making them unsuitable for photography. Species that rest flat against the trunk or branch of a tree pose few problems in terms of keeping the whole insect in focus, but others (because of their three-dimensional shape and size) need more careful

thought regarding composition to maximise depth of field and retain acceptable sharpness. Where the difficulty often arises is being able to keep the whole insect in focus. Important features such as the eyes and body must be sharp, even at the expense of allowing the wing tips to soften – a more acceptable compromise. Look carefully at the species and its position, and try to keep the camera back parallel to your chosen plane of focus. The resting positions of moths can often make it awkward and fiddly trying to position the tripod exactly where you want it.

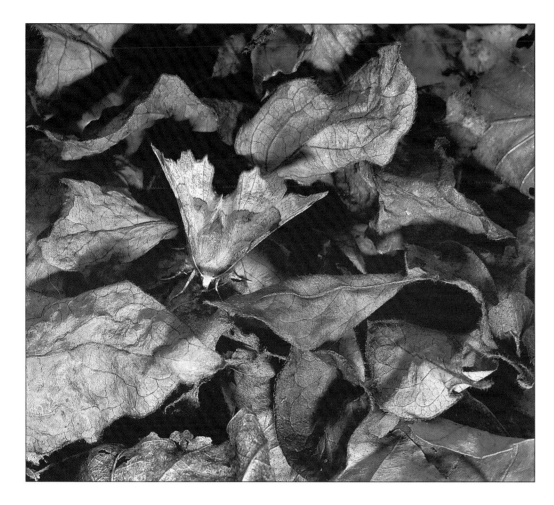

LUNAR THORN
Selenia lunularia

This species rests naturally with its wings spread slightly apart, which makes it difficult at times to retain sharp focus throughout the whole insect. It is not necessary to photograph every species as a portrait. I wanted to include a lot more of the habitat in the picture, to illustrate how cryptic this species can be when viewed in its surroundings.

Bronica SQAi, 110mm macro lens, fill-in flash, Fuji Velvia.

Using natural light

Using natural light is my preferred choice for this group. Most moths when at rest remain quite still. A sturdy tripod is essential, as you are often working in semi-shade and at difficult angles: make sure that it is solid and can cope in these situations. It is also worth investing in a focusing rail, because moving the tripod fractionally backwards and forwards on soft, uneven terrain in order to achieve correct focus can be very annoying. My own built-in unit is indispensable for this type of work, especially when making fine focus adjustments at higher magnifications in the field.

The ideal weather conditions for photographing moths is overcast light, especially early in the morning. If you are using any of the above-mentioned methods to attract species into your garden, or if you are using any of the portable light units in the field, you will need to get there early. When skies are clear many species will have already flown by the time you arrive. Exposure times will frequently be long because of the reduced light and the small apertures needed to maximize depth of field. This doesn't pose too much of a problem, however, as the subject is generally at rest.

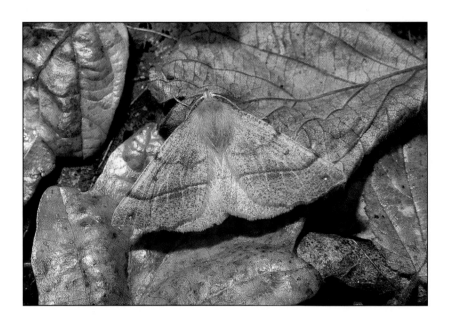

FEATHERED THORN
Colotois pennaria

This autumnal species appears in woodland and heathland. You can see from the photograph that using flash with some species produces a reflective sheen on the scales. This species is better photographed in natural light.

Mamiya 645, 80mm macro lens plus extension tubes, flash, Fuji Velvia.

When working at higher magnifications out in the field you need to be sure that the camera and tripod are firmly supported: this is crucial to obtaining a sharp image. If your tripod is not as stable as you would like it to be, place a couple of stones against the legs. Vibration is always waiting to happen, especially at these higher magnifications. Good photographers are generally excellent technicians, leaving very little to chance. Many of the principles mentioned in the previous chapters apply equally to moths. Always use a cable or electronic release, and lock-up the mirror if possible during each exposure in order to minimize the risk. Medium format cameras with focal plane shutters are especially susceptible to vibration at slower shutter speeds.

I use the 80mm or the 110 macros for most of my images, as getting close is not usually too much of a problem with this group. Fuji Velvia handles the long exposures fairly well with no major problems. In heavy shade and at speeds of one second or more I increase the exposure by half a stop, and this seems adequate in most situations. When photographing moths that are at rest, explore different compositions and look at the backgrounds carefully.

Flash

I don't normally use full flash with moths, for a number of reasons. I can hear you say that flash and black backgrounds would be the ideal combination for this group, since most species are nocturnal in their habits anyway, but a hundred images of moths with black backgrounds would be pretty boring and would show a lack of imagination on the photographer's part. Furthermore, we don't go out armed with our cameras in the dark looking for subjects. The majority of moths, remember, are resting in daylight during the day (albeit in shade or darkish areas), so when we find an adult we should be reproducing its surroundings as we see them in daylight. Even species that are considered nocturnal often fly in late afternoon or early evening for a short while. Another problem with using flash is that the tiny scales on the wings of many species are quite reflective and tend to produce a sheen that can often detract from the image. Flash can also react with the eyes, causing a clouding effect that spoils the aesthetics of the picture. Using a single flash often causes some of the problems already outlined in previous chapters, such as heavy shading and dark backgrounds. A twin set-up can produce a distinct double highlight in the eye, as well as emphasizing the sheen on the wings to a greater degree.

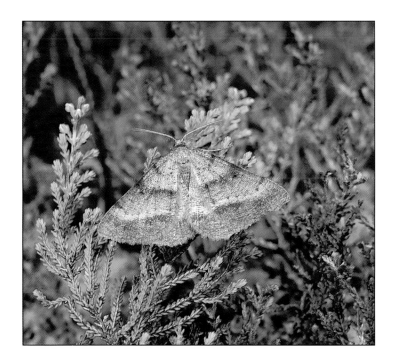

BORDERED GREY
Selidosema brunnearia

Some species have a reaction to flash. This moth twitched its antennae every single time the flash was discharged, producing a double image. I could actually see this happening when I pushed the shutter. Since the moth is seldom found, I took several shots using natural light as a precaution.

Bronica SQAi, 110mm macro lens, fill-in flash, Fuji Velvia.

Fill-in flash is often the best approach when working in heavy shade, or where the colour reflected from the surrounding foliage can produce an overall green tinge to the photograph. It can also add sparkle to any slide that is flat, especially when taken in subdued surroundings. Using a mixture of daylight and flash is fine if the subject remains perfectly still. Occasionally there are species that react to the flash, and their antennae twitch: this appears as a double image, giving the moth the appearance of having four antennae. It is worth experimenting with your own flash set-up to see what gives the most acceptable result.

Interesting aspects of their lifecycle to photograph

- The emergence sequence in moths is equally as interesting as butterflies. There are many more species to experiment with.

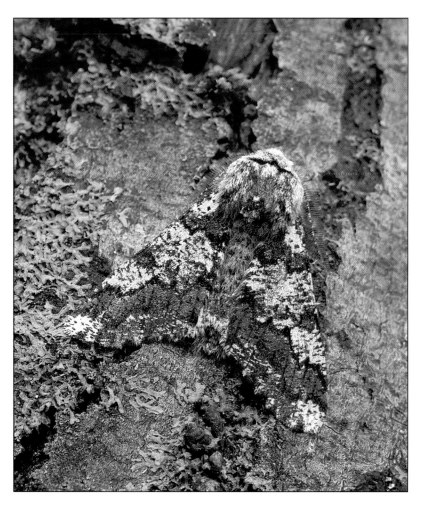

OAK BEAUTY
Biston strataria

Unlike butterflies, moths occur all year round, although only a few species are found over the winter months. This moth appears in early spring, mainly in woodland. I used natural light and was disappointed with the result because of the heavy overcast conditions. The whole image lacked punch. I was grateful that I also took a few shots with fill-in flash. It's always better to double up on your methods, especially when photographing a rarer insect which you may not see again for a while.

Bronica SQAi, 110mm macro lens, fill-in flash, Fuji Velvia.

- Many day-flying species spin cocoons in which to pupate. It is well worth photographing the larva at different stages in the construction of its cocoon.

- Where opportunities arise it is also useful to photograph the pupa of many species. They are extremely variable: many bear a resemblance to dark polished wood.

EMPEROR MOTH
Saturnia pavonia

Emergence shots are always time-consuming and sometimes a question of luck. This species over-winters as a pupa, protected in a tough, silken cocoon which is usually spun among heather. It is one of the prettiest and best-known of the day-flying moths, and is found mainly on heaths and bogs in early spring. When the insect emerges it climbs up a suitable support. The wings are small at this stage, but within a short period of time fluid is pumped throughout, expanding them to their full size.

Bronica SQAi, 110mm macro lens, fill-in flash, Fuji Velvia.

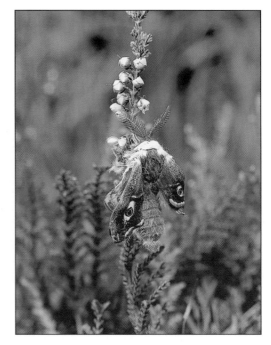

It takes a while for the wings to expand completely, and in the meantime the moth is extremely vulnerable. Should it sustain any injury to the wings at this stage they may fail to expand properly and the insect will eventually die.

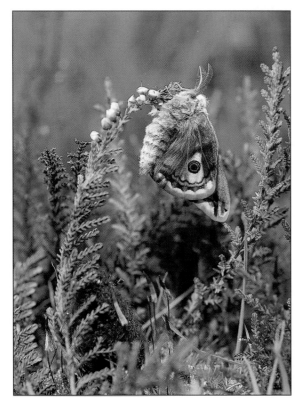

The wings are held together for a while until they harden sufficiently, and then opened to their normal resting position.

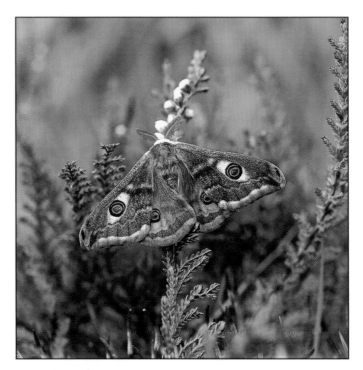

The adult moth in its natural resting posture.

Tips & suggestions

- Try attracting common species to your garden by switching on a strong outside light. Pick warm humid nights, since these are more productive. Get up early in the morning and examine the walls and surrounding trees and shrubs. This works best during the summer months when there are many more species flying.

- Join a local natural history society. There are always entomologists who will be able to give you help and guidance on finding suitable subjects.

- Visit suitable habitats where day-flying species are likely to be seen, such as coastal areas, heathland and woodland rides.

- Look carefully at the vegetation, and explore tree trunks and old fence posts for resting adults. Perseverance is the key word here.

- Don't touch the moth when at rest or you will damage the delicate pattern of scales on the wings.

- Avoid bright sunny conditions, because moths will be much harder to find.

- The vast majority of species can be photographed in their own habitats, which means that there is no real need to capture or remove them. If you do, always return them to their proper environment. Don't take species that are protected by legislation.

- Use a tripod and cable release, and lock-up the mirror if possible with this group as exposure times are often long.

- Seek permission from the appropriate authority or land owner before doing any photography or fieldwork.

- Buy a good book on moths that illustrates a wide variety of species. It should also cover the life history and identification, which you will need to learn if you want to increase your chances of success.

Useful contacts & societies

Many of the societies and organisations mentioned in the chapter on butterflies can provide information at a local level on moths. See information under Butterflies (p.115)

Reference books

Skinner, B. **Moths of the British Isles** (Viking)

Heath, J., Emmet, A.M. **The Moths & Butterflies of Great Britain & Ireland** (Harley Books)

Young, M. **The Natural History of Moths** (Poyser Natural History)

Leverton, R. **Enjoying Moths** (Poyser Natural History)

Brooks, M. **A Complete Guide to British Moths** (Jonathan Cape, London)

Riehm, H.R., Thomas, J., Goater, B. **The Butterflies & Moths of Britain & Europe** (Crowood Press)

Novák, I., Severa, F. **A Field Guide in Colour to Butterflies & Moths** (Octopus Books Ltd) Covers many species found throughout Britain and Europe

Mitchel, R.T., Durenceau, A. **Butterflies & Moths (A Field Guide to The More Common American Species)** (Golden Books Pub. Co. USA)

MOTH PUPAE
The pupae of moths are extremely diverse, with many different shapes and colours: no two species are the same.

Bronica SQAi, 110mm macro lens, Fuji Velvia.

Portfolio

MOTHS

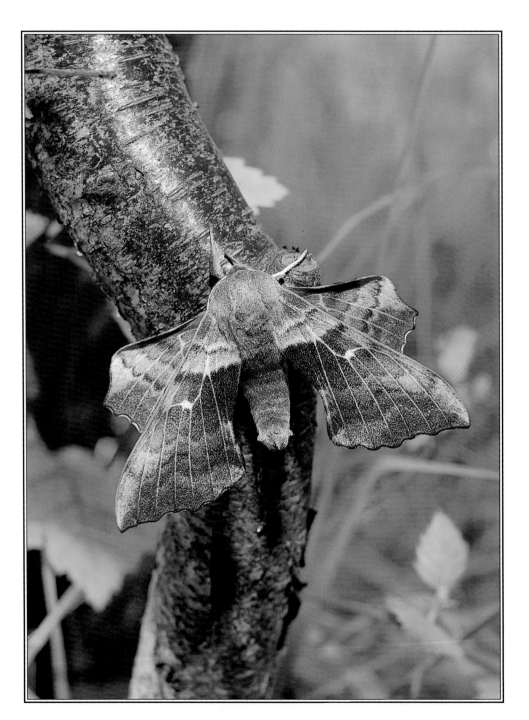

POPLAR HAWK-MOTH
Laothoe populi

A common and widespread moth with a curious resting posture, in which the hind wings are pushed forward in front of the forewings. This moth is occasionally found by the public, resting on walls or garden fences. These larger moths require a warm-up period before they can fly.

Mamiya RZ67, 140mm macro lens, fill-in flash, Fuji Velvia.

A MICRO MOTH
Diurnea fagella

A small moth belonging to a group commonly known as micro moths. This species emerges early in the year, usually in early spring. I disturbed this adult while walking through vegetation: it flew only a few yards before settling again. I needed to go beyond life-size, so I used the macro at 1:1 plus the 1.4x converter to gain additional magnification.

Bronica SQAi, 110mm macro lens plus 1.4x converter, fill-in flash, Fuji Velvia.

DARK MARBLED CARPET
Chloroclysta citrata

A pretty geometrid with a skittish nature that rests during the day on rocks and tree trunks. It occurs mainly in woodland and moorland. Shots such as these frequently test your technique, since you are often working in difficult terrain and at slow shutter speeds. Your tripod needs to be absolutely stable to prevent any movement during exposure.

Bronica SQAi, 110mm macro lens,
fill-in flash, Fuji Velvia.

LUNAR HORNET MOTH
Sesia bembeciformis

A large, harmless, day-flying species that belongs to a family of mimetic moths, resembling wasps or hornets. They are seldom seen in the wild, and are best looked for as freshly emerged adults from a host tree. Although I had looked most years for this insect, I had a 14-year wait before I managed to find my first adult. These moths emerge very early in the morning and sit on the trunk or branch to expand their wings.

Bronica SQAi, 110mm macro lens,
fill-in flash, Fuji Velvia.

ARCHER'S DART
Agrotis vestigialis

An attractive moth found mainly in coastal localities. It has a particular fondness for ragwort and heather. I found this resting adult extremely early in the morning at a coastal nature reserve, where it had settled on the heather during the night.

Bronica SQAi, 110mm macro lens,
fill-in flash, Fuji Velvia.

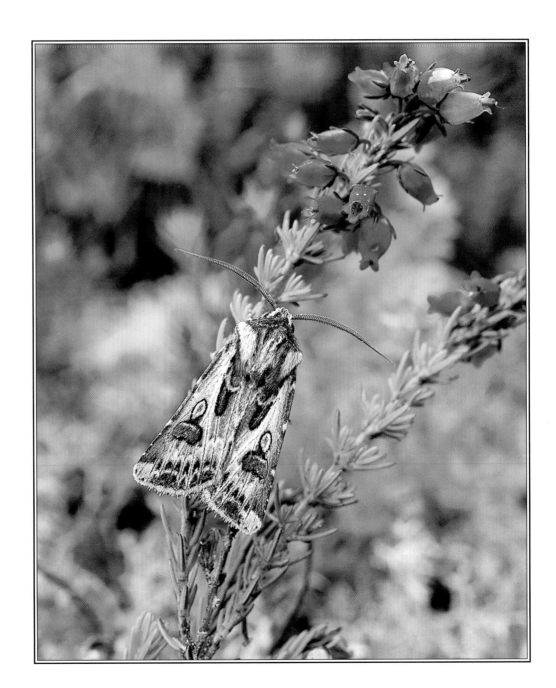

THE STREAMER
Anticlea derivata

This is a spring species inhabiting woodland edges and hedgerows. The moth is particularly well camouflaged when at rest on branches and tree trunks. Species that rest flat against the branch or trunk pose the least problems regarding depth of field. It's a simple matter to keep the camera back parallel to the insect's wings.

Bronica SQAi, 110mm macro lens, Fuji Velvia.

RED-NECKED FOOTMAN
Atolmis rubricollis

This moth flies by day in sunshine, often in large numbers at tree-top level. When at rest it can be found exposed on low vegetation. I was making my way along a mountain track to a small upland lake when I saw these adults and many more resting on the flower heads of plantain and other low vegetation. I positioned my tripod so that I could isolate these two from the surrounding vegetation.

Bronica SQAi, 110mm macro lens, fill-in flash, Fuji Velvia.

BEE MOTH
Aphomia sociella

This pyralid moth gets its name from the habits of the larvae, which live in the nests of bees and wasps. During the day the adults rest in the vegetation or on branches and the trunks of trees. I needed extra magnification for this shot, so I used the converter with the camera firmly on the tripod and fill-in flash.

Bronica SQAi, 110mm macro lens,
1.4x converter plus fill-in flash, Fuji Velvia.

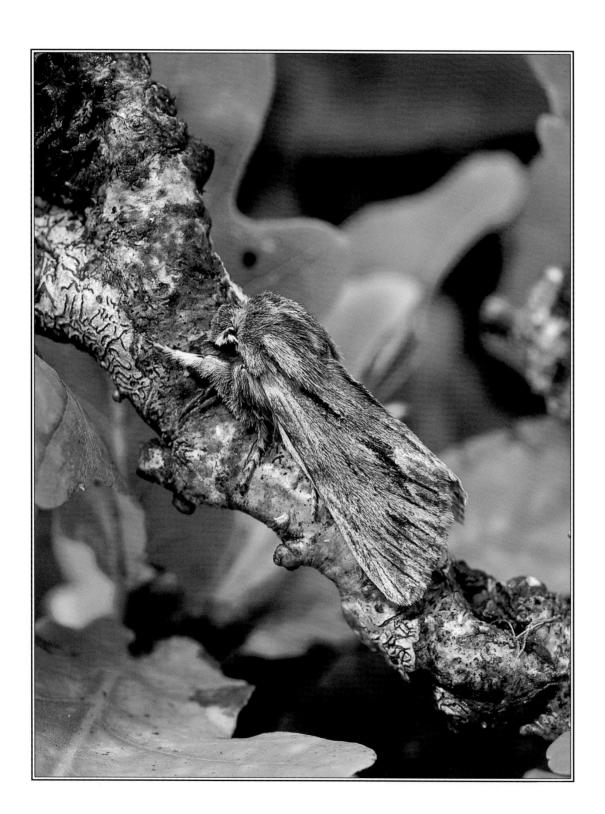

THE SPRAWLER
Asteroscopus sphinx

A late autumnal species found in deciduous woodland. When using flash among leaves, pay attention to where shadows fall and also to any water droplets that may be present on the leaves – these will often create hot spots as a result of using flash, so detracting from the picture.

Bronica SQAi, 110mm macro lens, fill-in flash, Fuji Velvia.

LARGE THORN
Ennomos autumnaria

Many of the thorns mimic dead leaves, and their patterns and colours often reflect this. This attractive moth appears during the autumn months. These species often produce a sheen on the wings as a result of using flash. I photographed this adult using a diffuser attached to the flash unit in order to minimise the risk.

Bronica SQAi, 110mm macro lens, fill-in flash, Fuji Velvia.

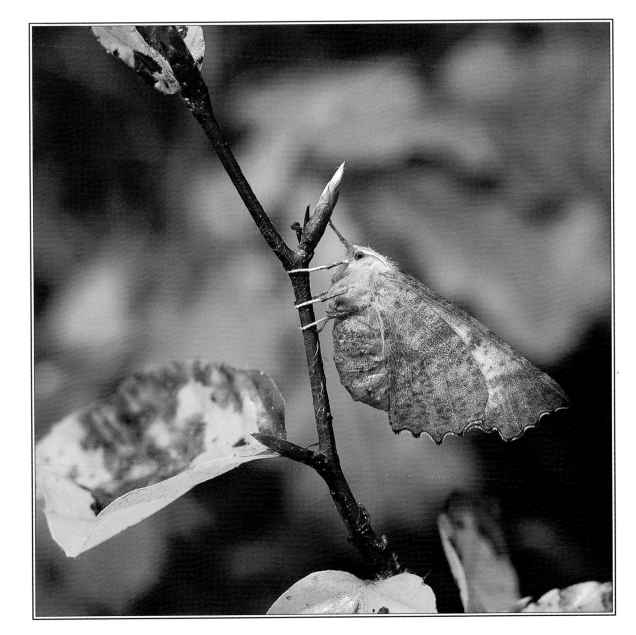

DARK SPECTACLE
Abrostola triplasia

*A small, pretty moth found in
a variety of different habitats,
including hedgerows and gardens.
I found the background here to be
a bit distracting, so I used manual
fill-in flash and kept it two stops
darker than the main subject.*

Mamiya 645, 80mm macro lens plus
extension tube, fill-in flash, Fuji Velvia.

MAPLE PROMINENT
Ptilodon cucullina

The survival of many moths depends largely on concealment. This prominent is incredibly cryptic when at rest among leaves. The focusing platform is invaluable in these situations, as I can position the tripod and make the finer focusing adjustments with the knob – eliminating the need to constantly move it backwards and forwards.

Bronica SQAi, 110mm macro lens,
Fuji Velvia.

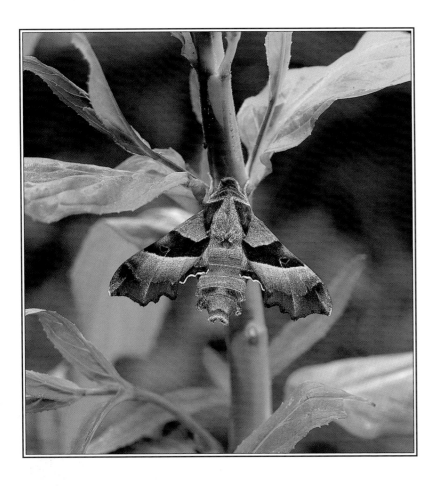

WILLOWHERB HAWK-MOTH
Proserpinus proserpina

A small attractive moth that occurs throughout many parts of Europe, usually along streams, riverbanks and woodland clearings, where its foodplant – willowherb – abounds. Like all species of hawk-moth it is not capable of instant flight and requires a warm-up period before it can evade a predator.

Bronica SQAi, 110mm macro lens,
Fuji Velvia.

EYED HAWK-MOTH
Smerinthus ocellata

One of the most striking of the British hawk-moths, with large eyespots on the hind wings which are normally concealed when the insect is at rest.

Bronica SQAi, 110mm macro lens,
fill-in flash, Fuji Velvia.

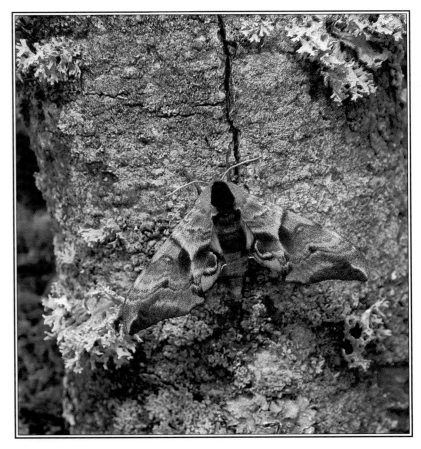

FEATHERED THORN
Colotois pennaria

An autumnal species found commonly in a wide variety of habitats. I used natural light for this photograph, as the scales on this species can often react with the flash, producing an unattractive sheen to the wings.

Bronica SQAi, 110mm macro lens, Fuji Velvia.

MERVEILLE DU JOUR
Dichonia aprilina

An attractive species found at the beginning of autumn. When at rest on lichen-covered tree trunks, it blends incredibly well with its background. I took several shots in natural light, but these proved to be disappointing because the surrounding foliage gave an overall greenish tinge to the images. As a precaution I used fill-in flash, which I found improved the photograph significantly.

Bronica SQAi, 110mm macro lens, fill-in flash, Fuji Velvia.

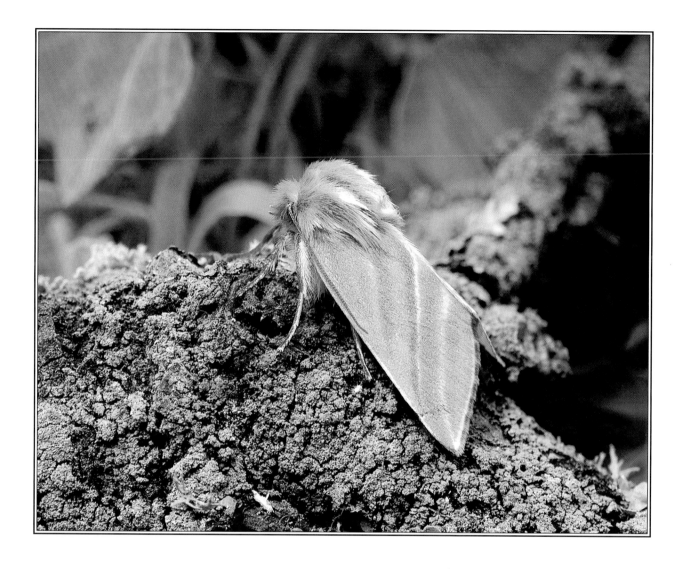

GREEN SILVER-LINES
Pseudoips britannica

*This pretty woodland species flies
mainly during early summer.
I had placed an actinic lamp in an
old oak wood the previous night.
When I arrived early the following
morning this moth, along with
several others, had settled close to
the unit. I photographed it exactly
as I found it, using fill-in flash,
as there was heavy shading from
the surrounding leaf foliage.*

Bronica SQAi, 110mm macro lens,
Fuji Velvia.

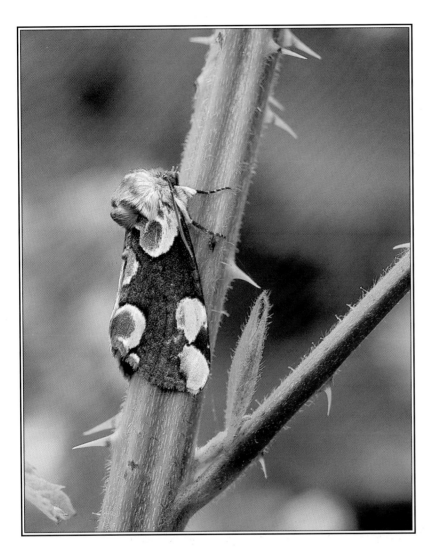

PEACH BLOSSOM
Thyatira batis

A common woodland moth found from late spring onwards. This adult was resting among bramble (its foodplant) a short distance from an actinic light unit. I used a couple of crocodile clips that I carry for holding back branches to get a clear view. I was careful not to disturb the moth, and used the converter to gain the extra working distance to keep the tripod back from the clutter of bramble.

Bronica SQAi, 110mm macro lens plus
1.4x converter, Fuji Velvia.

RED SWORD-GRASS
Xylena vetusta

A curiously shaped moth that appears in the autumn and hibernates as an adult during the winter months, reappearing again in early spring. Its shape aids its concealment among the leaves and other ground vegetation.

Bronica SQAi, 110mm macro lens,
Fuji Velvia.

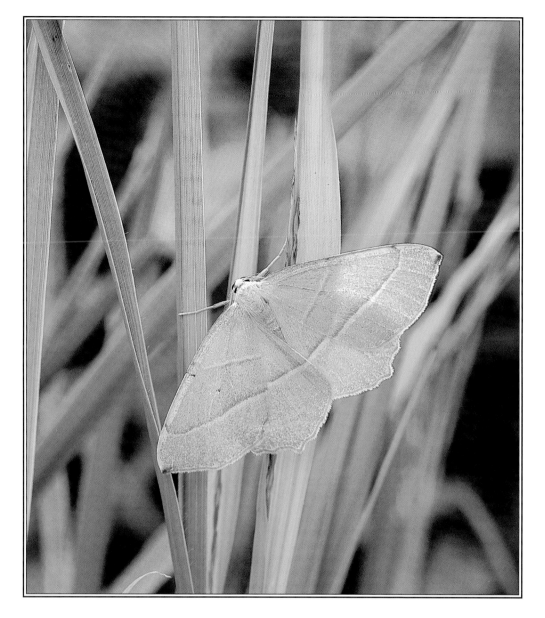

LIGHT EMERALD
Campaea margaritata

A large, pale green moth found generally in woodland habitats. When I found this adult early in the morning the sun was just beginning to catch the corner of the right forewing, so I had to work fairly quickly. Within 15 minutes of my taking this photograph the moth had gone.

Bronica SQAi, 110mm macro lens, Fuji Velvia.

CHAPTER SIXTEEN
Caterpillars

THE previous two chapters have been devoted to the adult stages of butterflies and moths. Caterpillars, or larvae as they are now often called, represent the most important stage in the lifecycle of these insects. They are fascinating subjects in their own right, with extremely varied lifestyles that provide endless opportunities for study and photography. Caterpillars are essentially eating machines, spending virtually all of their life consuming large amounts of food. Their structure is a simple one, comprising head and the 13 segments which make up the thorax and abdomen. They undergo a series of moults to permit growth and development. The stage between each moult is commonly referred to as an instar: there are usually between four and six, depending on the species. Their colouration often changes dramatically throughout each stage in their development. While the vast majority of butterflies and a reasonable number of moths are commonly encountered as adults, they are seldom seen as caterpillars – with the exception of a few species which may be found wandering across footpaths and roads in search of a pupation site.

The larval period is by far the most critical and vulnerable stage in the lifecycle of both butterflies and moths. Their survival as winged insects largely depends upon their ability to evade capture and successfully reach maturity. During this stage of development, they have more enemies than at any other time in their lifecycle. Without the capability to escape predation, they rely to a large extent on camouflage and various other strategies evolved over many thousands of years. The predator list is large, ranging from birds to mammals, spiders, wasps and parasitic insects such as ichneumons, which hunt them down to lay their eggs inside the young developing larva. Some larvae feign death to avoid being eaten, and then make a run for it, while others drop on a lifeline from the foodplant into vegetation and then crawl back when the danger has passed. Certain species hide during the day among ground vegetation, coming out only at night to feed. No matter what the individual strategies are, it is true to say that the vast majority of caterpillars rely completely on camouflage, which is the most effective and universally adopted method of avoiding detection.

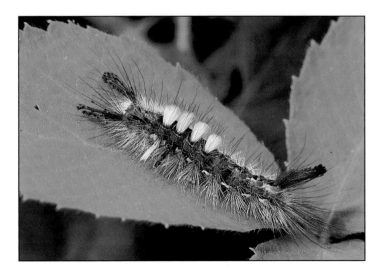

VAPOURER
Orgyia antiqua

A striking caterpillar that rests openly on the leaves of its many foodplants. The male moth flies during the day in late summer, and the wingless female remains on its cocoon. I found this almost fullygrown larva resting on bramble along a woodland track. I was careful not to touch the leaves close to the larva in case this prompted a swift departure.

Bronica SQAi, 110mm macro lens, fill-in flash, Fuji Velvia.

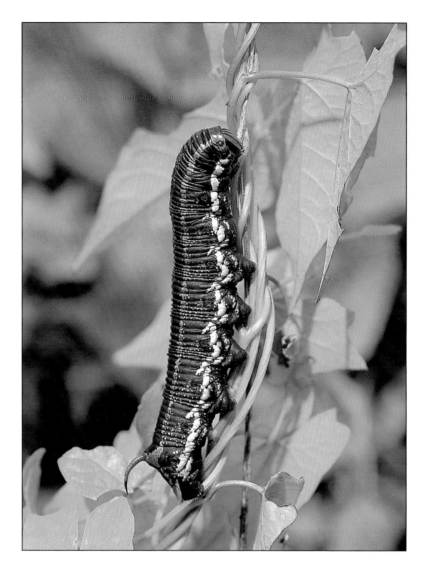

CONVOLVULUS HAWK-MOTH
Agrius convolvuli

A large, impressive caterpillar found throughout Europe and the Mediterranean. It takes its name from its foodplant – convolvulus, or bindweed as its commonly known. All of the hawk-moths have the characteristic horn-like projection at the end of the abdomen which makes them easier to identify.

Mamiya 645, 80mm macro lens plus extension tube, Fuji Velvia.

Caterpillars come in many shapes and sizes. The most impressive are the large hawk-moths. These are easily identified by the characteristic horn-like projection at the end of their body which distinguishes them from all other families. Their size and variety of colours make them a popular choice with photographers. Many of the smaller moths, such as the geometrids, bear a remarkable resemblance to small twigs in the larval stage: they remain motionless during the day and feed only at night. Others are extremely hairy, and possess large tussocks which make them difficult for birds and other predators to swallow. They feed and rest openly during the day, in some cases protected by their dense hairs and spines which are often an irritant and even, in some cases, poisonous. Some caterpillars produce toxic chemicals which persist into the adult form, their warning colouration reminding their enemies that they are equally distasteful at each stage of their development.

Where to find caterpillars

Caterpillars can be more elusive than their adult stage as a moth or butterfly. Some are found by chance, but remain concealed and are seldom noticed. With a little knowledge and practice it is possible to locate some species by carefully searching the appropriate foodplants. A small percentage over-winter (or hibernate) at an early stage in their development and resume feeding again the following spring. The vast majority, however, are to be found from late spring until the beginning of autumn, when many enter the pupal stage to over-winter until the following year.

EATEN SALLOW LEAVES
This shot shows the leaves of a sallow tree partially eaten by a large caterpillar, probably a hawk-moth. Many species provide clues as to their presence. Some larvae eat from both sides of the leaf, while others take only a small amount and then move to another.

There are many different techniques used for finding caterpillars. Some require specialist knowledge and are beyond the scope of this book, but many of the common species can be found by employing the methods suggested here. Searching the leaves of trees and shrubs is one of the most popular ways to obtain subjects for photography: oak, birch and sallow or willow are particularly favoured by caterpillars. Some species are confined to a single foodplant, while others are more cosmopolitan in their taste and will feed on a variety of different trees and shrubs. There are many tell-tale signs which indicate larval presence and activity, such as freshly eaten leaves or frass (caterpillar droppings). Understanding the life history of the species you are seeking greatly increases your chances. Young, isolated trees in sheltered areas or at the edge of a clearing are often the most productive for finding caterpillars. Examining the leaves and branches carefully for resting larvae will sometimes prove rewarding, especially towards the end of the summer when there are generally more species about. Many that hide during the day can be found with a torch at night, when they crawl up from the vegetation to feed.

One of the most poplar methods favoured by entomologists is commonly known as beating. This involves placing a white sheet or a manufactured canvas beating tray (even an inverted white umbrella will do) below the foliage and branches of trees and shrubs. Rapping the branch sharply with a strong stick will dislodge any caterpillars that are clinging to the foliage or the thin branches. Wait a few moments before examining the contents, as the larvae often lie motionless for a short time before moving. This is the most popular method for acquiring species to rear. Another popular method is to acquire a female adult moth and encourage it to lay eggs (as many will do readily in captivity) and then rear the offspring. Avoid beating on damp rainy days, as the tray becomes waterlogged. During windy conditions the caterpillars are more retentive and therefore difficult to dislodge. I should also mention that continually striking the stick at the same branch will serve no useful purpose other than to damage the foliage and the tree, as well as injuring the caterpillars. One sharp tap will usually be sufficient.

Rearing caterpillars for photography

Rearing caterpillars is always an interesting experience, especially if you plan to illustrate the development photographically from start to finish. This part of the life-cycle is poorly covered for the majority of species. You will need to keep them in a suitable container along with a daily supply of fresh foodplant. The most suitable containers are clear plastic tubs with a small piece of tissue paper at the base to prevent condensation forming on the inside. Avoid at all costs leaving the container in sunlight, as the internal temperature will rise dramatically – within a short time killing all the occupants. Start by keeping one, or at most two, species until you gain experience. The containers need to be cleaned out every day, and the stale food removed, in order to prevent disease or other viral infections. It takes a bit of time each night to attend to their needs and to get fresh food from the surrounding area. It's always wise to keep different species apart, as many show cannibalistic tendencies if overcrowded and deprived of food. When you've taken your pictures you can either continue to keep the larvae through to pupation or take them back to where you found them.

PALE TUSSOCK
Calliteara pudibunda

A typical plastic container for keeping young larvae. Don't put too much of the foodplant in the container initially, especially when the larvae are small, as they can be much harder to find.

SALLOW KITTEN
Furcula furcula

YELLOW-TAIL
Euproctis similis

While examining the branches and trunk of an old sallow I came across this larva constructing its cocoon. It spins a silken web, completely encasing itself, and it passes the winter months here. On completion the cocoon blends with the bark, making it virtually impossible to detect.

I don't often get away with shooting subjects above life-size without using flash, but on this occasion the conditions were perfect: no wind, the tiny larva resting on the leaf of a sallow tree. I hand-held the camera and explored different compositions before I mounted the camera on the tripod.

Mamiya 645, 80mm macro lens plus extension tube, flash, Fuji Velvia.

Bronica SQAi, 110mm macro lens plus 1.4x converter, Fuji Velvia.

When the caterpillar is fully grown and ready to pupate it must be provided with suitable conditions appropriate to its requirements. Butterflies need stems and foliage in order to suspend their pupae, while moths that pupate below ground require a bed of soft peat to burrow into. When caterpillars are ready to pupate they often shrink and change colour: at this point they are often mistaken by many as having a disease. When this happens, don't disturb them for at least three weeks, until the transformation is complete. If you want to know more about rearing caterpillars in captivity see the reference section at the end of the chapter.

It is also important to point out that species protected by legislation should not be taken for photographic purposes unless permission or a licence is obtained from the relevant authority. You should always, where possible, photograph subjects in their proper environment. If disturbed, they start to wander down to the base of the food plant, which can be extremely frustrating, and once on the move they rarely settle again for some time – making photography difficult at times. I don't recommend removing them unless you plan on looking after them properly while photographing all the different stages in their development.

Photographic tips

Caterpillars are excellent subjects for photography. Their diversity in colour, shape and size creates endless possibilities. When searching for species, examine fairly small trees around six or seven feet high: it is easier to photograph subjects on these. Caterpillars invariably rest in awkward positions, making it difficult to position the tripod and camera. I usually carry a few large crocodile clips in my bag so that I can clip thin branches back from the field of view. If they are too thick for this, I use fine green string and tie them back without touching the branch that the larva is resting on. It is important to keep the film back parallel to the body of the caterpillar, as this will help maximize the depth of field for the selected aperture. It is sometimes difficult to maintain sharpness throughout the entire body because of the resting position adopted by some of the larvae. In these situations you should focus on the head and

SMALL EGGAR
Eriogaster lanestris

The caterpillars of this species are gregarious, living together in a large silken web until almost fully grown. This larva may be about to undergo a moult and has spun a small web just above the top of the main communal web to help protect it. The adult moths emerge very early in the year. I tied back a couple of blackthorn branches to get a clear shot. Always check your depth of field for any small pieces of vegetation that may be out of focus when viewing but will appear on the final image.

Bronica SQAi, 110mm macro lens, fill-in flash, Fuji Velvia.

upper abdomen at the expense of the rest of the body appearing slightly soft.

Using natural light

Photographing in natural light is practical only if the caterpillar is totally at rest or in between a feeding phase. Many of the problems already discussed in previous chapters are also relevant to these insects, among them wind movement and the difficulty of working a tripod into a stable position. Since the insect isn't going to depart swiftly, it is always advisable to remove the camera from the tripod and try different positions to establish the most appropriate composition. Only when you have decided on your angle should you position your tripod. Adopting this approach means that you're less likely to hit the branch your subject is resting on. I like to use a macro for larval work, simply for convenience: it allows me to alter the magnification without

having to make fine adjustments to the tripod position or add and remove extension tubes. The weather has less of an effect when photographing caterpillars. Some species like to bask on the upper surface of the leaves in sunshine, while others lie along the mid-rib of the underside of a leaf. If you are photographing in sunlight it is a good idea to use either fill-in flash or a reflector to reduce the harshness of shadows, which are often more apparent due to the abundance of leaves on the surrounding branches.

Flash

Using TTL flash with caterpillars does in most situations work well and can be useful for a number of reasons. First, the surrounding foliage on the other branches is usually close enough to allow some light from the flash to expose it. In full sunlight flash also reduces the contrast produced by the directional light on the leaf foliage, giving a more

THE LACKEY
Malacosoma neustria

While photographing orchids in the French Alps, I found several of these larvae in a pretty alpine meadow. There was a persistent wind making it impossible to use either fill-in flash or natural light. I mounted the camera and flash bracket on the tripod. I chose the caterpillar which had background vegetation closest to it, and used full flash. Sometimes this is the only option.

Mamiya 645, 80mm macro lens plus extension tube, flash, Fuji Velvia.

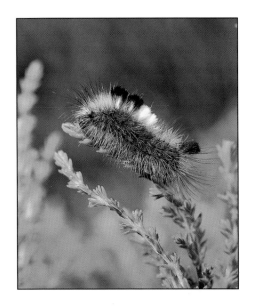

DARK TUSSOCK
Dicallomera fascelina

I found this larva in clear view, resting on the tip of a heather stem during the day. I was careful not to touch the heather branches with the tripod legs. There was a slight wind, so I took several shots in the calmer periods, using fill-in flash.

Bronica SQAi, 110mm macro lens, fill-in flash, Fuji Velvia.

balanced exposure. Many caterpillars require magnifications in excess of half life-size, so you will need to be careful using fill-in flash on overcast days, especially if there is a slight wind: leaf foliage often vibrates in the slightest breeze. If you are using slow film combined with fill-in flash your exposure times are going to be to slow to render the head and mouthparts perfectly sharp when the caterpillar is eating.

Interesting aspects of their lifecycle to photograph

- Photographing the various larval instars is worthwhile, as there is often a considerable difference between young and fully mature caterpillars.

- Moulting is an important stage in the caterpillar lifecycle and fascinating to record.

- Pupation is the most important part of the caterpillar stage. Larvae often construct cocoons and attach themselves to branches, or construct a pupation site under the soil. This is well worth the effort to photograph. Many of these stages have seldom been photographed in their entirety.

Tips & suggestions

- Search small isolated trees, which tend to be the most productive.

- From the middle of summer until the beginning of autumn is the best period. Larval hunting requires patience and dedication, sometimes with little reward for your efforts.

- Try not to disturb the caterpillars as they may start to wander, often to the bottom of the foodplant. This can make photography difficult and time-consuming.

- Search the underside of leaves that have been partially eaten and haven't gone brown at the edges: it's always worth a look.

- When you find a caterpillar, look carefully at the rest of the foodplant – there will usually be others.

- Work from a tripod and use a cable release.

- Purchase a comprehensive guide to caterpillars and their foodplants. This will prove invaluable by providing information and illustrations of many commonly encountered species as well as giving an indication of when the larvae are likely to be found.

Useful contacts and societies
See chapter on butterflies (p.115).

Reference books
Porter, J. **The Colour Identification Guide to Caterpillars of the British Isles** (Viking)

Carter, D., Hargreaves B. **Field Guide to the Caterpillars of Britain and Europe** (Collins)

Bartlett Wright, A., Peterson, R.T. **Peterson First Guide to Caterpillars of North America** (Houghton Mifflin Co USA)

PUSS MOTH
Cerura vinula

This is one of the most impressive caterpillars, frequently illustrated in books and other publications. This first instar larva is only 5–6mm long. By the time it reaches its third instar it begins to assume the colour and shape of the mature caterpillar. When fully grown it becomes quite large and fat, with distinctive eyespots. When threatened, it withdraws its head into the larger expanded segments of its abdomen, making it appear more ferocious. A pair of whip-like tails (flagellae) also appear from the last segment of the abdomen to help distract the predator.

Bronica SQAi, 110mm macro lens,
fill-in flash, Fuji Velvia.

1st instar larva.

3rd instar larva.

The typical threat posture of the adult caterpillar when alarmed.

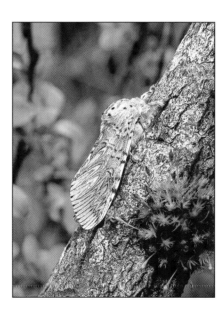

Adult puss moth

VAPOURER MOTH COCOON
Orgyia antiqua

This fully grown larva has spun a protective cocoon in which to complete the final stage of its transformation into an adult moth.

Bronica SQAi, 110mm macro lens,
fill-in flash, Fuji Velvia.

165

Portfolio
CATERPILLARS

CAROLINA SPHINX
Manduca sexta

Often referred to as the tobacco hornworm, this impressive caterpillar with its distinctive red horn occurs throughout parts of the central and southern United States. Many of the hawk-moths rest in this characteristic posture, which is commonly known as the sphinx position.

Bronica SQAi, 110mm macro lens, fill-in flash, Fuji Velvia.

LOBSTER MOTH
Stauropus fagi

This unusual caterpillar has long thoracic legs and an enlarged anal segment. It adopts this curious posture when at rest. Found in deciduous woodland, feeding mainly on beech and oak.

Mamiya 645, 80mm macro lens plus extension tube, flash, Fuji Velvia.

NORTHERN EGGAR
Lasiocampa quercus callunae

I found this partially grown larva while walking across a large cut-over bog. The species often rests openly on the ground or on vegetation. It had being trying to rain, and the droplets of water on the caterpillar attracted my attention. I would have preferred to photograph it using a longer focal-length lens to reduce the background coverage, but I didn't have another with me for this format.

Mamiya 645, 80mm macro lens plus
extension tube, Fuji Velvia.

BEDSTRAW HAWK-MOTH
Hylos gallii

*An attractive species that is
widespread throughout Europe
and North America.
Its principle foodplants are
bedstraws and willowherb. I took
several shots in natural light, but
they lacked the vibrancy of the
flash photographs, which made
the caterpillar stand out.*

Mamiya 645, 80mm macro lens plus
extension tube, fill-in flash, Fuji Velvia.

CLIFDEN NONPAREIL
Catocala fraxini

This large impressive caterpillar, cryptic when at rest, is found throughout Europe in mixed woodland. It feeds mainly on aspen and other species of poplars.

Bronica SQAi, 110mm macro lens, fill-in flash, Fuji Velvia.

FEATHERED THORN
Colotois pennaria

This caterpillar belongs to a family commonly referred to as 'loopers' because of the peculiar way they move by arching and straightening their bodies. Many are twig-like and incredibly cryptic when stretched out like an extension to the branch. I hand-held the camera first, as I frequently do with caterpillars, to decide on the best composition. When happy, I then mounted the camera on the tripod. I was careful not to touch or hit the branch.

Bronica SQAi, 110mm macro lens, fill-in flash, Fuji Velvia.

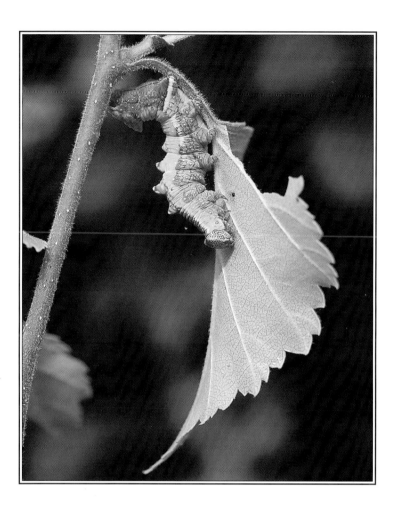

IRON PROMINENT
Notodonta dromedarius

This species often rests on the underside of the leaf where the stem joins the branch. You can see where it has partially eaten the birch leaf and then retreated to cover during its resting phase.

Bronica SQAi, 110mm macro lens, fill-in flash, Fuji Velvia.

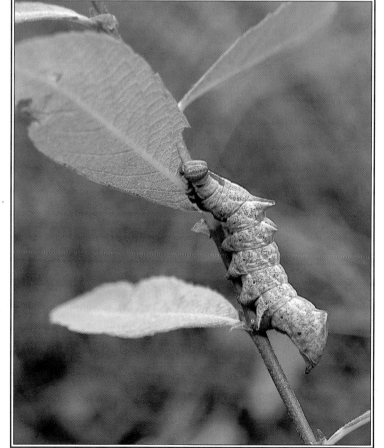

PEBBLE PROMINENT
Notodonta ziczac

This closely related species is more commonly encountered than the iron prominent. I often find them on the small lower branches of wiry sallows, usually in late summer.

Bronica SQAi, 110mm macro lens, Fuji Velvia.

EMPEROR MOTH
Saturnia pavonia

The caterpillar of the emperor moth is often found in late summer wandering across paths and tracks. When at rest on its foodplants (especially heather) it can be very difficult to see. I spent a few hours searching clumps of heather and meadowsweet at a local reserve which I know has adult emperors every year. I eventually found this almost fully grown caterpillar. Unfortunately there was a constant breeze, ruling out any chance of using natural light or fill-in flash. Since the background was fairly close, the light from the flash was sufficient to illuminate the surrounding vegetation.

Bronica SQAi, 110mm macro lens,
flash, Fuji Velvia.

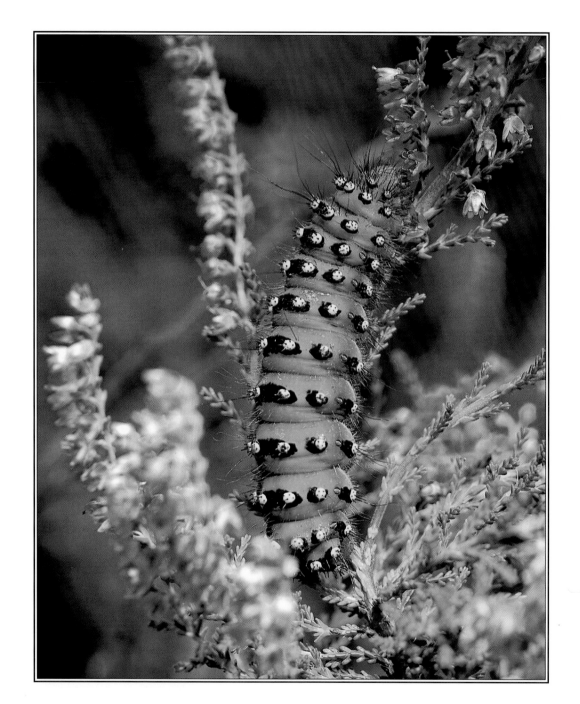

ELEPHANT HAWK-MOTH
Deilephila elpenor

An impressive caterpillar that takes its name from the trunk-like shape of its body. It normally feeds at night, but it is sometimes seen during the day resting on its foodplant, rose bay willowherb, or occasionally wandering about in search of a suitable pupation site.

Mamiya 645, 80mm macro lens plus extension tube, fill-in flash, Fuji Velvia.

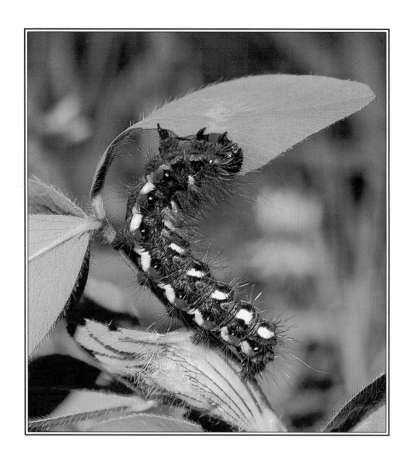

KNOT GRASS
Acronicta rumicis

A distinctive caterpillar that is often conspicuous when feeding low down among the ground vegetation. I used flash to freeze the movement. The background vegetation was sufficiently close, preventing it from being under-exposed.

Mamiya 645, 80mm macro lens plus extension tube, flash, Fuji Velvia.

EYED HAWK-MOTH
Smerinthus ocellata

This species also favours small sallow bushes, often at the edge of a bog or on marshy ground. Any small tree that has its leaves well stripped is worth investigating. I found this larger adult resting low down along the main branch of this young sallow. I held a couple of smaller branches back with crocodile clips before I framed the shot.

Bronica SQAi, 110mm macro lens, fill-in flash, Fuji Velvia.

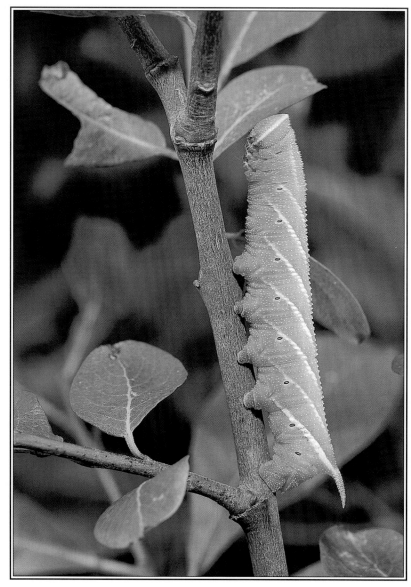

SPURGE HAWK-MOTH
Hyles euphorbiae

Found throughout central and southern Europe. A large striking caterpillar often found in the Mediterranean at the edges of fields and waste ground where various spurges grow.

Mamiya 645, 80mm macro lens plus extension tube, fill-in flash, Fuji Velvia.

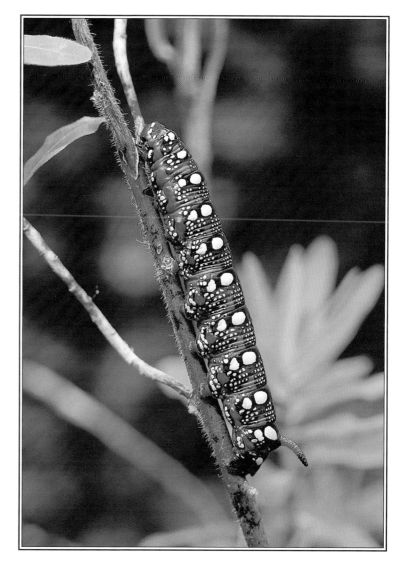

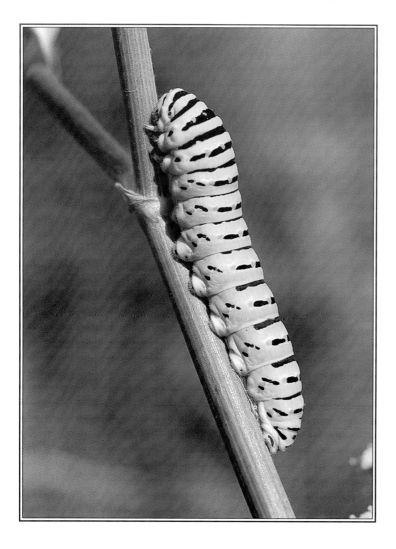

SOUTHERN SWALLOWTAIL
Papilio alexanor

This was one of the first caterpillars I photographed back in the late 1980s when I made a trip to Corfu to photograph orchids.

Mamiya 645, 80mm macro lens plus extension tube, fill-in flash, Fuji RFP.

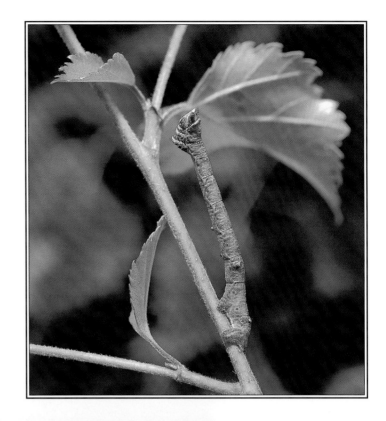

PEPPERED MOTH
Biston betularia

This species is widespread and
frequently found as a larva.
It feeds on a wide variety of trees,
including birch, sallow and oak.
In common with many other
geometrids, their structure
is twig-like.

Bronica SQAi, 110mm macro lens,
fill-in flash, Fuji Velvia.

SEPTEMBER THORN
Ennomos erosaria

This geometrid, like many other
species when at rest, resembles
a small twig. I found this
fullygrown larva outstretched
on the tip of a branch, and
used a clip to hold back a
small branch that was
encroaching in the foreground.
You can see the insect's lifeline
attached to the leaf.

Bronica SQAi, 110mm macro lens,
fill-in flash, Fuji Velvia.

BIRCH MOCHA
Cyclophora albipunctata

You can see the tiny lifeline, consisting of a single strand of silk, which the larva attaches to the tip of the branch in case it should get knocked off or needs to make a quick exit. I photographed this small species at almost life-size. The built-in focusing platform was essential to make fine adjustments for this shot, which would otherwise have been difficult to achieve.

Bronica SQAi, 110mm macro lens, flash, Fuji Velvia.

NORTHERN EGGAR
Lasiocampa quercus callunae
(early instar)

Like many other species, this early instar larva looks totally different from the mature caterpillar at the beginning of the portfolio. They are often seen basking on grass stems and other low-growing vegetation in late summer before entering hibernation.

Mamiya 645, 80mm macro lens plus extension tube, fill-in flash, Fuji Velvia.

MOTTLED UMBER
Erannis defoliaria

This species is common in woodlands during late spring and early summer, and is usually easy to find. The adult moth emerges in the latter part of the autumn. Only the males fly: the females are wingless and sit on the tree trunks waiting for them.

Mamiya 645, 80mm macro lens plus extension tube, flash, Fuji Velvia.

DEATH'S-HEAD HAWK-MOTH
Acherontia atropos

A large striking moth native to Africa, with skull-like markings on the thorax. It migrates every year to Europe and frequently to Britain. The caterpillar is equally impressive and feeds on members of the solanace family, such as potato and woody nightshade.

Mamiya 645, 80mm macro lens plus extension tube, fill-in flash, Fuji Velvia.

CHAPTER SEVENTEEN

Other Insect Groups

IN the previous chapters I have discussed in greater detail the larger and the most popular insects that are frequently sought after by photographers. There are many more families and species that are equally attractive but which, due to their habits and size, are less well covered. Apart from the grasshoppers and crickets, the other insect groups tend to be small and require a slightly different approach.

Grasshoppers and crickets

These are essentially summer insects, mainly diurnal, with the majority of species inhabiting the warmer regions of southern Europe and the Mediterranean. They are often heard but seldom seen because of their cryptic colouring, which aids their concealment among the vegetation. The easiest way to find them is on warm sunny days when the males sing by rubbing different parts of their body together. This behaviour, commonly referred to as stridulation, produces a distinctive sound unique to each species: with patience you can learn to distinguish one from another. The easiest way to identify grasshoppers from crickets is by their antennae, which are short. Crickets have long sweeping antennae extending beyond the length of the body. Many are highly colourful and make excellent subjects for photography.

ROESEL'S BUSH CRICKET
Metrioptera roeselii

Crickets are easily distinguished from grasshoppers by their long antennae. It would have been impossible to manoeuvre a tripod through the vegetation with this active adult. Using the monopod and flash was the best approach in this case.

Mamiya 645, 80mm macro lens plus extension tube, flash, Fuji Velvia.

MEADOW GRASSHOPPER
Chorthippus parallclus

Grasshoppers and crickets are essentially sun-loving insects. On overcast days they are much more difficult to detect. Their song is the key to tracking them down when conditions are right.

Mamiya 645, 80mm macro lens plus extension tube, flash, Fuji Velvia.

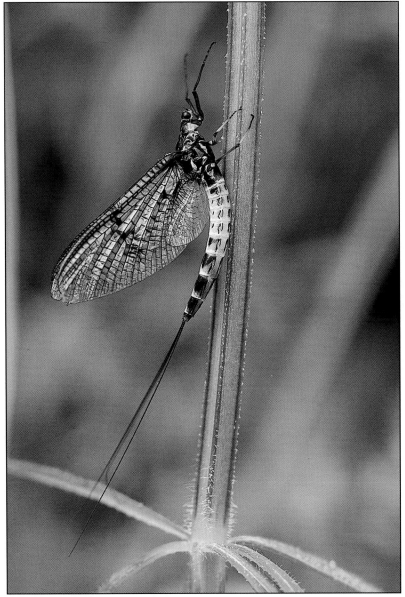

Mayflies

With a name like mayflies one would naturally assume that these insects occur only during May, but they are found throughout the spring and summer months in many types of aquatic habitat. Like dragonflies, their structure is a primitive one which has shown little change in millions of years. They are generally small, delicate insects by nature with long tails and large fragile wings which are always held vertically above their body when at rest. They spend most of their life as aquatic nymphs below the water, feeding mainly on organic debris. Prior to emergence the nymphs float to the surface, where the skin splits and the fully formed insect emerges. It quickly leaves the water and retires to nearby vegetation, where as an immature insect (commonly referred to by fishermen as a dun or sub imago), it rests before going through its final moult into a mature insect or imago. Like dragonflies they have an incomplete metamorphosis, in that they have no pupal stage. Their habits and distribution are less studied than for many other insects groups. Mayflies have always been closely associated with the angling world, since they feature importantly in the diet of many different types of freshwater fish. As a result of this association many have been given common names – among them the Green Drake and the Dark Olive. Several species are imitated by anglers in the form of artificial flies used to catch fish such as trout and salmon.

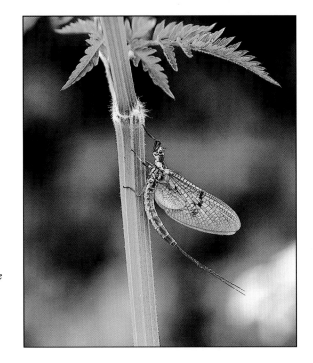

GREY DRAKE
Ephemera danica

A large, attractive insect often found in large numbers on lakes and rivers for a few weeks in late spring. The fully mature female imago (above) is commonly referred to as the Grey Drake after undergoing its final transformation. The colours are more vibrant and the wings become translucent.

Bronica SQAi, 110mm macro lens plus 1.4x converter, Fuji Velvia.

GREEN DRAKE
Ephemera danica

This is the name given by anglers to the immature dun when freshly emerged. I found this female by carefully searching the vegetation around the lake shore. It will rest here until it has undergone its final transformation into the mature insect.

Bronica SQAi, 110mm macro lens plus 1.4x converter, Fuji Velvia.

BEE BEETLE
Trichius fasciatus

An attractive insect found throughout central Europe and often seen visiting a variety of flowers. I photographed this adult in France using a single flash set-up. The bright sunlight acted as a fill-in, giving a pleasing balance to the picture.

Mamiya 645, 80mm macro lens plus extension tube, flash, Fuji Velvia.

ROVE BEETLE
Staphylinus erythropterus

Working with small beetles can be very time-consuming. The reflection from the flash off the elytra or wing cases can be a problem with some species. I frequently use a diffuser to help reduce the sheen.

Mamiya 645, 80mm macro lens plus extension tube, flash, Fuji Velvia.

Beetles

Beetles are the largest and the most diverse group of insects on the planet. There are some 370,000 species recorded, and many more probably await discovery. They occupy just about every type of habitat and feed on a wide variety of subjects, including plants, fungi, decaying organisms and other invertebrates. Many are extremely attractive and highly photogenic. Like butterflies and moths, beetles undergo a complete metamorphosis, having a larval and pupal stage prior to emergence as an adult. Most species have a hard exoskeleton, with a pair of wings hidden from view behind the hard tough elytra which form a protective cover over the delicate wing structure.

The vast majority of beetles can fly, but they choose to spend most of their time among ground vegetation and under rocks. When airborne they tend look awkward, and they rarely fly for long distances before crashing into the vegetation again. The chafers and longhorns are the best known and the most popular as photographic subjects. These brightly coloured insects are seen frequently in sunshine, visiting a great variety of flowers.

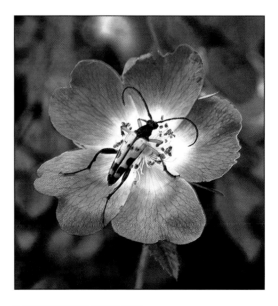

LONGHORN BEETLE
Rutpela maculata

A distinctive black and yellow beetle found throughout Europe. The larvae live inside the wood of deciduous trees. Adults are often seen from early summer visiting many different flowers.

Bronica SQAi, 80mm macro lens, flash, Fuji Velvia.

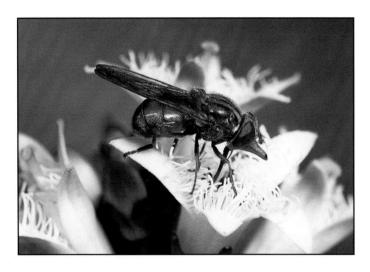

HOVERFLY
Rhingia campestris

A distinctive hoverfly with an unusually long rostrum which enables it to probe deep tubular flowers, it is commonly seen from spring through to autumn. This adult is probing the flower heads of bogbean.

Mamiya 645, 80mm macro lens plus extension tubes, flash, Fuji Velvia.

Hoverflies

A family of brightly coloured insects that fly during the daytime and are often seen from spring onward, hovering with great precision over flowers in a wide range of habitats. To aid protection from predation, many species resemble bees and wasps. They all feed on nectar and are often seen visiting umbellifers, especially during the summer months. One of the problems with this group in the past was the lack of a suitable guide to identify them. Their popularity among British photographers has grown in recent years since the publication of a guide for the native species, while other general insect field guides now cover many of the commonly encountered species. Hoverflies represent a challenge photographically, since the average size of most species requires magnifications around life-size and above. The only suitable and reliable method for photographing these wary insects is full flash. You need to be careful about the reflection of their clear wings, which can be a bit of a problem when photographed at certain angles.

Other bugs

The name 'bug' is often applied by non entomologists to all types of insects. True bugs belong to the order Hemiptera, which consists of many families, each showing remarkable

variation in shape, size and colour. All bugs possess a needle-like piercing mouthpart (rostrum), which they use to extract liquid juices from plants and another insects. The vast majority are herbivores, but there are some species (such as the assassin bugs) which are carnivorous. They are found in a great variety of habitats, and many are also considered as major agricultural crop pests. The common families such as shield bugs and leafhoppers have always attracted photographers, largely because of their different shapes and colours.

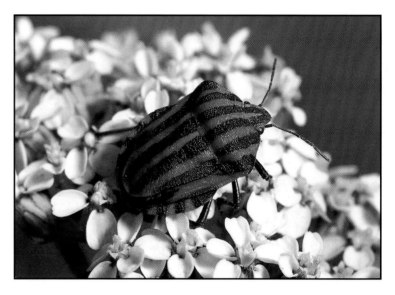

STRIPED BUG
Graphosoma italicum

One of the most attractive shield bugs found throughout central and southern Europe. These insects have a particular fondness for umbellifers, where they are often found abundantly.

Mamiya 645, 80mm macro lens plus extension tubes, flash, Fuji Velvia.

SLOE BUG
Dolycoris baccarum

A common and widespread species abundant on many different trees and ground vegetation, especially in the autumn. It enters hibernation and reappears again in early spring. These bugs rarely remain still for any length of time. I took several shots but kept only this one.

Bronica SQAi, 110mm macro lens plus 1.4x converter, flash, Fuji Velvia.

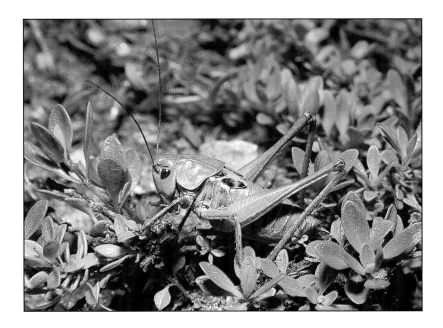

WART BITER
Decticus verrucivorus

This immature adult (nymph) blended incredibly well among the ground vegetation on a steeply sloped hillside in Switzerland. I hand-held the camera with the flash bracket, as the terrain was too difficult even to consider using a tripod.

Mamiya 645, 80mm macro lens plus extension tube, flash, Fuji Velvia.

Photographic tips

Many of the principles discussed in other chapters are relevant to these insect groups, but it is worth discussing very briefly some useful ideas and tips which might prove beneficial in the field. Most bugs, because of their size, require higher magnifications and are therefore best photographed using a full TTL flash set-up. Refer to the chapter on using a converter with macro lenses to attain higher magnifications.

A large percentage of photographs of grasshoppers and crickets are taken in bright sunny conditions, because they are easier for the photographer to locate by their song. The majority of species generally rest among the ground vegetation, which frequently obscures part of the insect and makes it difficult to get a clear shot. I prefer to use a macro for this group, purely for convenience and speed: they are quite variable in size. One solution is to encourage the insect to jump from cluttered vegetation into a more open area where it will be easier to position the tripod. Using fill-in

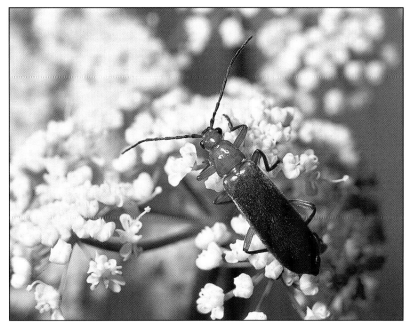

COMMON SOLDIER BEETLE
Rhagonycha fulva

One of the most common soldier beetles, frequently seen in large numbers during the summer months on the flowers of many kinds of umbelliferous plants and thistles.

Mamiya 645, 80mm macro lens plus extension tube, flash, Fuji Velvia.

flash is one way to help reduce the shadows in the grassy vegetation: if you find the tripod difficult to work you can try using the monopod to help support the camera. You can also use full TTL flash without the fear of having too dark a background, as many species will either be on the ground or close to it in the surrounding vegetation. Some people use their elbows as additional support for the camera when working flat at ground level. Finding these insects when the weather is overcast can be difficult, as they are generally easier to see and hear when the sun shines. When you approach a subject you are generally guided in the right direction by its song. A slow, straight approach is usually the best method. Most species stop singing just when you are within range, but if you wait for a short period they usually start again. Be conscious of your shadow and where it falls in relation to the subject.

Mayflies are more tolerant of the photographer and will generally stay put unless the surrounding vegetation is

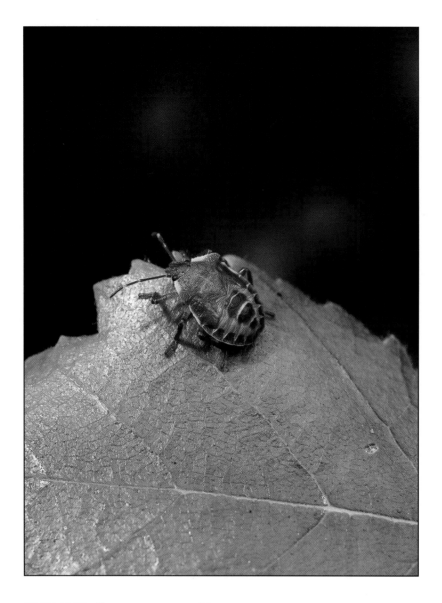

SLOE BUG (immature nymph)
Dolycoris baccarum

The nymphs of this species, which reach maturity in late summer, are extremely variable in colour. I wanted to convey the size of this tiny nymph in relation to the birch leaf it was resting on. I deliberately used the flash to keep the background darker so that it would not compete with the subject.

Bronica SQAi, 110mm macro lens, flash, Fuji Velvia.

disturbed. After emergence they leave the water immediately and seek shelter among the foliage of trees and grasses. It is worth exploring the bankside vegetation, especially looking under the stems and foliage where adults frequently rest. The majority of species are small and require

higher magnifications and are therefore best photographed with full TTL flash. Using a focusing rail is extremely beneficial when working with small subjects in the field. It is also worth diffusing the light source from the flash unit, as the large clear wings of these insects often produce hot spots that detract from the overall quality of the image. The hard, shiny wing cases on many beetles are also highly reflective, and it can be difficult to avoid the sheen produced from the flash unit. Using a diffuser will help in some situations.

Tips & suggestions

- Search the branches of trees carefully: many insects, especially shield bugs, are to be found resting among the foliage.

- The summer months are generally the most productive for small insects.

- Examine the flower heads of umbellifers. They are always good a good bet for many small beetles and other insects.

- Fom late spring onwards it is always worth looking for resting mayflies among the grassy tussocks at the edges of rivers and lakes. They are not always immediately visible, preferring to rest low down on the stems of grasses and umbellifers and on the underside of leaves that are well hidden from view.

- It is essential to have a good field guide to aid identification of the many different types of bugs.

Interesting aspects of their lifecycles to photograph

- The aquatic stages of mayflies are an interesting challenge to photograph. The tiny nymphs live among the stones and weed at the edges of fast-flowing water. They are easily collected with a sturdy pond net by dislodging the stones with your foot and placing the net in the current. The contents can be examined and the rest returned.

- The younger stages of shield bugs are commonly referred to as nymphs. They are often of different colours and are therefore well worth photographing at the separate stages of their lifecycle.

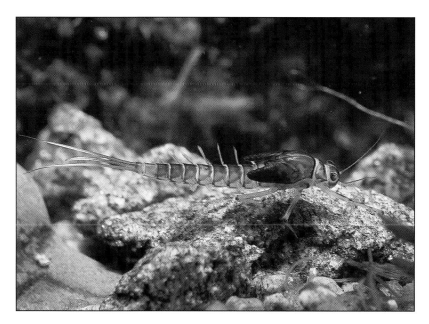

LARGE DARK OLIVE NYMPH
Baetis rhodani

This small mayfly was photographed in a small tank constructed with extremely fine glass. This shot was taken at 2½ times life-size. The execution of your technique has to be absolutely precise when you operate at these magnifications.

Mamiya 645, 80mm macro lens reversed plus extension tubes, flash, Fuji Velvia.

Useful contacts & societies

Below is a list of societies related to some of the insect groups discussed in this chapter. They should be able to provide information on regional societies and member groups in your own country.

Royal Entomological Society
41 Queen's Gate, London SW7 5HR
Email: reg@royensoc.demon.co.uk
Website: www.royensoc.demon.co.uk

It can advise you on many issues relating to insect groups and societies in your region.

Entomological Society of America
Annapolis Road Lanham, Maryland 20706-3115
E-mail: esa@entsoc.org
Website: http://www.entsoc.org/index.html

New York Entomological Society
c/o Lou Sorkin, Treasurer, Department of Entomology, American Museum of Natural History, Central Park West at 79th Street, New York, New York 10024-5192
E-mail: sorkin@amnh.org

Beetles
The Coleopterists Society, c/o Terry Seeno, Treasurer, 3294 Meadowview Road, Sacramento, California 95832-1448
E-mail: tseeno@ns.net
Website: http://www.coleopsoc.org/index.html

Grasshoppers & Crickets
The Orthopterists' Society, c/o J.A. Lockwood, Plant, Soil and Insect Sciences Department, University of Wyoming, Laramie, Wyoming 82071
E-mail: lockwood@uwyo.edu
Website: http://viceroy.eeb.uconn.edu/OS_Homepage

Reference books

Stubbs, A., Falk S. **British Hoverflies** (British Entomological & Natural History Society)

Gilbert, F.S. **Hoverflies** (Cambridge University Press)

Brown, V.K. **Grasshoppers** (Cambridge University Press)

Harker, J. **Mayflies** (Richmond Publishing Company)

Chinery, M. **Collins Guide to the Insects of Britain & Western Europe** (Collins)

Chinery, M. **A Field Guide to the Insects of Britain & Northern Europe** (Collins)

Bellmann, H. **A Field Guide to Grasshoppers & Crickets of Britain and Northern Europe** (Collins)

Harde, K.W **A Field Guide in Colour to Beetles** (Octopus Books Ltd) (Covers Britain and Europe)

Borror, A.J & White, R.E. (Peterson Field Guide Series) **A field Guide to the Insects of America North of Mexico** (Houghton Mifflin Co, USA)

Managing Your Photographic Collection

As photographers we all want to spend our time in the field taking pictures, because that's what we enjoy the most. Being confined indoors sorting and labelling slides is certainly not the most enjoyable part of the photographic process. It is however an important part of the business and should not be neglected or put off. Photographs which are not identified or captioned have little real value other than for your own personal memories. A great deal of time and effort has gone into getting those valuable images, so don't treat them in a careless, disorganized way. If you plan on accumulating a collection with the intention of selling your work you will need to give some serious thought as to how you organize and catalogue it.

Most professional photographers will probably admit that they have changed their filing systems at least once before settling on a suitable method that will accommodate large future additions without the periodic need to reorganize. There is nothing more soul destroying than to have to reorganize your collection and renumber thousands of transparencies: I can speak with experience, having been there. It's a simple enough task if you're dealing with five or six hundred pictures, but it becomes a real burden dealing with several thousand. I would strongly advise you to deal with your material as soon as it is returned to you and while the information is still fresh in your mind – don't allow your processed films to accumulate, because the bigger the backlog, the less inclined you are to do it and the greater the likelihood that you will want to cut corners.

Examine your films carefully after processing. Be ruthless: keep only the best and bin the rest. Evaluate them and see if there is anything you can learn or correct in your technique. Use a high quality loupe. If you have them returned unmounted, remove the strips from the cellophane before you check them.

Editing your returned films

The first important step in managing your collection starts with the processing of your films. When you've gone to a lot of trouble to capture that ultimate image, the last thing you want to see is a scratch or a nail mark on its return from processing. It is important to find a good reliable E6 laboratory. Give them your custom and loyalty, and they are more likely to 'pull out the stops' for you when you need a quick favour. I suggest that you use one of the Kodak Q labs: they may charge a bit more, but it's worth the difference to have peace of mind and the continuity in the processing.

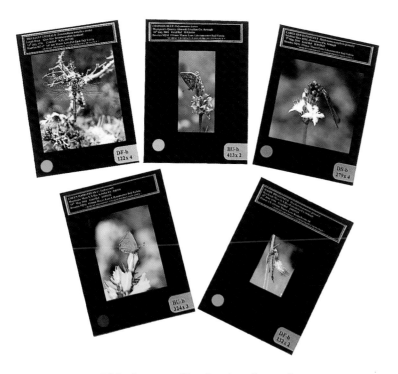

This is a small selection from the DW Viewpacks range of black card masks. The big advantage for photographers using different formats is the ability to store multi-format images in one hanging spine.

Management systems for transparencies

It's a good idea to decide from the start on the particular type of image management system you want to use. Decisions need to be made regarding the way you plan on storing your material, either in filing cabinets or custom-designed storage units. There are plenty of systems on the market, catering for most formats. You will also have to give some thought to the type of mounts you're going to use to store your slides. I have tried different systems and particularly like the black presentation masks from DW Viewpacks Ltd (see useful addresses). They have a very good range of mounts, masks and presentation pockets – clear acetate sleeves that slip over your mask, protecting the transparency from finger marks. The advantage of this system is that you can store multiple slides of different formats up to 6x7 cm in the same hanging spine. This is extremely useful for photographers who run different camera systems. The mask also gives quick access to the image without having to rip the mount apart each time it is sent for publishing. All formats are catered for up to 5x4. All of the clear pockets and suspension files are manufactured in archival polypropylene.

On return of your films you should spread them out on a high quality light box and, with a loupe, examine each slide critically. Be ruthless and keep only the best. For sentimental reasons we all want to hold on to some images that don't quite measure up, but bear in mind that they accumulate quickly over a period of time. Besides, most photographers don't show rejects or use them in lectures. They actually cost you money in terms of occupying pockets in your sleeves as well as taking up space in your filing cabinets. This doesn't present a problem initially, when you're building your collection, but if you keep enough of them they do become a problem further down the road. As a medium format user I am perhaps more aware of this, since most file sleeves have provision for twelve slides only and space is always at a premium. 120-roll film is not normally returned mounted from the lab as in 35mm. The other issue is one of cost: 6x6 plastic mounts are considerably more expensive than 35mm and are usually sold in boxes of twenty, so why mount and waste them on images that you'll probably never use?

I like the range of plastic mounts manufactured by Gepe. This is what I currently use for images that are used for projection purposes. I did try the Hamma range of mounts that hold your film in place by two sharp pins that perforate the film. I found that this created a weakness in the emulsion, and a couple of slides were torn at this spot after being scanned for publication. This mount probably works well if you do not need to remove the film from the mount. However, frequent removal means that you never get the slide lined up in exactly the same place, and the holes then increase in size, weakening the emulsion.

This is how I normally caption my plastic slides. I can have four lines of text, which I split into two. The main information (such as name, date, location and grid reference) appears on the top of the slide. The basic photographic information and copyright appear on the bottom.

Writing captions for your photographs

Whether you take slides or prints, it is important to have all the relevant information on your photograph. A slide without data it is merely a visual reminder of a subject seen: it is of no use to anyone other than you. When you add the details to an image it becomes a valuable photographic record, providing information regarding the distribution of a species as well as confirmation of its existence in a particular location. This may not seem to be of any great significance now, but as your collection expands over many years (and as the habitats and distributions of species change), your collection can become a valuable source of reference in the future. This approach is much more favoured today than the widespread Victorian practice of collecting, killing and storing masses of insects.

The first thing you should do, of course, is to identify what you have photographed. This is extremely important and will require time learning about the different insect groups and about the diagnostic structures which help you to differentiate one family or species from another. I have recommended some field guides that cover the identification of a large percentage of commonly encountered species in Britain, Europe and America (see reference books at the end of each chapter, Part Two).

A typical caption on my slide would contain the following information:

- **Common name,** where appropriate, followed by the **scientific name**. Remember, common or vernacular names vary throughout different regions and countries, but the scientific name is universal in any part of the world.

- **Location.** I always write the location in full, including the nearest town and county.

- **Date.** This is useful if you need to return to the area another year and want to know when the insect was on the wing.

- **Grid reference.** It's useful to know exactly where you found the subject. This may seem over the top, but if you're working a large area or photographing abroad its important to know exactly where you photographed it. We all think that we can remember areas, but as time progresses places change and memories get clouded.

- **Photo/info.** This usually comprises camera, lens and film, etc.

- **Name and copyright symbol.** An important feature, which should be clearly visible on each slide. This makes people aware that the image can't be used without seeking your permission prior to any reproduction.

This seems like a lot of information to put on a slide, but I can assure you that it is extremely useful. I have proved this time and time again when I've wanted to go back to an area to re-shoot some species and can see from my captions when particular insects were flying. It doesn't require as much time to type as you might think. I work with a template and change only the sections that need altering.

Label programs

The days of hand-writing captions on slides are coming to an end. Most photographers with reasonable-size libraries use a computer of some sort to perform this repetitive task. Besides, it looks much more professional and business-like than a hand-written scrawl that people often have difficulty reading. There are many custom-made labelling packages available for 35mm that will run on the vast majority of PCs. One system, excellent for labelling large numbers of 35mm transparencies, is the smart-label printer made by Seiko Instruments. A small thermal printer which uses a roll of single labels, it has a variety of different label sizes for other

THE SMART PRINTER FROM SEIKO INSTRUMENTS LTD

This in my opinion is the most efficient way of labelling vast amounts of slides quickly. There is no waste, because the label is on a single roll. This small thermal printer produces the label in three seconds and automatically shrinks your text when necessary to fit onto the label format. The 35mm labels come in rolls of 300. It also has many other label sizes.

I have a template, which I designed in Microsoft Word, for producing labels for the black masks that I currently use for storing my images. I have printed white text on black background because I find it less obtrusive. I change only those parts of the text on the template that require changing – and this cuts down on time.

applications as well, including addresses and so on. It also automatically adjusts the text font as you type, to ensure that all of your information fits within the dimensions of the label. I know a few agencies that use this printer and they swear by it. A roll for 35mm contains about 300 labels, and the quality of printing at very small fonts is truly excellent. There is no wastage, since you are printing the labels singly as and when required. This system is well worth considering if you have large numbers of trannies to caption. I will also work with the black masks for medium format slides as well.

Some of the other packages available for labelling can be a bit too complex. Most work through a laser printer using multiple labels on an A4 sheet, which can be a bit wasteful if you don't fill the sheet each time. You can feed the sheet through the printer again, but it does get a bit crumpled after a while. Some word processing packages such as Microsoft Word have a 35mm template in their labelling section, which is normally compatible with Avery label products. There is no software-labelling package available for medium format that I know of. If you're not fussy you can use a standard 35mm label on 645 format, but with 6x6 it becomes more complicated as there is only a 7mm thin plastic border

These are the three label types I currently use to caption my different mounts. Since the black masks are the same overall dimension, except for different apertures, the one-label format accommodates all the mask sizes. I also use another template for the plastic mounts.

around the slide, leaving very little space for a data label. I normally split the label into two parts with this mount. Two lines go on the top, and these normally contain the important information such as the name, location, date and grid-ref etc. The bottom two lines generally have photo info and my copyright symbol. You can design your own label on any of the word processing packages. I have always used Microsoft Word as it caters for the vast majority of my needs fairly well. The program is also extremely good for setting up custom-made templates, and that saves a lot of unnecessary typing.

I use three types of label to accommodate the different formats I currently use. All of my slides are placed in masks, with the exception of those which I mount in plastic for projection purposes to use in lectures. My custom-designed template gives me a maximum of five lines per centimetre at a font size of five in Word: this is reduced to four on the plastic mount for the 6x6. I also prefer to use black as opposed to white card masks to present my work to clients – I feel that the images look much better with a dark surround. The majority of card masks tend to be black for medium format anyway. Since the total width of a mounted 6x6 slide is 7cm, the label on the template has a maximum length of 6cm. It's then a simple procedure to cut the labels between the spaces with a scalpel and position them on the mount.

Another useful idea is to colour-spot each slide on the bottom left hand corner to indicate the correct viewing position. This is also a quick and useful method for ensuring that slides are positioned the right way round in the

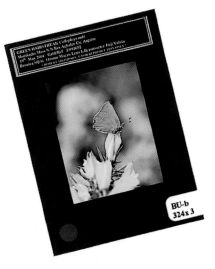

I use another template produced in Microsoft Word for captioning the plastic mounts, which I print in the normal way. I use a small Stanley knife or scalpel to cut them out.

I caption all of my slides with a unique number, which is the best way to accommodate expanding libraries.

projector: a quick visual check is all that's needed to make sure the spots all appear in the top right hand corner of the magazine. I usually have a different coloured spot for each insect group, which makes it easier to sort slides visually when filing material back into their respective folders.

Filing your photographs

Many photographers have their own system for filing and retrieving material. When your collection is small it doesn't present a major problem finding a particular transparency. However, when you have several thousand images it takes considerably longer to locate one, and if you happen to misplace it accidentally in another folder you can waste a lot of time tracking it down. Most photographers use some form of numbering system to make it easier to find images quickly and efficiently. Adopting a unique numbering system for each transparency from the start is the best approach. Many photographers have frequently remarked on the tortures of changing their filing systems. I have already fallen into this trap and am only too aware of the difficulties and the vast amount of time needed to change it. This is especially the case when you are continuously adding new material to your ever-growing library.

Filing systems can be as simple or as complicated as you want them to be. Remember, you want to spend the minimum amount of time filing and retrieving material. Having a complex system takes more time to manage, and if other people have to source your material it may be confusing to them. The insect section of my library is divided up in to categories, such as Dragonflies, Damselflies,

Moths, Caterpillars, Beetles and Butterflies. Each category is further subdivided into regions. For example: Butterflies is the main order, and it is subdivided into British, European and Tropical. Each section within the main category has the same two letters. They all have the standard subject code (BU), the next small letter denotes whether they are British, European or Tropical, BU-b (b means British), followed by a unique number, e.g. 324. If there are three identical images they get the same number, but I put x followed by the numeral 3. For example the full code for a subject that had three identical images would be BU-b 324x3. It also means when I check a particular hanger in the filing cabinet I can see at a quick glance how many slides of the same image are currently out on loan. When I add a new slide to the British file it will now become BU-b 325. There are many methods and variations to this approach, but you can of course experiment with your own ideas.

Duplicating your master slides

As photographers we naturally place a high value on our favourite images. One of the problems you are likely to face sooner or later if you want to publish your work is the possibility that a slide will get scratched or damaged while scanning. Very occasionally one may get lost in the post. I have had this misfortune on several occasions, as do most photographers whose work is published widely. While the vast majority of publishers do try to exercise due care and attention regarding your slides, they often send your material on to another company, such as a repro house, for scanning. Slides have to be removed from their mounts before they can be drum-scanned. Repro houses often use a

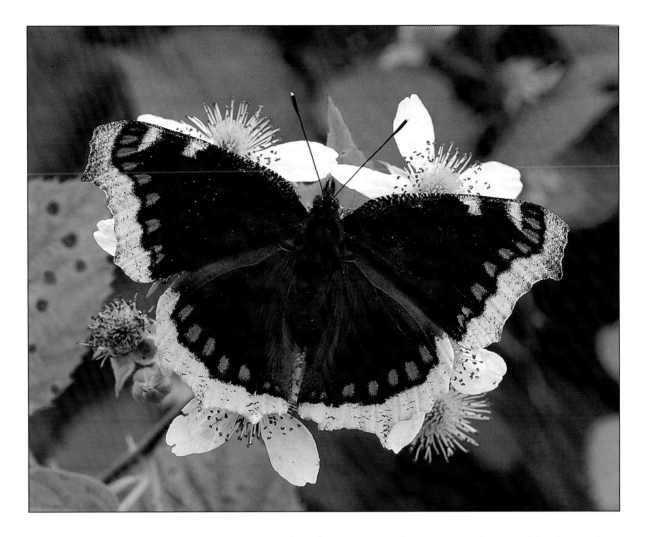

CAMBERWELL BEAUTY
Aglais antiopa

Duplicating your valuable images is the best way to preserve your master transparencies. I had this slide duplicated to protect the original, since I only managed to get a single shot of this attractive species. Images that are used frequently in publications do get slightly scuffed or marked eventually, no matter how carefully they are handled.

Mamiya 645, 150mm lens plus extension tube, fill-in flash, Fuji Velvia.

fluid on the emulsion surface of the slide to help fill in any small tiny scratches and other imperfections prior to scanning the transparency. This procedure is standard throughout the industry. On the return of your images you may also notice a series of numbers scribed on the black border surrounding the slide: this is common practice and is a reference for the person doing the scanning as to what size the image has to be. Once scanning is complete the slide should be properly cleaned and all the oil should be removed, leaving no visible traces on the emulsion. Unfortunately this is not always the case. I have had the misfortune on many occasions to have transparencies returned still covered in oil, with the mounts damaged as a result of careless handling. There is not a lot you can do to

prevent this happening, but is worth considering other options before you take the risk of parting with your valuable master transparencies.

One possible option you should consider is having your valuable images duplicated professionally. This can work out quite expensive, especially if you have large numbers, but it does safeguard your originals. The best and cheapest solution is to take additional shots of the same subject. This is a more cost-effective approach and, besides, an original is always going to deliver a higher quality reproduction than a second generation copy. With medium format I prefer to take multiple shots of a subject where possible, as duplicating originals on this format is not really cost effective.

Marketing and Selling Your Work

THE ambition of most photographers is to see their name and images in print. There is a real feeling of personal satisfaction and accomplishment when this happens. The natural history photographic market is extremely competitive and not easily conquered. There are so many good photographers nowadays, both amateur and professional, that the distinction between them is not based on ability, but rather on the income generated from their photographs. To succeed takes time and determination: if you are easily offended then you'll find it difficult to hack the refusals. Editors are extremely busy people, with a limited amount of time to devote to personal callers wanting to show their work.

Promoting yourself

One of the first things you should do before selling yourself is to define your field of interest. Look at your material critically and see how your images compare to what is currently being published. My interest in natural history photography came about largely through my fieldwork as an entomologist doing biological recording of dragonflies and other well-known insect groups for various wildlife and environmental organizations. This is where I got my opening, by providing pictures of insects and habitats to local agencies. Having your work published at a local level in various leaflets and brochures is a good way to start. Many of these publications find their way to other similar organizations, and they in turn will see your name and your images – and will hopefully contact you in the future.

One of my first tasks was to draft a list of all the organizations and trusts that I felt would possibly be interested in my work. I made appointments to visit them,

RED ADMIRAL
Vanessa atalanta

The most frequently requested butterflies tend to be those commonly seen by the public.

Mamiya 645, 150mm lens plus extension tube, Fuji Velvia.

bringing samples of my work which had been taken on their reserves and other similar locations. Most of these organizations produce booklets and brochures of their properties for the public domain and are always looking for good strong images of insects, plants and habitats for illustrative purposes. Promoting your work through personal contact does work for this type of market. The more images you can publish, the more you'll get noticed – getting pictures published leads to greater exposure and to other possible avenues and markets.

GARDEN TIGER
Arctia caja

This species when threatened reveals the bright scarlet warning colour on its hindwings, which is hidden when the moth is at rest. I am more often asked for images of this moth than any other species because of its striking colouration.

Mamiya 645, 80mm macro lens plus extension tube, flash, Fuji Velvia.

Writing text to support your photographs

The number of photographic avenues for selling single photographs of insects is naturally more restricted than other popular subjects such as birds and mammals. You need to have a good collection of many different families and species to have a reasonable chance of frequent sales. In my experience the images that I am asked for tend to be of well-known insects groups such as butterflies, dragonflies and the common moths. Since the species requested are generally common they are much more likely to be encountered by the public. It is good to have the rarer species too, but they are less in demand and tend to have a more specialized market.

One of the best ways to increase your chances of getting pictures published is to write an article to support them. Look at the various photographic magazines to discover the style and type of articles they publish. Most accept material from freelance photographers. Your submission needs to be strong photographically, theme-based and with images that work together as a unit. It's a good idea to draft an abstract along with your images and send it off first before you proceed any further. I use e-mail for most of my initial submissions now, rather than sending slides and text through the post. I normally send low-resolution scans of the images I plan on using, along with a brief outline of what the article will contain. You need to study the market carefully. Most magazines work well in advance, so there's no point in submitting an article on spring butterflies in March. Look carefully at other experienced photographers who are widely published, and see how they present their material. The market for insect-based articles is relatively restricted, but there are many other natural history publications that run features on all aspects of nature and these are also worth exploring. If they have published something on insects within the last year they may be reluctant to produce a similar article so soon unless it's extremely strong visually. It might be worth featuring some interesting reserve or other

Combining your images with a general article about a well-known locality is a good way of getting them into print.

well-known area and incorporating additional pictures of the habitat as well as the plant and animal communities that exist there. This is a useful approach when the publication has a more general natural history readership.

Writing is a skill, and if you're one of those fortunate people who have a natural flair for it then this is an added bonus. Don't be put off by rejections. Like many other photographers, I have had my fair share of those over the years. Writing needs commitment and dedication, but the more you do it, the better you become. There can be many reasons why an article fails to impress an editor, but if you have the enthusiasm and determination you are well on the way to succeeding.

Placing your photographs with an agency

Marketing and selling your photographs is a tough business, often with little reward for the time and effort spent. Finding clients in this highly competitive market is often difficult, as there are so many good photographers seeking avenues for their images as well. The vast majority of professionals and a large percentage of amateurs with reasonable-sized collections belong to agencies that sell and market their images for them. There are advantages and disadvantages to this approach. In theory it would seem to be a good idea: you take the photographs and they'll do the marketing and selling. In practice, however, it's not so straightforward. First you have to find an agent who will accept your work, and

that's becoming increasingly more difficult these days because of the number of photographers already signed up. Second, they have to compete with other agencies for business on your behalf. The standard of your work has to be extremely high if it is to be accepted into any of the top well-known agencies, who have many of the best photographers on their files already.

Most leading natural history agencies tend to have good photographic coverage of the common insects such as butterflies, moths and dragonflies on their files and are often reluctant to recruit other photographers with similar material. Agencies are busy organizations. They devote a lot of time and effort building clientele and searching out new markets and avenues for potenional sales. They have access to more outlets for pictures than you or I could ever have. They won't want to waste valuable time trying to market material that is below the standard produced by their competitors. Having a collection of images with an agent doesn't guarantee sales: all they can do is submit on your behalf, and after that it's up to the client.

All agencies take a commission on each sale, which on average is around 50 per cent. Contacting them before sending any material is generally the best approach. If your collection is small (comprising two or three hundred images) then it's going to be extremely difficult for you to get accepted. Even if you are successful, the returns on a small number of images (especially insects) are likely to be extremely poor and not worth the effort.

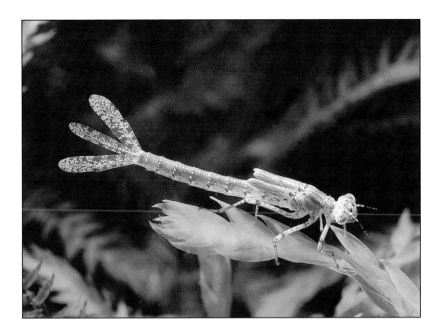

RED-EYE DAMSELFLY
Erythroma najas

TIGER BEETLE
Cincidela hybrida

*While it's nice to have unusual images of certain insects in your collection you will probably find
that they are rarely requested by clients, since the market for these photographs is very specialised.*

Mamiya 645, 80mm macro lens plus extension tube, flash, Fuji Velvia.

Mamiya 645, 80mm macro lens plus extension tube, Fuji Velvia.

Developing a partnership with an agency is a long-term commitment. They expect you to make frequent submissions and maintain your standard. Building your stock library takes a lot of time and effort, initially with very little return. It also involves shooting many different subjects that you may have only a casual interest in. Not all of your submissions will be retained: for every hundred images submitted you can expect half of them to be returned for a variety of reasons, the most common being that the agency is over-stocked on that subject. Remember that the most frequently published images are generally of common subjects: having a comprehensive collection of rare insects will be valuable in terms of the content, but it is unlikely to pay you large dividends. Most professionals who are with agencies have deposited large numbers of images with them, usually on a variety of subjects, in order to get a reasonable return. If you want to increase your potential in this direction, study the market place carefully. You will most certainly have to diversify and photograph other subjects if you are going to make it work. Specializing solely on insects is unlikely to produce a big return – besides, the vast majority of photographers don't depended entirely on agency sales for their survival. Look at different publications and make a list of the most commonly published subjects. Pay particular attention to seasonal aspects and what type of pictures magazines frequently use to highlight the changing seasons.

Acrida ungarica

The vast majority of insect requests to agencies are native or regular migrant species. The use of foreign images of insects tends to be much more selective and generally restricted to well-known subjects. However, now and again specialist publications will be commissioned about a particular country or region, and these can be productive if you happen to have a good cross-section of material from that area.

Mamiya 645, 150mm macro lens plus extension tube, Fuji Velvia.

Useful addresses

Benbo Tripods Impress Group Ltd, Stafford Park 1, Telford, Shropshire, England TF3 3BT

Colorworld Ltd P.O. Box No.2, Norham Road, North Shields, Tyne and Wear NE29 0YQ

D.W. Viewpacks Ltd Unit 7/8, Peverel Drive, Granby, Milton Keynes MK1 1NL

Uni-Loc Tripods Unit 10, Firbank Court, Firbank Way, Leighton Buzzard, Beds LU7 4YJ

Bibliography

Dalton, S. **Caught in Motion** Weidenfeld & Nicolson Ltd 1982

Hardcourt Davis, P. **The Complete Guide to Close-up and Macro Photography** David & Charles 1998

O'Toole, C., Preston-Mafham, K. **Insects in Camera** Oxford University Press 1985

Shaw, J. **Closeups in Nature** Amphoto 1987

Shaw, J. **The Nature Photographer's Complete Guide to Professional Field Techniques** Amphoto 1984

Shell, B. **Mamiya Medium Format Systems** Hove Foto Books 1992

Zuckerman, J. **The Professional Photographer's Guide to Shooting & Selling Nature & Wildlife Photos** Writer's Digest Books, Ohio

Website addresses

Camera companies & equipment accessories

Bronica www.tamron.co.uk

Canon www.canon.co.uk

D.W. Viewpacks Ltd www.dw-view.com

Fuji www.fujifilm.com

Gitzo Tripods www.gitzo.com

Hasselblad UK www.hasselblad.co.uk

Kirk Enterprises www.kirkphoto.com

Kodak www.kodak.com

Lowepro Camera Bags www.lowepro.com

Mamiya UK www.mamiya.co.uk

Manfrotto www.monfrotto.com

Nikon www.nikon.com

Robert White www.robertwhite.co.uk

Tamarac www.tamarac.com

Photographers

Stephen Dalton www.stephendalton.net

Niall Benvie www.niallbenvie.com

Laurie Campbell www.lauriecampbell.com

Heather Angel www.naturalvisions.co.uk

George McCarthy www.georgemccarthy.com

John Shaw www.johnshawphoto.com

Mark & Lisa Graf www.grafphoto.com

Useful insect sites

DragonflyIreland www.dragonflyireland.fsnet.co.uk

UK Moths www.ukmoths.force9.co.uk

Caterpillars of Eastern Forests www.npwrc.usgs.gov/resource/2000/cateast/families.htm

Hawk-moths of the Western Palaearctic http://tpittaway.tripod.com/sphinx/list.htm

Large Moths of North America www3.pei.sympatico.ca/oehlkew/izsaturn.htm

Moths & Butterflies of Europe http://digilander.iol.it/leps

Moths of North America www.npwrc.usgs.gov/resource/distr/lepid/moths/mothsusa.htm

Other interesting sites

Guide to the Webs Top Nature Sites http://members.aol.com/elgallery/topphotos.html

Outdoor Photography www.gmc.mags.com

Atropos (Journal on Butterflies, Moths and Dragonflies) www.atroposuk.co.uk

Natural History Photographic Agency www.nhpa.co.uk

About the Author

Robert Thompson

An accomplished wildlife photographer, naturalist and entomologist, Robert Thompson has had his photographs reproduced in many books, magazines, newspapers, CDs, calendars, posters and various other publications in Britain and Europe. His articles and photographs have been featured in *Outdoor Photography* as well as in many other photographic, natural history and entomological publications. His images are used widely by well-known societies and organisations such as the RSPB, National Trust, English Nature, Northern Ireland Tourist Board and other leading conservation organisations.

Robert has been a major contributor to many well-known publications on dragonflies and butterflies in the United Kingdom and Europe, and his photographs have been used to promote Mamiya's medium format cameras in the UK and Japan. He has conducted workshops and given lectures on photography and various other natural history subjects. He is also part of the Natural History Photographic Agency, which manages and sells his photographs. He is currently working on two other long-term book projects, *Moths of Northern Ireland* and *The Natural History of Ireland's Dragonflies*.

Index

Page numbers in **bold** refer to illustration captions.